Underwater
Photography

Underwater Photography

John Turner

Focal Press
London & Boston

Focal Press
is an imprint of the Butterworth Group
which has principal offices in
London, Sydney, Toronto, Wellington, Durban and Boston

First published 1982

© Camera Alive Ltd, 1982

British Library Cataloguing in Publication Data
Turner, John
Underwater photography
1. Photography, Submarine
I. Title
778.7'3 TR800

ISBN 0-240-51122-0

Photoset by Butterworths Litho Preparation Department
Printed in England by Butler & Tanner, Frome, Somerset

PREFACE

The underwater world is a blend of beauty and tranquillity, ferociousness and ugliness, excitement and danger. It is an environment that is potentially hazardous to man, the key to safe entry being specialised equipment and correct training.

Not everyone has the desire or physique to experience this alien environment at first hand but, as the success of many TV series has shown, there are few people not fascinated by this 'world of inner space'. The growth of diving as a hobby, the increase in offshore exploration and exploitation of mineral reserves and the demand for interesting and stimulating visual entertainment have all contributed to the need to record and transmit the sights and happenings of this environment, which we are only just beginning to explore.

My introduction to underwater photography came by chance. I was asked to photograph a Scientific Expedition. I agreed before I was told that a large part of it would be conducted underwater and so had to immediately embark on an intensive dive training programme. Very quickly I became addicted to the underwater world and my career aspirations turned from photography to underwater photography.

At this time I was in my final year of reading for a degree in photographic technology. My knowledge of terrestrial photography was therefore extensive, but I did not know how to apply this knowledge underwater. I started to read every book on underwater photography that I could obtain, but soon realised that not many have been written. These varied from raw beginners' books, that assumed no diving or photographic knowledge and so were too basic, to others that were too technical, containing information that could not be directly applied practically. Many concentrated on the manufacture and choice of equipment rather than its application; others were no more than a showplace for the author's photographs and only reiterated commonly expressed opinions on theory. Not one clearly expressed how to analyse my own equipment requirements and how to use that equipment to take photographs of the subjects that I would be encountering on the expedition.

I have therefore had to learn the hard way, by practical experience. From initial stills photography I progressed to filming and directing. I then entered the commercial diving industry and became immersed in providing photographic and video services to the then young oil and gas industry. This involved developing equipment and techniques to solve entirely new problems and then training divers to apply these solutions correctly. Having undergone this range of experience I felt ready to write the book that I would have liked to have found on the shelf when I was starting underwater photography.

The book will be of most value to someone with basic knowledge of diving and photography. The novice will find the necessary introduction to underwater photograpy and filming backed up by further explanations, discussions and practical assignments to help him become fully proficient. The expert will find specialist applications dealt with in both theory and practice and the discussion of subjects and their treatment is designed to stimulate thought and action. Although the book answers questions that will be asked on the road to proficiency it is intended more to develop and provoke thought and planning such that the photographer may use accumulated knowledge, gained both from the book and from experience, to solve the individual problems that will be encountered. To achieve proficiency dedication and effort will be required; but that is the secret of success with any hobby or profession. I wish you that success.

I must apologise to my female readers for the continual reference to divers in the masculine. This is not because I do not regard females as divers, but because it is more convenient to write 'he' rather than 'he or she' wherever the need arises. I hope that all references to 'he' will be assumed to encompass both sexes.

Many people have helped me in the compilation of the book and its illustrations. There is too little

room to list everyone individually but mention must be made of Thom Aldridge who taught me to dive, Peter Scoones and Peter Rowlands who have been the source of assistance, discussion and criticism over the years and Clyde Reynolds my Commissioning Editor, for his help, enthusiasm and advice. A special mention must be made of my wife, Susan, for putting up with me while I wrote, as well as typing and correcting the manuscript and giving the support that all authors need. Thank you all.

J.T.
Aberdeen

CONTENTS

Chapter 1 The problems 1

Chapter 2 The camera 7

Chapter 3 Lighting and filters 19

Chapter 4 Accessories and their use 35

Chapter 5 Films 42

Chapter 6 Photography in bad visibility 51

Chapter 7 Close-up photography 62

Chapter 8 Photographing divers 70

Chapter 9 Photographing marine life 81

Chapter 10 Photographing wrecks 98

Chapter 11 Underwater film-making 107

Chapter 12 The key to success 118

Index 123

1

THE PROBLEMS

The limitations of diving

Although attempts have been made throughout history to develop underwater breathing devices, it is only in recent years that man has succeeded in doing so. With the development of the Cousteau-Gagnan aqualung in 1943, the diver was freed from the heavy and cumbersome equipment that had until then characterised his penetration of the depths. Now he could carry his air supply on his back in cylinders, and need no longer rely on a surface team to pump air to him. His horizontal range was increased, and new discoveries came thick and fast; but the depths that he could reach were still limited. Water is so much more dense than air that the pressure exerted on the earth's surface by the atmosphere many miles deep is doubled by only ten metres depth of water. This pressure can have serious effects on both the man and his equipment. To be able to breathe underwater, a diver has to have air supplied to him at the surrounding pressure, and thus the greater the depth of the dive the greater the pressure of the air breathed. This increased pressure causes extra nitrogen to be absorbed into the body; at a depth of only 30 metres an effect known as *nitrogen narcosis* is experienced. This leads divers to make errors of judgement and put their safety at risk. At depths of over 100 metres, the pressure can cause oxygen itself to be lethal.

For dives deeper than 50 m (160 ft) it is now usual to employ mixtures of helium and oxygen in varying proportions; the proportion of oxygen may be as low as only 5% at depths of 300 m (1000 ft). Diving bells and decompression chambers are mandatory for such dives, with the breathing mixture, gas pressure and temperature all carefully controlled and constantly monitored by the surface support team. A system designed to allow dives to below 100 m (330 ft) can cost millions of pounds.

When surfacing, the gas in the body has to be given time to escape. This is the reason for the decompression tables that divers must follow when returning to the surface. If these are not followed, then the effect of the gas absorbed in the body is similar to that of the gas absorbed in a fizzy drink when the top is removed. With the release of the pressure bubbles of gas are immediately formed. When this happens in the body, decompression sickness occurs. If the bubbles are formed in the joints the effect is termed the 'bends' and can cause severe pain, spasms and even paralysis; if they form in the bloodstream or lungs, the resulting embolism (blockage of the blood vessels) can be fatal. Pressure can even have an adverse effect on the bone structure. Frequent diving, or diving to great depths, can cause necrosis. The natural renewal of bone around the joints can be halted with accompanying severe pain and stiffness.

Few have so far succeeded in diving to a depth of more than 500 m (1600 ft). Even with today's technology, only 12% of the volume of the sea can at present be explored. There is much work still to be completed before we can be said to be masters of the underwater environment.

Mechanical problems

The fascination of the sea and the underwater world has always proved strong; it has provided the impetus to solve many of the problems. The first successful underwater photographs were taken as early as 1893, and are attributed to Louis

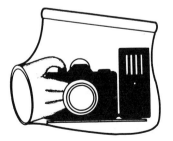

Figure 1.1. The simplest way of keeping a camera dry at shallow depths is to use a flexible plastic housing

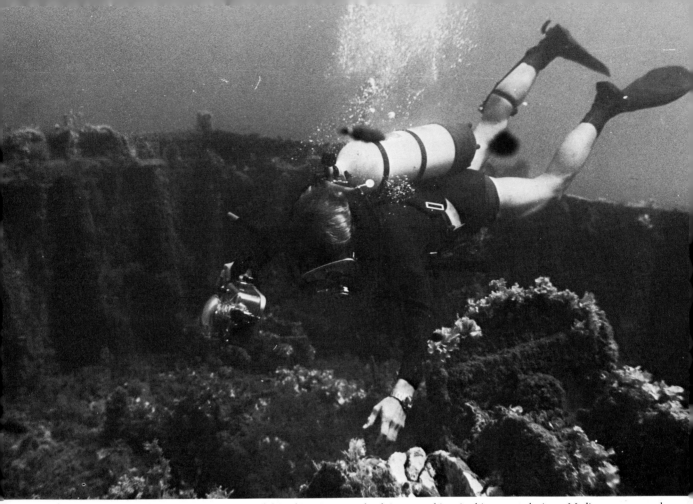

Photographs of divers are of more interest if the subject is seen to be doing something, in this case exploring a Mediterranean wreck

Boutan, a Frenchman, who designed a waterproof camera housing that could be pressurised with the aid of a bladder. He overcame the first problem to be faced by the underwater photographer, that of keeping the camera dry.

Photographic equipment can easily be damaged by water, particularly salt water. All apparatus for use underwater must be enclosed in a watertight housing that will resist the pressure of the water. The most commonly used materials for camera housings are aluminium, stainless steel and injection-moulded or sheet plastics. Housings can be built around apparatus designed for use on land, or they may be an integral part of the design of the equipment. With the growth of interest in underwater photography the latter solution is becoming increasingly popular; it can be exemplified by the Nikonos amphibious camera and Oceanic Products underwater flash units. Encapsulation of the camera leads to mechanical problems with camera controls such as film advance, shutter release, aperture, focusing and shutter speed setting. A housing needs an optically accurate window or *port*, which itself introduces its own problems, to understand which we must look at the optical properties of water itself.

Optical problems

Water affects the propagation of light in several ways. The main effects are *refraction*, *scattering*, *reflection* and *absorption*.

Refraction

Light travels at a velocity which depends on the nature of the optical medium. When a beam of light passes from one medium into another having

a different *optical density* it is refracted (deviated) at the interface, in a way that can be predicted from a knowledge of the refractive indices of the two media (Figure 1.2). If it passes into a medium

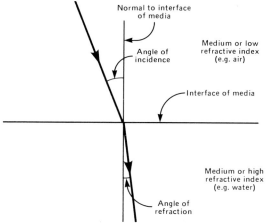

Figure 1.2. When light passes from one medium into another that is more optically dense it is deviated towards the normal

of higher optical density it will be deviated towards the normal (the line perpendicular to the plane of the interface) and, if into a medium of lower optical density, away from the normal. The higher the refractive index of a medium is the more the light beam is deviated. The refractive index of air is 1; that of water is 1.33, and that of a typical optical glass about 1.5. Refraction explains why underwater objects seen through a flat port appear nearer and larger than they really are (Figure 1.3). Light passing from the denser water

to the less dense air is refracted away from the normal. This magnifies the image in a ratio 4:3, the ratio of the refractive indices of water and air. An object that is four metres away actually appears to be only three metres away (for the present purpose the effect of the glass of the port can be ignored).

When a camera is used underwater in a housing with a *plane* (i.e. flat) port, the focus must be set to three-quarters of the subject distance. In practice this is complicated by the fact that the diver himself will be wearing a face mask with a plane port, and will be seeing the same magnified image as the camera. If he estimates the distance that he is away from the subject visually as he would estimate the distance on land, then this is the distance to set on the camera. If he estimates the distance by comparing it with an object of known size, or actually measures it, then three-quarters of this distance must be set. At the same time as apparently changing the distance and size of an object, refraction reduces the angle of view of a lens behind a plane port to three-quarters of its angle of view in air.

Because most lenses are computed on the assumption that they will be used in air, and have only air-glass interfaces, using them underwater with the additional water-glass-air interface introduces a number of defects, known as *aberrations*, into the performance of the lens. These affect the quality of the optical image. The only solution is the use of specifically designed underwater optical systems. When using such systems the actual subject distance can be set directly on the focusing

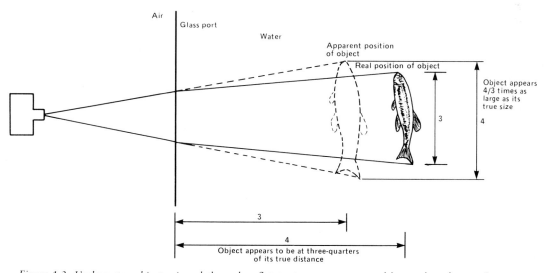

Figure 1.3. Underwater objects viewed through a flat port appear nearer and larger than they really are

The effect of water on a camera image. The picture on the left was taken with a 35 mm lens behind a plane port. Notice how the water magnifies the subject and also how contrast is lost underwater. The picture on the right was taken with a 15 mm full frame fisheye lens behind a dome port. Notice how the magnification effect is reduced (in a fully underwater corrected system it would not be apparent) and how underwater contrast and definition have been improved by moving closer to the subject (Susan Turner)

scale; also, the angle of view of the lens in air is retained underwater, and aberrations are reduced to a minimum.

The natural light that enters the sea is also affected by refraction. Because the light is passing from air into the more optically dense water, it is deviated towards the normal (Figure 1.4); thus sunlight underwater appears always to come from almost directly above. The intensity of light entering the water is also affected by the angle of the sun. When the sun is low in the sky, the light has to pass through more of the atmosphere and is attenuated by it to a greater extent. It is also illuminating a greater area than when directly overhead (Figure 1.5), and a higher proportion is reflected, particularly when very low in the sky.

The combination of these effects suggests that it is advisable, when possible, to confine available light photography to the hours around midday.

Scattering

Underwater, light rays are scattered by the water and by suspended particles; attenuating the light intensity. Light is scattered even in distilled water; but in lake or sea water the scattering is aggravated by silt, organic matter, plankton, air bubbles and other suspended matter. The effect is similar to viewing an object on a foggy day or in a smoky room. As the fog or smoke increases, so the fine detail of the object becomes less distinct, until

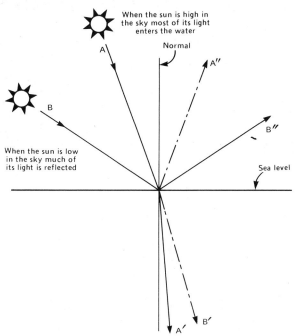

When the sun is high in the sky most of its light enters the water

Normal

A'

A''

When the sun is low in the sky much of its light is reflected

B

B''

Sea level

A'

B'

Figure 1.4. All sunlight entering the water is refracted towards the normal and so appears to come from more directly overhead

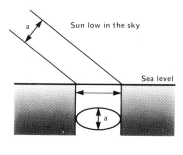

Sun low in the sky

a

Sea level

a

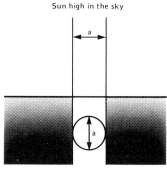

Sun high in the sky

a

a

Figure 1.5. When the sun is lower in the sky it is illuminating a larger area, and the light intensity in the water is lower

eventually only the outline or form of the object can be seen, before it disappears altogether.

Only light coming directly from the subject will contribute to its optical image: the scattered light produces an overall illumination, or *flare*, which overlays this image and reduces its contrast. The effect is increased by lack of direct sunlight in the water. When the sun is obscured by clouds the only light to enter the water is diffuse sunlight. Diffuse light itself produces low-contrast images, as can be seen when photographs of the same subject taken in sunny and cloudy weather are compared. The contrast is reduced further by the underwater environment. Thus the problem of obtaining adequate contrast in underwater photographs is one of considerable importance.

Reflection

When artificial light is used to try to overome this and other problems, it is scattered on its way to the subject and may be reflected back to the camera lens. This *backscatter*, as it is called, is apparent both as overall flare and as *hot spots* where the artificial light is reflected back from large particles suspended in the water. Artificial light must be arranged so as to minimise backscatter.

Absorption

Water does not absorb light uniformly across the spectrum. The longer wavelengths, at the red end of the spectrum, are absorbed more than the shorter ones at the blue end. Hence colour is progressively lost as either depth or distance from the subject is increased. Reds disappear first, followed by oranges, yellows and greens, until finally only blues are left. The underwater world then takes on a monochrome appearance, until finally blue light itself is absorbed and everything is immersed in darkness. In murky coastal waters very little daylight may be apparent at depths of only 50 m (160 ft), though in mid-ocean daylight may extend to more than 400 m (1300 ft).

The loss of colour can be alleviated to a certain extent by the use of colour filters, but in most cases artificial light must be used to restore the natural colours in underwater subjects, and may even be needed to make photography possible at all. For still photography the most useful light source is flash, either electronic or bulb, but for movie photography some form of continuous light source is required.

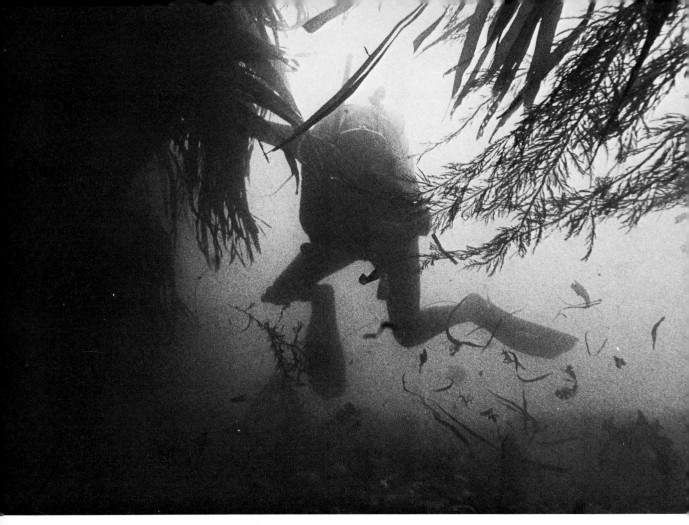

Available light photography is even possible in British waters. Rocks and weed make an attractive frame for a subject

Summary

Having introduced the major problems faced by underwater photographers it is necessary to look at ways to solve them. As the more specialised aspects of the subject are investigated, so more minor problems will arise — but this is one of the factors that makes underwater photography interesting and challenging. The solutions to the problems are often relatively simple, although inevitably some of them will be compromises. If underwater photography was really difficult then it would not be so popular!

One word of warning: do not underestimate the sea. It is an alien environment, and diving is not just a matter of buying all the latest equipment and then jumping into the water. Under no circumstances should you enter the water without adequate training and supervision. Without the correct training, diving is about as safe as jumping off a cliff but with a proper course of instruction, and adherence to safety drill, it is one of the safest sports. Obey the rules, and underwater photography can be a fascinating hobby or a rewarding profession.

2

THE CAMERA

Special requirements

The variety of cameras available may lead to a great deal of confusion. Having made a choice between the various formats, viewing systems and layouts there still remains the decision as to which make and model to buy. Individual preference and the type of photography required are important factors in any final decision, but no single camera is suitable for all possible uses. It is necessary to consider all of one's requirements in the light of the fact that a camera, no matter how complex or simple, has the sole function of exposing film to light in a controlled manner.

An underwater photographer has the choice of using either an amphibious camera designed specifically for underwater use, or of encapsulating in a waterproof housing a camera designed originally for use in air. Before comparing the two options directly, it is worthwhile to consider certain factors.

Figure 2.1. A 35mm cast aluminium housing. These are normally tailor made for a particular camera

The basic camera functions: viewfinder, shutter release and film advance are essential. Other controls, such as shutter and aperture setting, focusing, etc. are needed to undertake a range of photography underwater. However, some simple cameras have one or more of these preset to simplify operations when the camera is used under fixed conditions. Other camera functions, such as the self-timer, depth of field preview, manual override of automatic exposure etc., are not normally required for underwater use.

Motor drives or power winders can usefully replace manual film advance. This reduces the external controls on the housing, and also allows it to be constructed to lie flush with the camera back, because the film advance lever does not need space to be pulled out. So the housing can be made more compact and the camera eyepiece system viewed from a closer position.

Automatic exposure control eliminates the need for aperture and shutter speed controls for available-light photography. If artificial light is also used then aperture control is needed, and this increases the versatility of an aperture-priority automatic-exposure system. Various devices for achieving automatic focus are currently available for use in air and doubtless it will not be long before some enterprising manufacturer adapts one for underwater use. This will overcome one of the major difficulties of underwater photography.

Viewing systems

Most cameras have one of three different types of viewfinder systems (Figure 2.2).

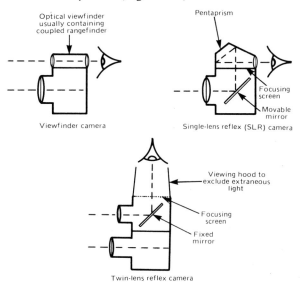

Figure 2.2. Most cameras have one of the three types of viewing system

The simplest designs have a viewfinder separate from the optical system of the camera. Although this gives an indication of the field of view it does not indicate focus. Some cameras have built-in split-image rangefinders which, when coupled with the focusing mechanism, set the focus directly. However, rangefinders are not in general practicable for underwater use. When a camera with a separate viewfinder has interchangeable lenses, the viewfinder is normally marked with the approximate field of view of several lenses. The viewfinder must be designed for use with the widest-angle lens commonly used and will give a very small image when used with long-focus lenses.

This system also suffers from *parallax*. Because the viewfinder is situated away from the lens axis it will always see a slightly different view from that seen by the lens (Figure 2.3). This is not normally

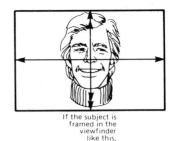
If the subject is framed in the viewfinder like this,

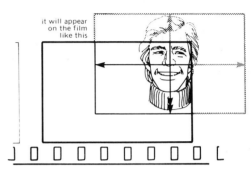
it will appear on the film like this

Figure 2.4. Parallax in close-up photography, where the viewfinder is mounted above and to the right of the lens axis

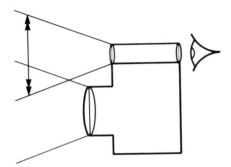

Figure 2.3. The effect of parallax: although the subject is framed accurately in the viewfinder the camera does not see the same field of view

noticeable except at distances less than 2 m (6 ft 6 in). Viewfinders are mounted above and often to one side of the lens. For example, if the viewfinder is mounted above and to the right of the lens axis and the subject is framed accurately as far as the viewfinder is concerned, the resulting photograph will be framed low and to the left (Figure 2.4) so that part of the upper and right-hand edges of the required scene are cut off. The effect increases as subject distance decreases.

Most viewfinder cameras have marks in the viewfinder so that some allowance can be made for parallax, but for close-ups some other method of framing must be found. This is discussed in Chapter 7.

In a twin-lens reflex camera the viewing system utilises a lens of the same focal length as the taking lens. The subject is viewed by looking down into the camera from the top, although a *pentaprism*

attachment can often be fitted for eye-level viewing. The mirror in the viewing system reverses the subject laterally, but the use of a pentaprism in eye-level viewing corrects this reversal. The viewing lens is attached to the same focusing mount as the taking lens. This provides for a precise indication of focus and field of view – but does not overcome parallax. A moving pointer coupled to the focusing system and visible in the viewfinder can be used to indicate the position of the top of the film image, but this system is not very satisfactory. Although this design offers some advantages over a separate viewfinder, twin-lens reflex cameras are bulky, and interchangeable lenses for them expensive. As a rule the design is associated only with the 6 × 6 cm film format.

The single-lens reflex (SLR) format overcomes the problems of parallax, focus and framing. The viewing system comprises a mirror, which swings out of the way to enable a photograph to be taken, and a ground-glass viewing screen. A pentaprism is commonly fitted to correct the lateral reversal introduced by the mirror and to allow eye-level viewing. Whatever is seen through the viewfinder will appear on the film. This means that SLR cameras are especially suitable for close-up photography. The system does have the disadvantage that, as the viewing system is complex and absorbs a good deal of light, an SLR camera is difficult to

focus in poor light. Some additional light source is frequently needed to aid focusing underwater. Viewing is also interrupted at the instant the photograph is taken, though 'instant-return' mirrors ensure this break is very brief.

When a fixed pentaprism SLR camera is used in a housing, it is not normally possible to view the whole screen area simultaneously without some optical aid. In some models of camera the pentaprism can be interchanged for a viewfinder which gives a magnified image viewable up to 60 mm behind the camera. These are ideal for underwater use, as they retain the advantages of the reflex viewfinder even with the camera in an underwater housing.

Shutters

Cameras are available with either *diaphragm* or *focal-plane shutters*. Focal-plane shutters are installed in the camera body, as near to the film plane as possible, whereas diaphragm shutters are installed between the lens elements. Cameras with interchangeable lenses are usually cheaper if a focal-plane shutter is used, as the shutter in the camera body is used with all lenses. A diaphragm shutter built into each lens is a somewhat expensive alternative. The great alternative, however, of a diaphragm shutter is that it allows flash synchronisation at all shutter speeds.

The lens

When a camera is used in an underwater housing with a plane port, refraction reduces the effective angle of view of the lens to three-quarters of its value in air (see p. 3). The angle of view of a 35 mm wide-angle lens underwater is thus reduced to approximately that of a 50 mm standard lens in air.

The factors affecting the passage of light through water, such as scattering, were also discussed in Chapter 1. In order to reduce these effects, and hence to obtain optimum picture quality, the light path should be kept as short as possible. This is achieved by photographing the subject from as close as possible, so that to reproduce the subject in its entirety a wide-angle lens is required (Figure 2.5).

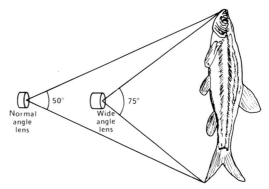

Figure 2.5. A wide-angle lens allows the whole subject to be photographed from closer, giving improved quality

A wide-angle lens is a lens with an appreciably larger angle of view than the standard for the format. The standard lens for a still camera has a focal length approximately equal to the length of the diagonal of the film format. Table 2.1 gives the

Table 2.1

Film format	Diagonal of film format (mm)	Standard focal length (mm)	Wide-angle focal length (mm)	Superwide-angle focal length (mm)
Still				
110	21.4	23–26	17	12
126	41.0	40	28	20
Half frame	30.0	25–30	17	12
35 mm	43.3	45–50	35	24
4.5 × 6 cm	75.0	75	55	40
6 × 6 cm	84.8	80	60	40
6 × 7 cm	92.2	90	65	50
Movie				
8 mm	6.1	10	8	6
Super 8	7.1	12	9	7
16 mm	12.7	25	20	10

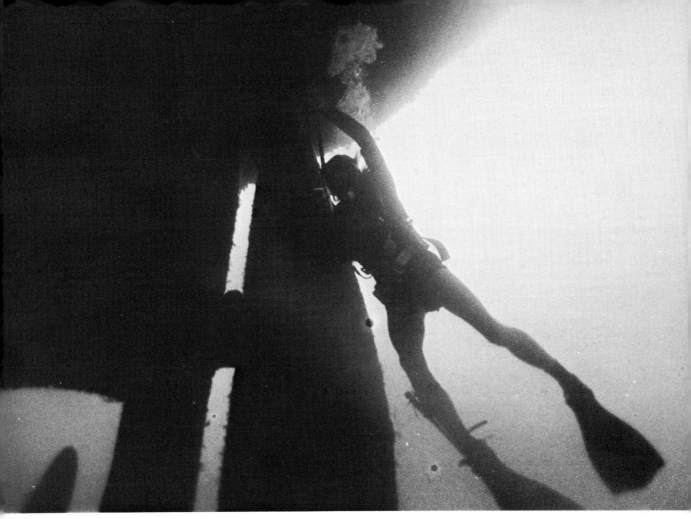

Silhouettes can be dramatic. Note that the use of a wide-angle lens has introduced some perspective distortion, making the diver's fins appear larger in proportion to his head than they really are

'standard' focal lengths for a number of different film formats and compares them with the focal lengths of wide- and superwide-angle lenses. Notice that the standard lenses for movie cameras have considerably longer focal lengths than those for still cameras.

Format

Many film formats are used underwater; these are discussed on pp. 42–43. The choice of camera for underwater use is limited by physical size; the largest film format in common use is 6 × 7 cm, the smallest being the 110 format.

Types of camera

Simple cameras

Most people take the majority of their photographs in clearly defined conditions, either outdoors in daylight or indoors with flash. Simple cameras are designed to suit just these conditions. The lens is either of fixed aperture or has a small range of settings, so that it provides adequate depth of field without the necessity for a focus control. The shutter offers either one or two speeds, or simple electronic exposure control. For manual cameras the exposure controls are usually linked to a weather-symbol setting (sunny, cloudy

etc). Automatic-exposure models seldom offer the user any override facility.

Several simple cameras are waterproof for use both on land and in shallow dives. This type of camera can produce adequate photographs of divers and scenery in shallow water when the sun is shining. Its main disadvantage is that focus is normally preset, with sufficient depth of field to render both landscapes and portraits in focus. On land the nearest 'sharp' distance is about 2 m (6 ft 6 in). Underwater, behind a plane port, this be-

This consists of a focal-plane shutter, film transport mechanism, hinged pressure plate, frame counter and viewfinder. The connection for flash synchronisation is contained in the outer body.

The film-advance and shutter-operating mechanism is a particularly practical design. A single lever operates both. To advance the film the lever is pushed in with the forefinger until it catches, and it is then pushed again to release the shutter. When released it returns to its original position (Figure 2.6). This action ensures a very

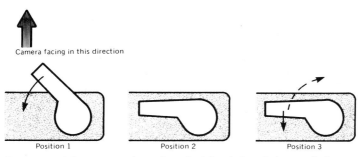

Figure 2.6. Schematic to show the principle of the wind-on and shutter-release mechanism of the earlier models of the Nikonos camera

comes about 2.7 m (9 ft), which is too far away for most subjects, particularly in turbid water. Even a simple camera for underwater use requires either control of focus or a facility for fitting a close-up lens to bring the plane of focus to about 1 m (3 ft). This type of camera is suitable for snorkeling rather than diving, although, being of the 'point-and-shoot' variety, it does allow the photographer to concentrate on the subject matter rather than the equipment.

Some simple cameras can be fitted with flash-cubes, and may even have a built-in electronic flash. The flash is close to the lens axis and so backscatter can be a problem in all but the clearest water. Also, unless a fast film is used the flash is only suitable for subjects about 1 m away.

The amphibious camera

Amphibious cameras may be very simple or very sophisticated. However, the only commonly available camera with the versatility required by the serious underwater photographer is the Nikonos. Although small improvements have been made with each model, the latest version still retains the same design concepts as the original Calypsophot. In the early versions the body is in two parts, an outer 'housing' and the inner camera mechanism.

fast operation and is also easily adapted to a thumb release when used on an accessory bar. A shutter lock can be operated with the shutter in the set position. The bayonet-fitting lens is used to lock the body assembly together. It must be removed before the body can be taken apart for changing the film (of course, the film must always be rewound into the cassette before this is done).

Four Nikon lenses are available: 15 mm $f/2.8$ and 28 mm $f/3.5$ for use in water, and 35 mm $f/2.3$ and 80 mm $f/4$ for use in both air and water. The viewfinder contains frame markings for the latter two lenses, but for underwater use external viewfinders are necessary. The system is completed with a bulb flash unit, a close-up kit and other minor accessories.

The most recent versions of the body depart from the layout of previous models in a number of ways. The camera body is no longer in two parts but has the form of a conventional 35 mm camera, the back swinging open for film loading. The wind-on and shutter-release mechanism is now conventional in design. The mechanical shutter has now been replaced by an electronic shutter with through-the-lens automatic metering built in. The viewfinder has also been moved to directly above the lens axis. In spite of these important changes and others of a more cosmetic nature, the camera still takes the original series of lenses

although the automatic metering does not function with the 15 mm lens.

Independent manufacturers are mainly responsible for the versatility and success of this system. A large range of additional lenses, lens attachments, close-up attachments, viewfinders, handling systems and flash units is available in various qualities and prices. Whatever the subject matter, somewhere there is a supplier of the appropriate attachment to photograph it.

Its compact nature and ease of handling also make the Nikonos the ideal camera with which to go sailing or water-skiing, or for photographing any activity in which the camera is likely to get wet or dusty. It is very near to being the ideal underwater camera. However, the absence of a built-in exposure meter in the earlier versions means that an additional item has to be carried when working by available light. Accessories exist for mounting an exposure meter on a camera handling frame, but this loses the advantage of compactness. The built-in exposure meter of the more recent versions overcomes this.

The main disadvantage of the camera for the serious underwater photographer is the lack of through-the-lens viewing. Because an accessory viewfinder must be used, framing is not completely accurate, and parallax becomes a problem when focusing. All distances must be estimated by eye or measured, corrected for refraction, and set manually. This increases the time taken to set up the camera underwater.

Because amphibious cameras are specifically designed for underwater use, they are usually smaller, lighter, easier to use and handle better than many encapsulated cameras. Were it available, a Nikonos-type camera with a built-in exposure meter and through-the-lens viewing would be the ideal underwater camera. For most underwater photography the amphibious camera still retains advantages, but it cannot match the potential versatility of a major 'system' camera in an underwater housing.

Viewfinder cameras

A compact viewfinder camera is a very good choice if underwater subject matter is to be limited to divers and general scenery. It is also convenient for surface photography, being light and quick in action, especially if fitted with rangefinder focusing and automatic exposure control. Especially suitable are 35 mm viewfinder cameras. Typically,

these have a fixed lens of somewhat shorter focal length than the 50 mm standard for the format. Most have diaphragm shutters, so that flash synchronisation offers no problem (see pp. 20–22).

The compact nature and layout of the camera, although good for land use, is not ideal underwater. There are difficulties in adapting the camera controls when the camera is encapsulated. If photography is carried out by available light, an automatic exposure control renders aperture and shutter speed controls redundant, but focus still has to be preset and photographs taken with a zone dependent on the depth of field at the aperture used. In flash photography the difficulties are aggravated, because once the lens aperture is set, the correct exposure is available only at a fixed distance.

Housings for this type of camera are normally made of injection-moulded plastics, giving a compact shape. In general they will accept a full range of accessories and flashguns, and are often little larger than the Nikonos camera. Such a camera can be a good choice with which to begin underwater photography.

35 mm SLR cameras

The 35 mm SLR camera is ideal for adaptation to underwater photography. Its shape and the layout of its controls make it easy to encapsulate while still maintaining full control of the camera functions. Typically the SLR camera has interchangeable lenses, focal plane shutter and built-in through-the-lens metering. Because there are so many models, all with differing features, layouts and prices, the choice of camera is not easy. The following considerations should be taken into account for underwater use.

If possible, the camera should have a removable pentaprism, particularly if a 'Speed Finder' or 'Actionfinder' type of magnifying viewfinder is available. If the camera is to be used for available-light photography, the exposure meter should be built into the camera body and not into the pentaprism. Power winders or motor drives are available for most models. Power winders are much more compact than motor drives and the faster framing rate of a motor drive is not important underwater.

The layout of the camera functions is particularly important for their control underwater. In this respect the shutter-speed control is the least critical, especially if most of the photography is to be

carried out with flash or using an exposure metering system with aperture priority. If shutter-speed control is required a camera with the control on top of the body should be chosen. The aperture controls of the interchangeable lenses should all be in the same position with reference to the lens mount, as this simplifies the positioning of the couplings in the housing. The exposure meter should be of a type which does not switch itself off after every exposure. The camera should preferably have a 3 mm coaxial flash synchronisation fitting on the front of the body. If only a hot-shoe fitting is supplied, the housing will have to be built larger to enable the fitting of an adaptor.

The camera should be part of a system with a wide choice of lenses, extension tubes and other accessories. It is advisable to use only accessories supplied by the camera manufacturer, as this ensures full compatibility of all parts, and a uniform level of reliability. Remember the saying that a chain is only as strong as its weakest link. It is unsound practice to spend a lot of money on a good camera only to degrade its performance with cheap accessories especially when a camera fault underwater may mean an aborted dive.

The 35 mm SLR camera represents the best solution to general underwater photography. Its size, ease of use and versatility have ensured its continuing popularity, as can be attested by the range of housings available.

Large formats

Larger-formats for underwater use are 4.5 × 6 cm, 6 × 6 cm, or 6 × 7 cm. The large format, with a picture area nearly four times as large as the 24 × 36 mm format of the 35 mm camera, gives negatives of excellent quality. Larger formats still, as used by studio photographers, have little use underwater because of their bulk and method of operation. Twin-lens reflex cameras, particularly the Rolleiflex, were once extremely popular, but they have now largely been displaced by single lens reflex cameras, which offer interchangeable lenses and film magazines in addition to the advantage of viewing through the taking lens. The Hasselblad-type layout, with interchangeable lenses, viewfinders and film magazines, is the most common but other shapes are available. Most cameras take 120 or 220 film and give 15, 12 or 10 (30, 24 or 20 on 220) exposures, depending on frame size. Some can be fitted with magazines taking up to 150 exposures on 70 mm bulk film.

In general, fewer accessories are available for larger-format cameras than for 35 mm cameras; the range of lenses may also be restricted. In addition to being bulky and expensive, the cameras may be difficult to adapt to housings.

While larger format cameras do offer real advantages to the professional photographer — primarily because he must provide results of very high quality — their expense, size and handling difficulties make them less suitable for amateur underwater photography. Few photographers will choose to use a larger format camera underwater if their requirements allow the use of a smaller format.

The housing

The sole requirement of an underwater housing is to keep the camera dry. Indeed some housings for shallow-water use are no more that a sealable plastic bag which incorporates optical glass ports for the camera lens and viewfinder, and a glove so that the camera functions can be controlled. Deeper diving demands a more robust solution.

Plastic (usually acrylic) housings are the most common. These may be injection moulded, or made up from cylindrical or flat sheet to the required shape. Injection-moulded housings are particularly good, as they have no seams to come apart, and can be tailored to the shape of the camera, and are thus compact. Although many underwater photographers use home-made plastic housings it is wise to take expert advice before attempting to make one. The task requires considerable skill and experience in working with plastics. Once flooded a camera is seldom repairable. If you use a home-made housing remember to pressure-test it to beyond its desired maximum working depth before diving with a camera installed in it.

Housings made from clear plastics enable camera settings to be seen through their sides thus avoiding the need for complex controls and remote readouts. They also have the advantage that if a leak does occur, any water ingress is immediately visible. Though they are not as robust as metal housings they will give many years of service if treated carefully, and not left around in the sun or stored at high temperatures.

If plastic housings are not kept cool before a dive, condensation can occur on the coldest part of the housing when it is taken underwater. Unfortunately this is usually the port. A desiccant such as

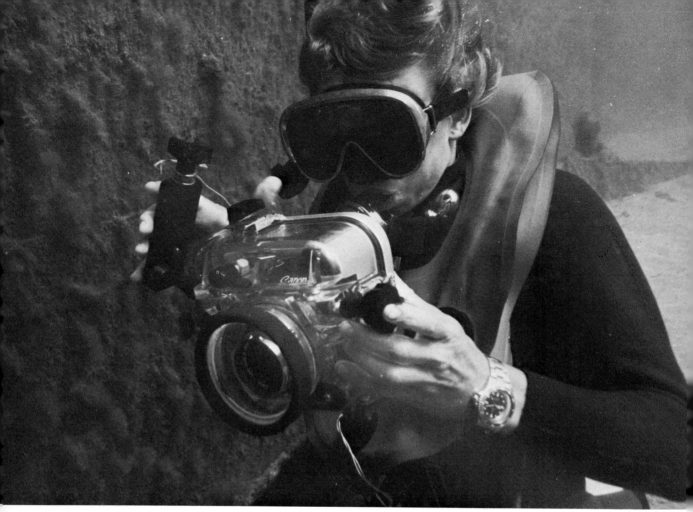

Diver with Ikelite housing. The housing is made of injection-moulded clear acrylic and so allows all camera controls to be viewed directly in setting them for photography

silica gel can be of some help, but as such desiccants are comparatively slow in action they are of little use if the housing has been sealed just before a dive. The solution is to provide a site for preferential condensation. Metal control rods will act in this way, but it can sometimes be useful to incorporate in the housing a small metal plate, in thermal contact with the water.

Although metal housings are more robust than those made of plastics they are heavier out of the water, and much more expensive. They also need complex controls to set camera functions, and remote readouts. Unless these are correctly attached when fitting the camera in the housing, settings may be incorrect. The added complexity can mean lengthy procedures for preparing the

camera for a dive; even loading the film or changing the lens can be a major task. Both aluminium and stainless steel are excellent materials for housing construction. Aluminium is a comparatively soft metal, and may be cast and machined easily; but it needs to be anodised or otherwise protected to prevent corrosion in sea water. The other materials used in accessory construction must also be carefully chosen as aluminium in contact with steel or brass will corrode preferentially, if immersed in sea water. Stainless steel is hard and difficult to machine, so housings made of it are expensive. However, a stainless steel housing will outlast all others and is the preferred choice for really heavy use.

In general, unless a housing is used a great deal,

Figure 2.7. The use of acrylic allows housings to be injection moulded and so mass produced

under adverse conditions, or to great depths, plastics materials are perfectly adequate. These also have the advantage that they do not corrode. Metal housings, particularly stainless steel, are of real benefit only in full-time commercial diving.

Camera controls

The controls are probably the most important aspect of a housing design as they dictate its handling properties and ease of use in the water. If dives are to be carred out at depths greater than 30 m it is important that the operation of the controls should not be influenced by pressure. A camera function may be easy to set on the surface or in shallow water, but it is useless if it cannot be reset at depth. Simple designs are affected most, particularly those dependent on friction (Figure 2.8). Directly linked systems using toothed or pin

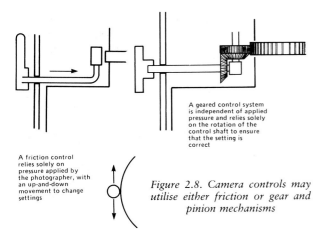

A friction control relies solely on pressure applied by the photographer, with an up-and-down movement to change settings

A geared control system is independent of applied pressure and relies solely on the rotation of the control shaft to ensure that the setting is correct

Figure 2.8. Camera controls may utilise either friction or gear and pinion mechanisms

drives are independent of pressure effects and are essential in metal housings in order to ensure the accuracy of remote scale readouts.

Some gear systems are disconnected while the camera is being fitted into the housing, and if not reconnected correctly can become loose during a dive. Great care must be taken when they are reset. For example, the aperture control of one popular design operates on a remote readout scale on the back of a housing and is connected to the aperture ring by a shaft and cog system (Figure 2.9). It is possible for this shaft to be pulled partly out, so disconnecting the linkage. To reset it underwater, when the aperture scale cannot be seen, the lens aperture must be turned to its widest opening, the linkage broken again, and reset to show this aperture on the remote readout. The setting can then be checked by rotating the control to the limit of its travel in both directions. Of course, the diver must remember the maximum and minimum apertures of the lens to be able to do this at all. The design could be improved by fitting a split pin or circlip just inside the housing on the control shaft, allowing the shaft to rotate but not to move in and out.

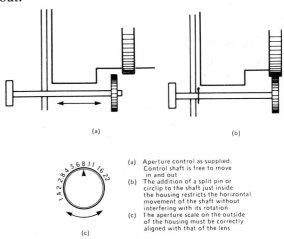

(a) Aperture control as supplied. Control shaft is free to move in and out
(b) The addition of a split pin or circlip to the shaft just inside the housing restricts the horizontal movement of the shaft without interfering with its rotation
(c) The aperture scale on the outside of the housing must be correctly aligned with that of the lens

Figure 2.9. An example of a badly designed aperture control

All housing controls should be operable by a diver wearing heavy gloves. When buying a housing take a pair of diving gloves with you to check this.

If speed of operation is important, but a motor drive cannot be fitted, then the shutter release and film wind should be operable with one hand. A particularly good example of this is the Ikelite SLR design. Both controls are easily operated without moving the right hand from the grip.

Accessory attachments

A housing will rarely be used on its own. It should have facilities for the attachment of accessories, at the very minimum a mounting for an accessory attachment bar. Look for a robust attachment point as heavy loads on this part of the housing can cause serious damage and affect the sealing of the housing.

To allow the fitting of a wide range of lenses a housing must have interchangeable ports. The extended focusing movement of a macro lens or the use of extension tubes will often necessitate the use of an extension port, while wide-angle lenses should be used behind dome ports to achieve results free from distortion (see pp. 54–56). Super-wide-angle and fish-eye lenses require purpose-designed ports to match their extremely wide angle of view.

Consideration must be given to the ease of reloading or changing lenses. If the setting-up procedure is complex, for example if many parts have to be removed and refitted, working in a small boat can be well nigh impossible. The longer these procedures take, the greater the likelihood that the valuable equipment will be splashed by another diver or by a wave coming in over the side.

Seals

The method that is used to seal the housing is also important. All housings use O-rings or other rubber gaskets to form a seal. The O-ring must be deformed in order to produce a good seal, so pressure must be applied to it when a housing is closed. This pressure will be increased with the increased water pressure at depth, but it should be remembered that, just below the surface, only the natural resilience of the rubber is producing the necessary deformation (Figure 2.10). The rubber should be in good condition, springy and showing no signs of deterioration.

The most efficient forms of seal utilise grooves specially designed to take an O-ring of a given size. The groove reduces deformation under pressure in directions other than those which increase the efficiency of sealing; it also protects the O-ring from physical damage and the ingress of foreign particles and dirt. The seals used on shafts often employ a groove or protected channel and, because the shafts need to move, they often have a double O-ring for extra security (Figure 2.11).

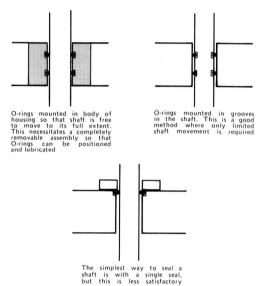

O-rings mounted in body of housing so that shaft is free to move to its full extent. This necessitates a completely removable assembly so that O-rings can be positioned and lubricated

O-rings mounted in grooves in the shaft. This is a good method where only limited shaft movement is required

The simplest way to seal a shaft is with a single seal, but this is less satisfactory

Figure 2.11. Methods of producing a shaft seal

Some housings have a gasket-type seal where the O-ring, or a flat rubber seal, is glued to one component and has to be compressed before immersion in the water to make an efficient seal. This type of seal is not common because it must be compressed equally all round and thus requires precise machining and a complicated closing mechanism.

It is normal practice to make a housing in three parts. The largest part is the main body containing most of the controls. To this is attached the port, and a rear section to allow the camera to be removed. The port may be screwed in or attached with spring clips or over-centre clips. The screw fitting is preferable as this applies a more even

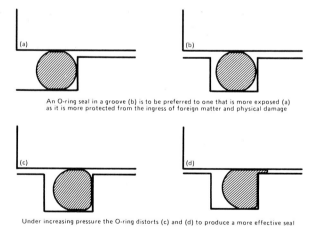

An O-ring seal in a groove (b) is to be preferred to one that is more exposed (a) as it is more protected from the ingress of foreign matter and physical damage

Under increasing pressure the O-ring distorts (c) and (d) to produce a more effective seal

Figure 2.10. The principle of the O-ring seal

preliminary pressure on the O-ring and is less likely to be accidentally released. However, any type will be satisfactory as long as the fittings are robust and are not likely to wear with constant use.

The camera is usually attached to the rear housing component, ensuring correct positioning in relation to the port and controls. This section is secured with over-centre clips. Reference marks or locating pins are useful in ensuring correct alignment.

Handling qualities

The buoyancy and handling of the housing and camera in the water are very important. Most photographers prefer a neutral or slightly negatively buoyant housing so that it is not always attempting to float to the surface. Even though a housing may be neutral it may not naturally assume the correct angle of alignment (Figure 2.12) and so may not handle precisely in the

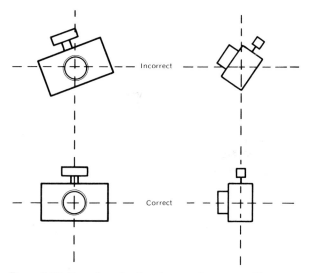

Figure 2.12. Even though a housing may have neutral buoyancy it may not naturally assume the correct angle of alignment

water. Small lead weights or foam buoyancy material can be attached to the housing until it assumes the correct rest angle. Time spent carrying this out will be repaid in full. Do not forget that sea water is more buoyant than fresh water, and so a camera that is exactly right for use in a swimming pool will be too light in sea water. Remember to take into account the rest of the system, the flash, handling frames, flash arm etc., when carrying out buoyancy and alignment trials.

Care of the housing

A housing will last only if it is properly cared for. All seals must be regularly taken out of the housing, cleaned, inspected for any deterioration or defects and lightly coated with silicone grease. This preserves the O-ring and ensures that it seats correctly and seals efficiently. Do not use silicone spray, as it is extremely difficult to ensure that it is coated evenly. Also if it is applied near a plastic housing or port the solvent can cause crazing or cracking.

Take care not to let any silicone grease get onto the surfaces of lenses or ports, as it is extremely difficult to remove. Nikon recommend petroleum jelly rather than silicone grease for the Nikonos as it is easier to remove from lenses, but it must not be used if the housing could come into contact with air at high pressure as there is risk of explosion.

Before refitting O-rings, clean the grooves they lie in. Particles of sand or dust or even a hair in these grooves can result in a flooded housing. If the housing is to be stored for a long time remove the O-rings, as otherwise they can be permanently deformed by the pressure applied by the assembled housing.

After use in fresh water, always dry the housing, After use in salt water soak the housing for five minutes or so in warm fresh water to which has been added a little detergent. This will stop the accumulation of particles of salt which can otherwise cause leaks and corrosion. Rinsing under a tap is recommended only when it is impossible to soak the housing properly.

Protect the housing from knocks and from direct sunlight when it is out of the water. More equipment is damaged in transit and by accidental impact during dive preparation than is ever damaged underwater. Ports and plastic housings are particularly susceptible to scratching, and bent control rods can cause leaks and jamming. Minor scratches can be polished out with metal polish without seriously affecting the performance of a port, but deep scratches cause optical degradation, and may lead to failure of the housing under pressure.

During transit to and from the dive site, the camera should be protected by placing it in a plastic crate or dustbin. It should remain there until you are in the water, and be handed out of the water and placed in safety before you leave the water. Never enter or leave the water carrying the camera. The rapid movements may seriously damage the housing.

Attach the housing to yourself by means of a length of line and a quick-release shackle. If you are forced to use both hands to avoid or to extricate yourself from an emergency situation, you will not lose your camera. The quick release fitting is needed in case the camera becomes seriously entangled during a dive. It is better to release the camera quickly than to run out of air trying to free it. However, remember that the quick-release is for emergency use only; do not release the camera to float about on its own. Such an action is the mark of slack diving habits and an invitation to damage.

If the housing has not been used for some time test it underwater without the camera, down to about 10 m, examining for leaks as you go. Leaks usually occur before the water pressure forces the O-rings into a position to seal effectively.

Summary

The choice of a camera is largely a personal matter, based on the type of photography most likely to be undertaken. The 35 mm SLR is the most versatile camera for underwater use, although the Nikonos has many advantages, particularly if the camera outfit is to be purchased solely for underwater use. For the beginner, a rangefinder camera in a housing is a good way to start.

Large-format cameras are best left to the professional or semi-professional, who can offset their costs by selling the photographs produced with them. They offer few, if any, advantages over the 35 mm format for the enthusiast.

3

LIGHTING AND FILTERS

Lighting

The most frequently used light source for photography is the sun. When the sun shines and the water is clear, many subjects can be photographed underwater with only a basic camera and a knowledge of exposure. However, these conditions only commonly occur in tropical waters but even there, without the use of some form of artificial illumination, it is impossible to take advantage of all the opportunities presented underwater.

There is no alternative to the use of artificial illumination when ambient light levels are low, either because of the turbidity of the water or lack of sunlight. Even when the natural light is bright enough to permit photography some form of artificial illumination is essential to reproduce accurately the colours of the underwater world. Just as few people would consider wearing blue tinted glasses on a visit to an art gallery, so artificial light is essential underwater.

Artificial light can also be used for artistic effect; for example, to illuminate a subject a in close-up ensuring maximum depth of field and so greater subject detail. It can even out the lighting of subjects unevenly illuminated by sunlight, light part of a subject or, when coloured by filters,

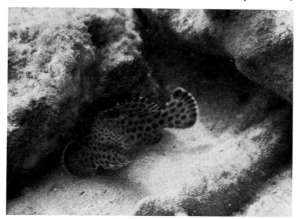

A photograph taken by available light. Notice how the subject movement has not been effectively frozen as it would be by the speed of flash and so has ruined what would otherwise be a pleasing composition

produce surrealistic effects. The use of artificial lighting introduces a whole range of new possibilities when photographing underwater.

The choice of light source

Underwater we have to accept the restraints of diving equipment and a camera which, in most cases, is larger than its equivalent on land. An artificial-light source is a further impediment to freedom and so it should be as small as possible while still having an acceptable light output. The choice of artificial lighting is also dependent on the type of photography to be undertaken.

Movie photography needs a continuous-light source but this is not the case for still photography. A flash source is much more convenient especially when it is considered that, to achieve a reasonable output, a continuous-light source must be powered from a generator on the surface connected by an electrical umbilical. This is a considerable restriction to diving freedom especially when it is realised that the output of a 1000 W lamp is low compared with even a small flash source.

A flashgun of average power will be rated at 100 joules (watt-seconds); this is the electrical power stored in the capacitor and discharged through the flash tube. This power is expended in one flash of 1/1000 second, so the power output becomes equivalent to a 100 000 watt continuous source. In practice an electronic flash does not work at 100% efficiency, although flash sources, with their compactness, low weight and portability, offer many advantages for the stills photographer underwater.

Flash sources

There are two types of flash source, electronic discharge tubes and expendable bulbs. Both have advantages and disadvantages in different situations but before discussing these it is advantageous to look at the principles behind each source.

19

Flash bulbs are sealed glass bulbs filled with shredded metal foil or wire (usually zirconium or magnesium/aluminium alloy) in a low pressure atmosphere of oxygen. The outer glass can be clear or lacquered blue.

When a low voltage (3–30 V) is applied across the contacts it ignites a blob of firing paste, causing the metal foil to burn extremely quickly in the oxygen atmosphere and so emitting an intense flash of light. The duration of the whole process is between 1/100 and 1/50 second.

In the simplest bulb flash units the bulb is connected directly across a dry battery. To ensure greater reliability it is more usual to employ a capacitor circuit, a typical example of which is shown in Figure 3.1. The battery charges the capacitor through a current limiting resistor, used

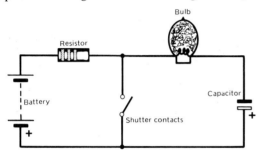

Figure 3.1. A typical capacitor flashbulb circuit

to ensure that the bulb will not be fired prematurely. As soon as the shutter contacts are closed the capacitor is discharged so firing the bulb.

There are many different classes of flashbulb depending on the light intensity required and the fittings in which they are supplied; bayonet, Edison screw, flashcube etc. Class FP flashbulbs are different from all other bulbs in that they hold their peak intensity for a short time before it falls off. The use of this will be appreciated when we discuss flash synchronisation. The light output of all other types of bulbs (classes M, MS, MF, S, flashcubes etc) can be categorised as a whole. They burn quickly to a peak light intensity, that is normally brighter than FP class bulbs of an equivalent size, and then fall off equally quickly. Typical light outputs are shown graphically, with light intensity plotted against time, in Figure 3.2.

With electronic flash an electrical discharge takes place across a tube filled with an inert gas, normally xenon. This discharge excites the gas causing it to emit light for an extremely short duration of around 1/1000 second. This process may be repeated as often as the discharge can be induced across the tube.

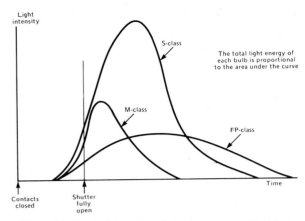

Figure 3.2. Typical duration of the three types of flashbulb

The essentials of an electronic flash circuit are shown in Figure 3.3. A high-voltage source, in the region of several hundred volts, is used to charge a capacitor through a current-limiting resistor. The pressure of the gas in the tube is such that, at the voltage to which the capacitor is charged, no flow of current takes place. By applying a *triggering voltage* via an external electrode the gas is ionised permitting the capacitor to discharge rapidly through it and producing a bright flash.

Electronic flash can be powered from rechargeable nickel-cadmium batteries, dry batteries, accumulators or mains electricity.

Flash synchronisation

As the flash is of short duration it must be synchronised to come exactly when the camera shutter has opened. To understand flash synchronisation it is necessary to be familiar with the basic principles of the two commonly used types of camera shutter; the diaphragm shutter and the focal plane shutter.

A *diaphragm shutter* is usually built into the lens of a camera (sometimes behind) near the

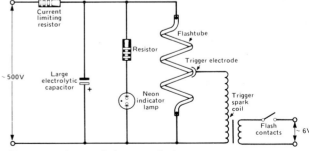

Figure 3.3. A typical electronic flash circuit

position where the beam of light passing through the lens is narrowest; hence the shutter has the minimum distance to travel to be in the fully open position.

Diaphragm shutters are used in both simple and more complex cameras. In simple cameras they are often single-bladed, with the movement of the shutter release being used both to cock and release it. For this reason they are often set to a single shutter speed which is a compromise between that necessary to stop camera shake and that slow enough to utilise the light output of a flashbulb. More complex cameras have multi-bladed shutters which open like the leaves of an iris diaphragm (similar to the aperture control of most lenses). They can be set to different shutter speeds, opening and closing at an interval determined by the shutter speed set. With diaphragm shutters the whole of the film is exposed at all times that the shutter is in operation.

A *focal-plane shutter* is usually contained in the body of a camera as near as possible to the film plane and consists of two blinds made of light-tight fabric or thin metal sheet (see Figure 3.4).

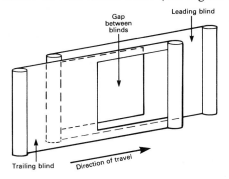

Figure 3.4. Principle of the focal-plane shutter

When cocked the *leading blind* covers the whole of the film. On firing the shutter the leading blind is released, being followed at a predetermined distance, depending on the shutter speed set, by the *trailing blind* which re-covers the film. The direction of travel may be in a horizontal or vertical plane, but in both cases the exposure time is governed by the width of the gap between the blinds; the smaller the gap the shorter the exposure, the larger the gap the longer the exposure. As the exposure is lengthened there will be a shutter speed at which the leading blind has completed its travel before the trailing blind starts its travel to terminate the exposure. For a fraction of a second the whole of the film is exposed simultaneously instead of progressively. This shutter speed is

normally in the region of 1/60 second depending on the size and nature of the shutter and is extremely important for flash synhronisation.

Electronic flash has very different characteristics from bulb flash. It reaches its peak output virtually as soon as the circuit has been completed while with a bulb there is a delay of several milliseconds between closing the contacts and peak output. The characteristics in terms of light output plotted against time are shown in Figure 3.5. But how does all this affect the photographer?

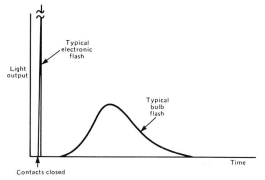

Figure 3.5. The duration of a bulb flash compared with electronic flash

With the exception of simple cameras, which are normally set for either a bulb or an electronic flash that is an integral part of their design (and so allowed for) shutters offer a choice of flash synchronisation. There are three main classes of flash synchronisation, X, M, and FP.

X-synchronisation is found on both diaphragm and focal-plane shutters. It is used with electronic flash and ensures that the flash is fired only when the shutter is fully open. With diaphragm shutters X-synchronisation will work at any shutter speed but with focal-plane shutters only speeds at which the total area of the film is exposed can be used. The operation handbook of a camera with a focal-plane shutter should be consulted to find the recommended speed for correct synchronisation as this can vary between 1/30 and 1/125 second from model to model.

M-synchronisation is normally found only on diaphragm shutters and is for synchronisation with bulb flash. It allows for a delay, after pressing the shutter release, before activating the shutter mechanism so that the shutter is opened only when the bulb has started to burn. Different shutters synchronise at different speeds and so the camera operation handbook should again be consulted to confirm that the correct speed is used.

21

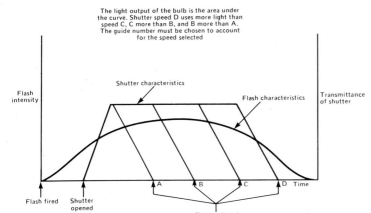

The light output of the bulb is the area under the curve. Shutter speed D uses more light than speed C, C more than B, and B more than A. The guide number must be chosen to account for the speed selected

Flash intensity

Shutter characteristics

Flash characteristics

Transmittance of shutter

Flash fired Shutter opened A B C D Time

Shutter closed

Figure 3.6. Utilisation of light output of an FP class bulb at various shutter speeds

FP-synchronisation is used only with focal-plane shutters in conjunction with class FP flash-bulbs. It was introduced to overcome the problem of using flash at fast shutter speeds. It works because the bulbs give a near constant light output for the time that the gap between the blinds of the focal-plane shutter takes to completely traverse the whole of the film. Hence the whole of the film is evenly exposed even though it is not all simultaneously exposed to the flash. It should be noted, however, that the faster the shutter speed used the less the light available for the exposure, since less of the output of the bulb is being utilised. This is illustrated in Figure 3.6.

It is very important to refer to the camera operation handbook for all aspects of flash synchronisation. Some current 35 mm single-lens reflex cameras only have X-synchronisation but can still be used with bulbs at certain speeds. Even though correct synchronisation is set, a wrongly set shutter speed can ruin results.

Choosing the right flash

Bulb flash has a very low initial cost. All that is required is a simple underwater reflector bulb holder assembly and different adaptors for different bulbs; but running costs are high because the bulbs can only be used once.

A bulb flash is very powerful for its size, significantly more so than an electronic flash of similar size and weight, but bulbs are inconvenient to carry underwater and may implode at depths greater than 40 m. Several methods of carrying bulbs underwater are illustrated in Figure 3.7 but care is needed to ensure that they are not all released when only one is required. The time to

change bulbs underwater can also be excessive, resulting in wasted dive time and lost subject opportunities.

Different reflectors can be chosen for different applications, to match the angle of view of the lens in use and hence ensure greater efficiency in the utilisation of the light output.

Bulbs are available clear or blue lacquer coated. The choice will be discussed more fully when colour temperature is discussed but clear bulbs can be used to partially correct for the blue filtration of water.

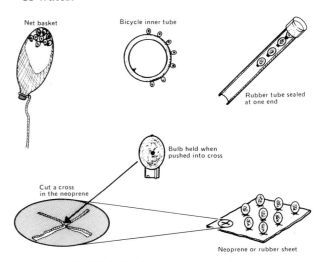

Figure 3.7. Methods of carrying flash bulbs underwater

Bulbs can be chosen to meet the power requirements of different jobs while still using the same reflector and can easily be paired up for multiple flash. In general though, their use is declining because of the advantages of electronic flash, especially purpose-designed amphibious units.

22

If bulb flash is chosen for a particular assignment first check that is possible to synchronise your camera with bulbs. The increasing acceptance of electronic flash as the main form of illumination for surface photography has led some manufacturers to provide only X-synchronisation and so the camera is limited to synchronisation

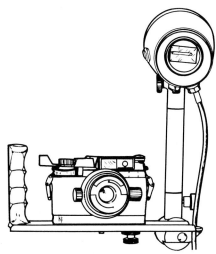

Figure 3.8. An amphibious camera and flash make a good combination for all general photography

with bulbs at slow speeds. This will only be acceptable when photographing in conditions of low ambient illumination so that there is no risk of producing ghost images; a secondary image being produced by the ambient light superimposed on the primary image formed by the flash.

Electronic flash for underwater use is expensive to purchase but soon repays the investment as running costs are low, with only batteries needing replacement or recharging from the mains. Recycling time is short, usually under ten seconds, but powerful units are heavy and can be bulky because of the large battery packs needed. Reflectors built into the units may not be suitable to illuminate the full field of view of wide-angle lenses without a diffuser, but specialist amphibious units are available to fill most, if not all, of the needs of underwater photography.

The selection of bulb flash equipment is not difficult because there are relatively few units available. It is best to choose one designed specifically for the camera in use; for example the Nikon flashgun for the Nikonos or the Ikelite for cameras in Ikelite housings. The selection of an electronic flash is more difficult as a choice has first to be

made between using a surface unit in a housing or a purpose-built amphibious unit.

By far the cheapest way of using electronic flash underwater is to encapsulate a surface unit, particularly if it already makes up part of your surface photographic outfit. Ikelite for example, make a large range of housings for such units and other manufacturers offer housings made for units that they think are suitable for underwater applications.

When purchasing a surface flash unit for underwater photography it is worthwhile to consider the following points.

1 There must be a housing readily available.
2 An automatic photosensor exposure control will be of no use underwater because of reflection from the housing, backscatter from the water and the fact that most underwater subjects do not correspond to the average subject necessary for this type of exposure control to function correctly.
3 None of the accessories available for some units, for example remote photosensors, variable angle light beam, bounce flash attachments, will be operable underwater as it is likely that the only control available in the housing will be the on/off switch.
4 Flash synchronisation underwater will be primarily via a 3 mm coaxial cable rather than a 'hot-shoe'. Adaptors can be purchased but they waste housing space and can easily be lost.
5 A compact, regular shape will enable the housing to be made as small, and therefore as cheap, as possible.
6 The power of the unit should be selected according to the type of photography that you plan. It is of no use buying a very powerful, and

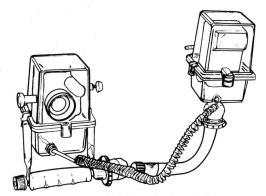

Figure 3.9. Cameras and flash units intended for terrestrial photography can be encapsulated to provide a simple system for underwater photography

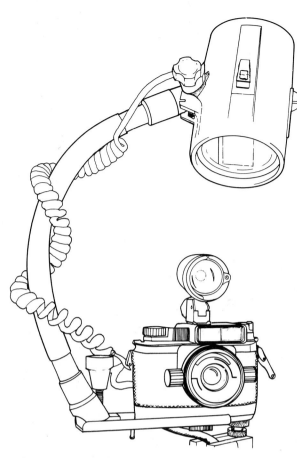

Figure 3.10. An underwater flash must be chosen as part of the complete underwater photographic system

Amphibious electronic flash units overcome the main disadvantages of using a surface unit in a housing. They are designed with reflectors that give a wide angle of even illumination sufficient to cover the angle of view of all but superwide-angle lenses. In most cases they are designed as part of a system and so have a variety of mounting arms and brackets available specifically for them. Because they are designed for underwater use they are often easier to handle in the water and their only real disadvantage is that, because they are not produced in large quantities, they are expensive.

Flash connectors

Having chosen an underwater flash unit, a means of achieving flash synchronisation underwater will have to be selected. An electrical connection has to be made between the 3 mm coaxial socket on the flash and that on the camera.

The most common way of achieving this through the flash housing is by a permanent gland connector. The lead passes through the wall of the housing and is sealed by tightening a gland against the cable itself (see Figure 3.11). Most manufacturers choose this method because of its low cost and as long as the locking nut is kept tight it is generally satisfactory. Occasional maintenance will be necessary to keep both gland and cable in good condition and this can be achieved by stripping the connector, checking that the gland and cable have not perished or are unduly squashed, lubricating lightly with silicon grease and reassembling. If the gland or cable is perished or damaged in any way it should be renewed, or in the case of the cable, shortened. Other types of

hence expensive, unit and having to decrease its output if only close-up photographs are to be taken. The consideration of underwater flash exposure, introduced later in this chapter, will enable this choice to be made wisely.

7 If the unit has built-in nickel cadmium rechargeable cells check that the number of flashes available for this power pack will be adequate for a photographic session, remembering that in a remote location there may be no opportunity to recharge them between dives. A unit with a choice of power pack, so that rechargeable cells may be interchanged or even replaced by alkaline cells, is always advantageous.

8 Make sure that the angle of light coverage is adequate for the lenses that the flash will be used with, remembering that because of refraction this angle will be reduced to three-quarters of its value if the unit is used behind a plane port underwater.

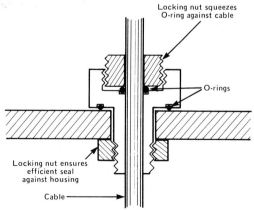

Figure 3.11. Permanent gland connector for flash synchronising cable

electrical bulkhead connectors are sometimes encountered, the most common being the Electro Oceanics (EO) connector, but because they are expensive their use tends to be rare except in specialist applications.

Certain cameras have connectors that are unique to themselves. The Nikonos is one such example where even the connectors of the Mark II and Mark III/IV versions differ. It will be noted that there are three contacts in the Nikonos female, or camera, connection. The left is for FP-synchronisation, the right for X-synchronisation with the bottom one common to both. The male connections are made with only two conductors, either for FP- or X-synchronisation, so beware of changing a connector from a bulb flash to an electronic flash or vice versa. In use, keep the O-ring clean and lightly lubricated with silicon grease and install the connector with great care to avoid damage to the pins, especially with the Nikonos III and IV. It is also important not to forget to replace the blanking cap on the flash connector if the body is to be used without flash.

Another commonly encountered flash connection is manufactured by Ikelite. This uses a male connector on the flashgun lead which plugs into a female bulkhead fitting on the housing. An adaptor is also available so that the system can be used with Nikonos cameras. An improvement on this system is the later SST system which, although it uses the same connectors, produces a pulse of electricity from a 22.5 V battery in the camera housing. The pulse activates a relay in the flash housing to fire the flash. It overcomes the problem of intermittent flash firing. In use, fill the holes in the bulkhead connector and smear lightly around the contact points, with silicon grease. Ensure that the metal surfaces are free from corrosion and clean and attach the cord connector with light finger pressure, being careful not to overtighten and possibly damage the connector.

There are many types of underwater connector available for general applications with most costing in excess of the price of a surface flash unit, but these are intended primarily for deep water or high voltage use in commercial diving or the communications and oil industries. Only one manufacturer, Electro Oceanics, has a connector in its range that is particularly suited to underwater photography. EO connectors are available in bulkhead, male and female fittings with adaptors available for Nikonos use. There is even a slave unit available which will fire a flash remotely without direct electrical connection. They are fully under-water pluggable and as long as they are lightly lubricated with silicon grease before use, extremely reliable. Where one flash unit is desired to be used with a variety of cameras, adaptors are easily made up.

Electronic flash in practice

When using disposable batteries use alkaline cells rather than their dry battery equivalent. They store more power and are more capable of high current drain. The high current drain of electronic flash units can lead to premature exhaustion of dry cells, although they sometimes recover after a rest period, and the restriction of current by batteries can lead to longer recycling times. No matter which type of disposable battery is chosen always remove them from the flash unit when it will not be used for some time.

Nickel cadmium cells offer many advantages as they may be recharged a thousand or more times. They are also capable of taking an extremely high current drain and so, in general, will allow a faster recycling time than disposable cells. To keep them in good condition they should be recharged as soon as the recycling time of the flash has doubled from the time taken when the batteries are freshly recharged. Do not be tempted to drain the batteries beyond this point as they could be damaged. Recharge as soon as possible after they have been discharged but do not overcharge as this could seriously reduce their working life. The stored charge will fall off with time but do not be tempted just to top this up occasionally because the batteries could develop a memory effect and so only hold a much reduced charge. If the batteries have not been used for some time it is far better to discharge them until the recycling time is double that when they were freshly recharged and then to fully recharge them.

Certain manufacturers have chargers available that switch to a topping-up charge, or trickle charge, when the batteries have been fully charged. These are excellent for keeping the batteries in peak condition and always in a fully ready state. Nickel cadmium batteries may be kept on a constant charge if the rate does not exceed their capacity in ampere-hours divided by 20. If the charging current is above this figure then damage is likely to occur with extended charging.

The neon flash 'ready' light comes on, in most cases, just before the capacitor has fully charged. If

a photograph is taken at this point underexposure could result. The electronics of a flash unit normally emit a whining sound when recycling, which is caused by the inverter. When this sound stops the capacitor will be fully charged, although it can often be heard before exposure topping up the

Figure 3.12. An amphibious flash is essential to match the angle of view of wide-angle lenses underwater

capacitor. Compare this with the time that the ready light takes to illuminate to see if any allowance must be made to ensure that the capacitor is always fully charged before taking a photograph.

If the flash unit has not been used for a long time, it will be necessary to 're-form' the capacitor before use as it tends to lose its ability to store charge with inactivity. This will cause much longer recycling times at first and a great drain on the batteries. Flashing and recycling the unit three or four times should overcome this but if the unit has not been used for several months then the procedure should be repeated until the batteries are discharged, the batteries recharged, discharged and recharged again. When carrying out this procedure do not flash the unit rapidly for a long

period without allowing time for the heat to dissipate, or damage could result to some of the components.

When photography with the flash has been completed, or when it is to be stored, recycle the unit and switch off with the ready light glowing and the flash unfired as this will help to keep the capacitor in good condition.

Flash exposure

Flash units usually have their light output quoted in terms of a series of *guide numbers* which vary with film speed and can be expressed in feet or in metres. The relationship to aperture and distance is as follows:

$$\text{Guide number} = \text{Aperture} \times \text{Distance}$$

provided that both guide number and distance are measured in the same units. This relationship is used in the compilation of the calculator dials found on the side of most surface flash units,

Figure 3.13. Many manufacturers market a complete range of equipment to ensure that housing, flash and accessories are more easily used together underwater

26

usually with an additional scale to allow for changes in film speed.

If the guide number is quoted in terms of one film speed it can be calculated for a different film speed according to the following relationship:

New guide number =

Old guide number $\times \sqrt{\dfrac{\text{New film speed}}{\text{Old film speed}}}$

The units of both guide numbers must be the same and film speed quoted in terms of ISO arithmetic or ASA values. Even in this metric age it is more useful to express guide numbers in feet and to use this as the standard measure of distance underwater, as it negates the use of fractions in exposure calculations. It is rare that photographs are taken at distances exceeding 2 m (6 ft) underwater and so the use of the smaller unit of distance is more useful.

The guide number is allocated to a flash unit on the supposition that flash photography will be carried out in a room of average size with average reflective wall surfaces. This is clearly not the case underwater since, in addition to not having walls, water itself absorbs light, as has already been seen. It is hence necessary to recalibrate a flash unit for underwater use.

Flash calibration procedure

There is only one place to calibrate a flash accurately for underwater use and that is in the water in which it will be used. However, this rarely possible and so a compromise solution is to calibrate it in a swimming pool, preferably in the deep end away from the walls.

Place a subject of average reflectivity in the swimming pool in such a position that there is plenty of space in front of it. Another diver is ideal provided that he can be persuaded not to wear a wetsuit. Attach a tape measure to the subject and extend it to about one third the limit of visibility, which is as far as flash photography will be practicable because of loss of contrast. Select several distances starting from the closest that it is desired to work at (see Table 3.1 for a guide to this) and, from the surface guide number provided with the flash, calculate the exposures that would be used at each of these distances if photographing in air. At each distance make an initial exposure at this aperture and then another three exposures at the same distance but opening up the lens in one stop increments for each of the additional expo-

sures. The result will hence be an exposure series for each of the distances selected.

Make sure that all distances and apertures have been accurately recorded at this information will be needed in analysing the results.

It is best to choose a transparency film for this calibration procedure because it is more likely to show up differences in exposures that a negative film. Develop the film normally and for each distance choose the first transparency in each exposure series that gives a well exposed result. Consult your log to see at which aperture this photograph was taken. If it was the third exposure in the series then the lens had been opened up by two stops from the exposure indicated for use in air and so the guide number must be divided by two for underwater use at this distance. Repeat the process for all the distances used to see the effect of increasing distance.

The guide number as calculated for use in the swimming pool can be used as the basis for photography in open water but it must be remembered that water conditions can vary widely and can affect exposure correspondingly. Every time that conditions are different from those encountered before, bracket the exposure. For example take three photographs, one at the calculated aperture, one with the aperture opened up by one stop from this and one with the aperture closed down by one stop. Keep a careful log and in a short time you will possess a document which will allow you to assess the correct exposure for a wide variety of different situations.

As a rough guide the surface guide number should be divided by two for photography at distances up to six feet and divided by three for distances in excess of this, if visibility allows. As explained in Chapter 6, the limit of photography underwater is normally taken as being half the visibility for available light and one third the visibility for flash photography.

Another factor to consider is that the calibrated guide number will only be suitable for subjects similar to the subject used for the calibration. In order to reproduce shadow detail with dark subjects it may be necessary to open the lens up by one stop, and to reproduce highlight detail with light subjects it may be necessary to close the lens down by one stop.

All this may seem very complicated and confusing at first but after a little practice everything will fall into place. Keep a log of the exposures you use, do not be afraid to experiment to see the effect of different exposures and you will very soon be an expert in the use of flash underwater.

Table 3.1

Distance (feet)	2	4	6	10	16
Aperture calculated for use in air	f/32	f/22	f/16	f/11	f/5.6
Apertures used in exposure series	f/16*, f/11 f/8	f/16, f/11 f/8, f/5.6	f/16, f/11 f/8, f/5.6	f/11, f/8 f/5.6, f/4 f/2.8	f/5.6, f/4 f/2.8, f/2
Aperture which gave best results	f/16	f/11	f/8	f/5.6	f/4
For underwater use divide guide number by	2	2	2	2	1.5**

* f/16 is the minimum aperture on the lens used for the evaluation.
** Result affected by ambient light.

Part of the exposure series used in the calibration
of a flash unit (see Table 3.1)

2ft	f/16, f/11, f/8		
4ft	f/16, f/11, f/8		
4ft	f/5.6	6ft	f/16, f/11
6ft	f/8, f/5.6	10ft	f/11

Fill-in flash

As well as providing the main source of lighting, flash can also be used in addition to natural light. This technique of balancing the flash with the ambient illumination is called *fill-in flash* and is extremely useful for selectively lighting a subject or restoring the colours to the foreground of a subject without affecting the background; for instance, it can be used to reproduce a fish in full colour against its natural habitat, which will be reproduced in predominantly undistracting blue.

The technique relies on the ambient illumination being adequate for photography without artificial light, the exposure being based on natural light. Note that the term 'fill-in flash' as applied to underwater photography has a slightly different meaning from photography on land, where it is used to lighten shadow tones and to control contrast.

In practice it is necessary to take an exposure meter reading and to set up the camera for this indicated exposure with the shutter speed set for flash synchronisation. For example, if the meter reading indicated an exposure of 1/60 second at $f/8$, and the flash had a guide number of 24 (in feet) with the film being used, the flash would have to be positioned 3 ft from the subject to achieve the correct effect. The only control of the flash exposure in this technique is the distance from the subject, unless the intensity is reduced with neutral density filters. If the flash in positioned nearer to the subject than calculated overexposure will result; if too far away the subject will still be well exposed but the restoration of colour will be to a lower degree. This may, however, be more desirable. Try different flash-to-subject distances using this technique, underexposing the flash exposure by up to one stop, to find the effect that you prefer.

A normal flash exposure produces ideal exposure in only one plane and so the use of this technique will bring much more depth to your photographs while still retaining the colours that flash brings to underwater photography. It should be used whenever possible, even though it requires a little more planning and setting up, as the results are normally well worth while.

Using multiple flash

A situation may arise when the subject is too far away to use fill-in flash effectively with the flash mounted on the camera or it is desired to selectively light a subject from more than one angle. How can this be done underwater?

It is possible to trigger several flash units from the camera by the use of the synchronisation cable, but unless these units are all identical or have the same electrical impedance only one may fire. The situation is more critical with electronic flash than with flashbulbs as even seemingly identical units can have slightly different impedances and prove temperamental when attempting multiple firing. This technique is hence of value only with balanced units. Cables may be purchased or made up to achieve this effect.

A better technique, and one that avoids the need to have cables running all over the worksite, is to use *slave flash*. A photosensor in the slave unit picks up light from a flash attached to the camera and fires the flash that it is connected to. Direct light is normally used for this but some units are so sensitive that they can be triggered by reflected light. Slave units are sometimes built into electronic flashes, but can be purchased separately either for surface use and used inside a housing or specifically for underwater use as with the EO slave unit.

When multiple flash is used, the same exposure considerations apply as long as the light outputs from the flashes do not overlap. For the purpose of guide number calculation, the distance to use is from flash to subject and subject to camera divided by 2. For example, if the flash were 2 ft from the subject and the subject 10 ft from the camera then the distance used to calculate the aperture would be $2 + 10 = 12 \div 2 = 6$ ft. Note that this differs from normal photographic practice, where the flash-to-subject distance alone determines the exposure.

When multiple flash is used for fill-in flash applications the flashes should all be positioned, with reference to the above calculation, to give the same aperture for the correct amount of fill-in to be achieved. If two or more flash units of equal output are used to light the same subject and their output overlap then the exposure will have to be adjusted according to the following relationship:

$$\text{New aperture} = \text{Old aperture} \times \sqrt{\text{Number of flash units}}$$

In practice this means that if two flash units of equal output are used, then the lens should be stopped down by one stop from the aperture calculated for one flash. If three units are used,

29

then the lens should be stopped down by 1.7 stops etc. The above supposes that all flash units are placed near the camera.

If the units are of unequal power then the situation is made very complex and is best dealt with by a flash exposure meter which measures the light outputs from the flashes and gives the aperture that should be used. Flash exposure meters are not easy to use underwater and their use is normally restricted to very sophisticated lighting situations. In this case it is normally better to redesign the lighting arrangement and consideration is given to this when discussing the treatment of individual subjects.

Colour temperature

Light from different sources can be of slightly different colours. Light from tungsten or quartz-halogen bulbs has more yellow and red in its spectrum than either daylight or electronic flash. To illustrate this, consider a situation in a town just after sunset when the lights in houses, shops and offices have just been switched on. Viewed from outside they seem yellow compared with the remains of daylight, but once inside the light appears white. This is because our eyes adjust to the spectrum or colour content of ambient light to such an extent that if we wear green tinted sunglasses for an hour or so, when they are taken off everything will be seen with a magenta (purplish) cast until the eyes readjust.

The colour content of different light sources can be measured on a scale of *colour temperature*. The ideal of colour temperature can be appreciated by considering what happens when a poker is left in a fire. At first it is a dull black, but as it becomes hotter it glows red, orange and finally white. Therefore sources having a low colour temperature will have a much redder light than sources having a high colour temperature, which will emit a more blue/white light.

Colour temperature is measured on the absolute temperature scale (in kelvins). Absolute zero (0 kelvin) is equivalent to $-273°C$. The quoted colour temperature indicates that the spectral content of the source in question matches the spectral content of the light produced by an ideal 'black body' radiator at a given temperature. For photographic purposes, it can be taken simply as a numerical indication of the colour of the lighting. Table 3.2 gives the colour temperature of several commonly encountered light sources.

A consideration of colour temperature is important because, while the eye can compensate for its effects, photographic film cannot. Exposing film designed for light of one colour temperature by light of another colour temperature produces unnatural colour. The subject of different films is dealt with more fully in Chapter 5.

Table 3.2. Colour temperature of some common light sources

Light source	Approximate colour temperature (K)
Candle	1 930
Domestic tungsten lamp	2 800
'Warm white' Fluorescent lamp	3 000*
Studio lamp	3 200
Photoflood lamp	3 400
Clear flashbulb**	3 800
'Daylight' fluorescent lamp	4 500*
Mean noon sunlight***	5 400
Blue flashbulb	6 000
Electronic flash tube	6 000
Average daylight	6 500
Blue sky	15 000

* Fluorescent lamps have a discontinuous spectrum, so colour temperature may not accurately predict their effect on colour films.
** Clear flashbulbs are no longer in quantity production.
*** This is an international standard used for calibration purposes, and does not represent any actual situation.

Light sources of different colour temperature should not be mixed for photography unless special artistic effects are desired. The colour temperature of a light source is usualy specified in its operations manual. Most flash units have a colour temperature of about 6000 K, which is similar to that of daylight and can hence be used without reserve when photographing by daylight. While blue flashbulbs also simulate daylight, clear flashbulbs do not, their colour temperature being about 3800 K, and this should be taken into consideration in their use. By using clear flashbulbs it is possible to partially correct for the blue filtration of water but care should be taken not to use this type of bulb close-up with daylight balanced film or the results will have a yellowish appearance. They are more useful for photography at distances greater than 1 m.

In order to create special effects, light sources of different colour temperature, or even coloured with gelatin filters, may be used. Using a quartz-halogen light source with daylight film to selectively illuminate a subject will produce a small

area of reddish light which could highlight the natural colour of the subject or enhance a particular aspect of it. It is worthwhile investigating the use of different light sources, and filters over light sources, to obtain eye-catching effects.

Continuous-light sources

Continuous-light sources are used for movie photography and to provide enough light for focusing still cameras in conditions of low ambient illumination.

There are two main classes of continuous light sources, self contained units powered from battery packs, and lamps powered from mains electricity. The former are used for close-up movie photography and as focusing lamps, while the latter are normally reserved for professional movie productions. Quartz-halogen bulbs are normally used in

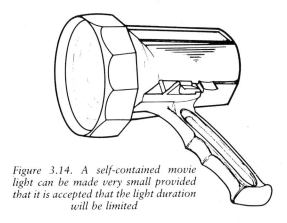

Figure 3.14. A self-contained movie light can be made very small provided that it is accepted that the light duration will be limited

both types because they are more efficient than normal tungsten lamps. Their compact size and the stability of their light output, both in terms of colour temperature and luminous efficiency, mean that lighting situations can be more accurately controlled.

Self-contained units rarely have an output in excess of 100 W; to give a reasonable duration with power in excess of this the battery pack would be prohibitively large and heavy. The lamps normally have a duration of the order of 40 minutes and take up to 12 hours to recharge.

For any serious filming, lighting systems supplied from the surface will have to be used. These use a voltage of 110 or even 240 V and so are potentially very dangerous to use without necessary safeguards such as earth leakage trips to cut off all power instantaneously if a short circuit

occurs. These systems consist of light heads which contain only bulb and reflector in a watertight housing and are hence compact and reasonably light in the water. Each head may be rated at up to 1000 W and banks of lights may be used to provide lighting for large areas.

The use of movie lighting is dealt with more fully in Chapter 11 but it must be remembered that the use of high voltages underwater is potentially hazardous and only equipment that has been properly designed and correctly maintained should be used, preferably with a qualified electrician to supervise its use and to check that all the safety devices are functioning correctly.

Filters

There are five types of filter employed in photography: contrast filters, colour-compensating filters, colour-conversion filters, neutral-density filters and special-effects filters. In underwater photography the role of filters has less importance than in conventional photography. Nevertheless, in the specialised environment of photography underwater, filters play their part. They are available as gelatin sheet, dyed glass, or acrylic. The largest range is available in gelatin form, but glass or acrylic filters are much more robust.

Glass filters are supplied ready mounted for attaching to the front of the camera lens. They may be used either inside or outside a housing; in the latter case they must be carefully washed and dried after use. Mounting a filter in contact with water can cause problems with pressure compensation (see p. 66). If a filter is used in contact with water, it should be frequently examined, and discarded at the first sign of deterioration.

Moulded acrylic filters are supplied either in screw-in mounts like glass filters, or as squares which slot into a holder. If such filters are used in a housing they need to be firmly fixed in their slot-in holder before the housing is sealed. Use on the outside of the housing allows greater versatility.

Gelatin filters are very susceptible to physical damage from handling or humidity. They must be mounted inside the housing, as immersion in water ruins their optical quality. With amphibious cameras gelatin filters may be attached to the lens behind the rear element, but it is necessary to ensure the filter cannot come loose.

A small amount of rubber cement or even silicone grease will usually keep the filter in place,

but its application must be very sparing, to avoid contact with optical surfaces or moving parts. Never handle a gelatin filter with your fingers except at the extreme edges.

When a filter is to be used inside a housing or attached to the rear element of lens, it must be mounted before a dive; therefore, its use must form part of any pre-dive planning.

Filters for black-and-white film

The main use of filters in black-and-white photography is to control contrast. So coloured filters are often called 'contrast filters' when used for monochrome work.

Contrast filters

Light can be considered as a mixture of three primary colours; blue, green and red. By mixing them in varying intensities, any colour, including white, may be produced. Daylight may be considered as white light, composed of more or less equal proportions of red, green and blue light. In photography, filters can be used to control the relative intensities of these colours. This is achieved by the use of a filter of a complementary colour. A yellow filter is used to control blue light, a magenta filter for green light and a cyan filter for red light. The filter should, ideally affect only the colour to which it is complementary.

Consider a blue object on a red background of similar tone, to be photographed on black-and-white film. The object is easily distinguishable by eye because of its colour contrast, but both the blue object and red background may be reproduced as a similar grey in the final print, because they both reflect approximately the same proportion of light. There will be no contrast between the object and the background. The use of filters overcomes this problem. A yellow filter absorbs most of the blue light reflected from the object, so causing it to be reproduced darker than the background. A cyan filter, on the the other hand, absorbs most of the red light reflected from the background, causing the background to be reproduced darker than the object. Either method results in increased contrast between object and background.

The principle also works in reverse. If a blue filter is used, all colours except blue will be reproduced darker. If the density of these is kept the same by increasing the exposure, the effect is to lighten blue. The principle can be extended to all other colours.

One of the main problems in underwater photography is to maintain contrast at an acceptable level; also, as water itself acts as a blue filter, blue is the predominant colour underwater, especially at some depth. To counteract this effect various strengths of filters, ranging from yellow through orange to red, are used.

One problem encountered in the use of filters is that they work effectively only when the light is predominantly white. At depth, all light except blue has been absorbed. Light reflected from red and green objects decreases with increasing depth until they are both reproduced as black. Where blue light prevails, all objects except those which reflect blue (i.e. blue or white ones) look dark. Filters are no use here because they cannot absorb light selectively when it is all one colour. Artificial light must be used to restore contrast and colour.

So far, it has been assumed that a filter affects only the light of its complementary colour. Thus a cyan filter should only affect red light. In fact it also reduces light from white and other neutral-toned surfaces by at least one third. Also, impurities in the cyan dye cause it to absorb some green and blue light. To compensate for the reduction in light, the exposure must be increased. This increase is expressed in terms of a *filter factor*. For example, a filter factor of 4 demands a fourfold increase to retain the correct exposure. The lens aperture should be opened up by two stops, or the shutter speed reduced to a quarter of the speed used in the same conditions without a filter.

Yellow, red and blue filters are of most use underwater. Yellow and red filters can be used when photographing a light object against water. The water will be reproduced darker, increasing the contrast: the stronger the filter, the greater the effect. When photographing black wet-suited divers against a water background, a blue filter will result in the water being reproduced lighter, and visual contrast will again be increased.

Filters for colour film

Only certain types of colour filter are used regularly with colour films. There are two basic types, *colour-compensating* and *colour-conversion*.

Colour-compensating (CC) filters

Colour-compensating filters can be of any primary or complementary colour. Only red and magenta

filters are used underwater for colour photography. CC filters are measured in units of correcting power. For example, CC10R is 10 units of red, and CC05M is 5 units of magenta.

Red filters are used to compensate for the red light that is filtered out by the water. For full correction Kodak recommend that 12 colour correcting units per metre length of light path are used for average water conditions. The light path is considered as the distance from the light source to the camera via the subject. In available-light photography, this is the depth plus subject-to-camera distance. Thus at 1 m depth and 1 m distance the correction is 24 units. As the filters are only available in units of 5, 10, 20 and 50 a CC20R would be used. In all cases under-filtering is better than over-filtering. In coastal waters the predominant colour tends to be green rather than blue, because of the influence of marine organisms in the water, so magenta CC filters are used rather than red.

The density of the required filter pack quickly increases if the recommended strength is used. In practice it is not advisable to use a filter pack above CC50R or CC50M because of the increase in exposure necessitated by the filter factor. The use of filters as the primary source of colour compensation is thus restricted to shallow water. At greater depths, in order to achieve optimum colour reproduction, the use of artificial light is obligatory.

Colour-conversion filters

Colour-conversion filters are of a bluish or yellowish colour. They are used when a film balanced for one colour temperature has to be exposed in light of different colour temperature. If daylight film is exposed to artificial light of 3200 K then a bluish filter, specifically a Wratten 80A filter, ensures that all colours are reproduced correctly. Table 3.3 gives the filters that should be used to ensure correct colour reproduction with film and illumination of different colour temperatures.

Neutral-density filters

Neutral-density filters are used to reduce the intensity of light entering the photographic system. Their transmittance is constant over the whole visible spectrum, so they have no effect on the colour reproduction of an object. They may be used with equal effectiveness with both colour and black-and-white emulsions. The two most widely available have filter factors of ×4 and ×8. Neutral-density filters find little use underwater, as the main problem is to obtain sufficient light, not to reduce its intensity. However, if the camera shutter speed is fixed by the constraints of flash synchronisation, or by a particular framing rate in a movie camera, neutral-density filters can be of use in controlling the light intensity and hence the aperture used. Their use also makes possible close-up photography with powerful light sources without the need to change to a slower film; they can also allow a larger aperture to be used under given lighting conditions, restricting depth of field where it is desired to emphasise the subject against an out-of-focus background.

Special-effects filters

Special-effects filters allow soft-focus, starbursts from point light sources, graduated colouring, multi-images and many more effects. The use of such filters is left to the preference and taste of the individual photographer. Although they do allow the production of so-called creative effects, only careful thought and experimentation can lead to

Table 3.3. Colour-conversion filters to use films of a different colour temperature

	Daylight	*Photofloods* 3400 K	*Studio lamps* 3200 K
Daylight film	No filter needed	80B (filter factor 1 2/3 stops)	80A (filter factor 2 stops)
Artificial light film 3200 K	85B (filter factor 2/3 stops)	81A (filter factor 1/3 stops)	No filter needed

really effective results. Their use is not recommended for routine photography; it must be very sparing if they are to make the desired impact.

Polarising filters

Polarising filters can also be considered as special-effects filters. They are used primarily to reduce reflections when glass or other shiny non-metallic objects are photographed or to darken blue sky. In use, they must be rotated in front of the camera, with the subject illuminated as it will be photographed, to find the angle at which they are most effective. The constraints of housings render them less useful underwater than on land. Polarising filter have nevertheless been used, particularly in attempts to reduce backscatter, and to increase contrast in both black-and-white and colour photography underwater.

Summary

Some form of lighting is necessary to realise the full potential of underwater photography. While this chapter has introduced the forms of lighting available and the technical aspects of their use, it will be necessary to study individual subjects and their treatment in order to master the artistic side of the subject. This is introduced in later chapters.

4

ACCESSORIES AND THEIR USE

In order to exploit the picture-taking potential of a camera to the full, a range of accessories is needed. Interchangeable lenses, close-up accessories, artificial-light sources and filters are considered in other chapters, but other more basic accessories are equally important, and contribute much to the success of underwater photography. Among these are viewfinders, exposure meters, lens attachments, handling systems and focusing lights.

Viewfinders

A viewfinder is necessary with any camera in order to compose photographs accurately. Unless a camera has a magnified through-the-lens system such as the Canon Speed Finder, an external viewfinder will be necessary; but even with a SLR camera, when it is necessary to frame and shoot quickly, or when the light is poor, an accessory viewfinder will prove useful.

There are two basic types of accessory viewfinder, the *frame-* or *sports finder* and the *optical viewfinder*. The framefinder, as its name suggests, consists of a simple frame. If the eye is placed at a certain distance away from this frame, usually

Figure 4.1. A simple frame type viewfinder with parallax correction device

dictated by its structure, the field of view will be similar to that of the lens it is designed to be used with. The position of the eye relative to the frame is critical and hence the field of view indicated is not very accurate or reproducible.

Figure 4.1 shows a typical sports finder. These are usually made of metal or plastic, occasionally of engraved acrylic sheet mounted on a metal framework. In practice, the diver's mask is brought into contact with viewing 'blob' and this is lined up with the central mark on the frame. The correct field of view of the lens is then indicated by the outer frame. The field of view hence depends on the distance between the eye and the frame and this varies according to the type of mask worn.

Figures 4.2 and 4.3 show the Nikonos framefinder. These finders are three-dimensional structures designed in such a way that when the eye is the correct distance away from the viewfinder only the back, and not the sides of the structure, will be seen. In theory this should allow for different designs of face mask, as the mask does not need to be pressed against the viewfinder. In practice this type of viewfinder is not easy to use accurately.

Both types of viewfinder also suffer from parallax, although they may have an adjustment to allow them to be tilted forward to compensate (Figure 4.4). To use a frame viewfinder with superwide-angle lenses the frame size has to be increased to such an extent that it becomes too large to be used effectively, as the eye can no longer take in the whole of the frame when in the correct viewing position.

Optical viewfinders offer a much more effective solution. Glass or acrylic lenses are used to give an optically reduced representation of the field of view of the lens in use. In some cases the finder is designed with a very wide angle of view and incorporates engraved frames showing the field of view of different lenses. The lines from the frames are superimposed optically on the field of view and are visible only when the eye is in the correct viewing position. This type of finder has the advantage that subjects swimming into the field of view can be monitored without moving the camera.

Optical viewfinders may be capable of compensating for parallax, again by tipping them forward slightly relative to the camera lens, but only through-the-lens systems overcome parallax completely.

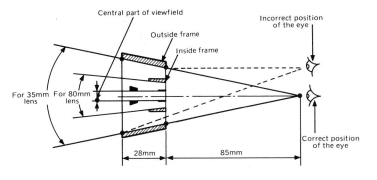

Figure 4.2. The principle of use of the Nikonos Underwater Frame Finder, designed for use with 35 mm or 80 mm lenses (see also Figure 4.3)

(a) Correct

(b) Too far away

(c) Too near

Parallax compensation

If a viewfinder has not been designed specifically for a camera housing/lens system it will be necessary to study the effect of parallax before using the system in open water. It has been explained that parallax only really becomes a problem when photographing subjects closer than 2 m, but in coastal waters visibility often dictates that photography has to be carried out closer than this. It is therefore advisable, in order to achieve the best possible photographic results, to study the effect of parallax on your camera system. The only way of doing this is practically, by trial and error underwater.

The sides of most swimming pools are covered with square tiles. A chinagraph pencil can be used to temporarily mark these tiles and the marks can be removed with a rag. Obtain permission to do this beforehand. Select an area of size similar to the field of view of the lens in use at the maximum distance at which it is desired to make the study, say 2 m, and mark the centre tile so that it is easily distinguishable (Figure 4.6).

If the tiles are small it is also worth marking every fifth tile in each direction from the centre to aid the interpretation of the results. Place markers on the floor of the pool to indicate distances from the wall of 2 m, 1 m and the closest focusing distance of the lens. At each distance take four or

Figure 4.3. Illustrating the use of the Nikonos viewfinder. (a) shows how the viewfinder should look when viewed from the correct distance. The viewfinder appears two-dimensional, surrounding the subject. The outer portion indicates the field of view with the 35 mm lens and the inner portion with the 80 mm lens. When viewed from too far away, as in (b), the outside of the viewfinder can be seen. When viewed from too near the inside of the viewfinder can be seen. In use the viewfinder will appear blurred as the eye will not have sufficient depth of field to view it and the subject at the same time

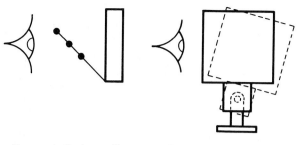

The eye is lined up with various 'blobs'. The topmost indicates the closest focusing distance

The whole of the optical finder swings forward on a preset scale

Figure 4.4. Parallax compensation on accessory viewfinders

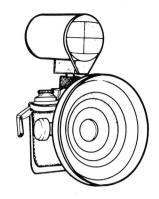

Figure 4.5. An optical viewfinder is essential for a wide-angle lens

five photographs, raising and lowering the camera from the eye each time (to check on the reproducibility of the framing), and centring the tile that has been marked in the viewfinder.

When the film has been processed, examine the results. The centre tile will not be in the centre of the film. It may also not be in the same position in all the photographs taken from any one position.

To work out the correction to be applied in each case, make a note of the number of tile-widths the camera needs to be moved up and to the side in order to centre the marked tile on the film. Take the average of all exposures for each distance. Also make a note of how many tiles are included in the field of view of the lens, both in a horizontal and a vertical direction from the centre of the film. As an

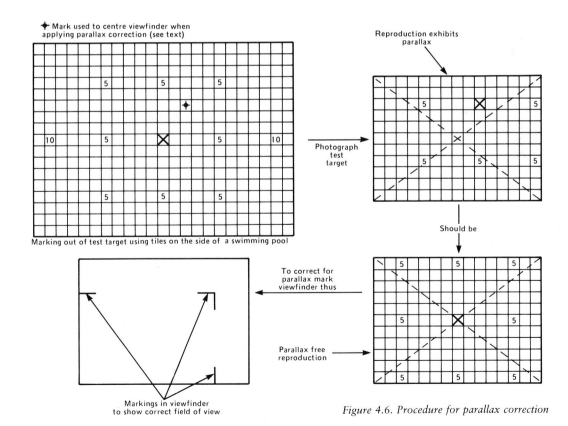

✦ Mark used to centre viewfinder when applying parallax correction (see text)

Marking out of test target using tiles on the side of a swimming pool

Markings in viewfinder to show correct field of view

Photograph test target

Reproduction exhibits parallax

Should be

To correct for parallax mark viewfinder thus

Parallax free reproduction

Figure 4.6. Procedure for parallax correction

37

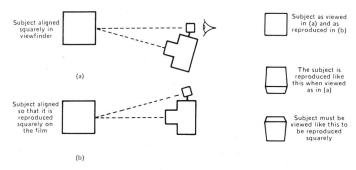

Figure 4.7. *Factors affecting composition when making parallax corrections*

example (Figure 4.6), at 1 m the marked tile is seen to be 3 tile lengths above and 2 to the right of the centre of the film. The field of view is shown to extend 15 tile lengths horizontally and 11 vertically. The correction is applied by centring the viewfinder on the tile 3 above and 2 to the right of the marked tile (marked in Figure 4.6). By counting 2 tiles up and 5 tiles to the right, the edge of the field of view will be found. This can then be marked on the viewfinder by means of a mark (paint or a scratch) to show how the subject should be framed to allow for parallax. These marks should be readily visible but not overpowering.

A similar procedure applies with viewfinders which can be tilted forwards to allow for parallax. Remember, when tilted forward the viewfinder will be looking down on the subject with respect to the camera; and this must be allowed for by viewing from slightly above the subject (Figure 4.7).

Exposure meters

Although on land it is possible to estimate exposure for commonly encountered subjects by rule of thumb, to ensure consistent results underwater there is no alternative to the use of an exposure meter.

There are two basic types of exposure meter cell, *photovoltaic* and *photoconductive*. The first, which requires no voltage source, is typified by the selenium-cell meter which produces an electric current in proportion to the light intensity, and this can be displayed on a scale. The scale deflection is proportional to the light intensity.

The second is typified by the *cadmium sulphide* (CdS) or the *silicon blue* cell. When the cell is exposed to light its electrical resistance falls in

proportion to light intensity. If the cell is placed in circuit with a small constant-voltage source, changes in resistance will correspond to changes in current, which will be seen as a scale deflection on a meter as before. Although selenium meters are cheaper and have no running costs, they are usually larger and less sensitive than CdS or silicon blue meters. The choice depends largely on the proposed use of the meter. For many purposes a selenium cell will be adequate for underwater use, but if much available-light photography is envisaged, the greater sensitivity and durability of the photoconductive type of meter is an advantage.

There are a few amphibious exposure meters, the best known being a CdS meter by Sekonic; but there are many exposure meters available for land use which can be encapsulated for use underwater. Choose one which gives a reading with the minimum of different movements.

Exposure meters usually display a readout which must be tranferred to a series of rotating scales in order to obtain the exposure settings. This complicates housing controls and wastes time underwater. Look for a meter which gives a direct indication of aperture, once shutter and film speeds have been set. Some exposure meters have a digital display of aperture and these are ideal for underwater use as they are both easy to read and simple to operate.

How meters can mislead

All exposure meters, whether built into cameras or not, are calibrated to give correct exposure for an 'average' subject on land. This calibration assumes that all the light reflected from the subject can be integrated (mixed) to give an intensity over the whole subject similar to the light that would be

reflected from a grey card of 18% reflectance under the same lighting conditions. The meter indicates an exposure such that the grey card will be reproduced as the correct shade of grey in a colour transparency. Even though the meter will always give an acceptable exposure with average subjects, it may not do so when presented with anything abnormal. To appreciate the reason for this, try the following experiment. Set up three cards, one black, one grey and one white, under the same lighting conditions. Take an exposure reading from each card, ensuring no background is included within the acceptance angle of the meter. The meter will indicate a short exposure for the white card, a long exposure for the black and an intermediate exposure for the grey card. If an exposure is now made of each card, using the exposures indicated, all the cards will appear in the transparencies as an identical grey. Calibrated as it is to reproduce grey as grey, the meter has 'assumed' that all the cards are grey. To the meter, the white card appears to be just the grey card under conditions of high illuminance, and the black card the same grey card under conditions of low illuminance. To have obtained the correct result, i.e. to have reproduced the white as white and the black as black, the exposure indicated by reading the grey card should have been used for all three.

Underwater, most subjects are far from being of 18% reflectance. Wetsuited divers are darker, marine growth is a little darker, a sandy bottom is lighter, and water itself can vary from dark to light depending on visibility and location. An exposure meter is likely to be of little value without interpretation. The only way to overcome the situation is to bracket the exposure, by giving one and two stops above and below the indicated exposure, in every new situation. Examine the results carefully; with experience it will be possible to interpret the meter reading to give the correct exposure.

If exposure must be determined in a once-only situation, examine the subject carefully. Look for the lightest part, then the darkest, and choose an intermediate tone from which to take the meter reading.

Cameras equipped with automatic exposure control react in the same way. If they are consistently producing under- or overexposed results when used underwater this can be allowed for. Most modern cameras have an override on the automatic system allowing the lens to be opened up, or stopped down, by a selected number of stops, or fractions of a stop, from the aperture selected by the automatic system. Even if this device is not fitted, exposure can be altered by changing the film speed. Set a faster film speed if the camera is over-exposing and a slower film speed if the camera is underexposing. Simple cartridge loading cameras do not have such an option and so the only solution available is to modify the film processing to alter the marked film speed. This is further discussed in Chapter 5.

Always remember than an exposure meter does not give the correct exposure unless used under the same conditions in which it was calibrated. It gives a reading that must interpreted by the photographer to give the correct exposure.

Lens attachments

A wide variety of lenses is available for terrestrial cameras with interchangeable lenses. Different manufacturers produce series of lenses at various prices; many low price lenses will fit in an underwater housing. This is not the case, however, with the Nikonos, as it would be uneconomic for a lens manufacturer to provide alternative lenses for so specialised a camera when there is already an underwater Nikkos series, particularly in terms of the low volume of potential sales. However, a number of optical attachments are made for the Nikonos. These are used mounted on the front of the camera lens, and alter its angle of view to wide-angle, superwide-angle or *fisheye* (see p. 56).

Although these lenses give a good optical performance they do not match the performance of a purpose-designed lens. In addition it is necessary to increase the exposure by up to two stops when they are fitted. This restricts their application in poor light. However, there is the advantage that they can be attached and removed underwater; they are also a good deal less expensive than a purpose-built lens.

The uses of lens attachments are discussed in Chapter 6.

Handling systems

The most neglected aspect of underwater photography is the design of efficient handling systems for cameras and flash units. Although manufacturers of complete systems, such as Oceanic Products or Ikelite, have given considerable thought as to how their housings will be used with accessories,

and supply housings complete with fittings to allow the attachment of flash arms or exposure meters, the independent manufacturers of housings have not always been so thoughtful. The importance of the buoyancy and angle of alignment of a camera system has already been discussed (p. 17), but unless accessories can be attached to the camera easily and firmly, and the flash moved as required for different lighting set-ups, much of the dive will taken up with adjusting equipment rather than concentrating on the subject. The Nikonos is a case in point. It is easy enough to use on its own, but becomes awkward when you need to use it with a flash or exposure meter unless all the components are attached to a handling bar. To aid operation with such a bar, thumb-operated release levers are available to work the film and shutter release lever without letting go of the handling bar.

When selecting a housing it is essential to choose one which allows a bar to be securely mounted. The fitting should be designed so that the housing remains upright with the load attached. Most mountings are on the bottom of the housing; but with suitable counterbalancing it can be at the top. The point of attachment must be strong so as not to distort or break under heavy loading, and ideally should be independent of the watertight structure of the housing. This will reduce the possibility of distorting the housing under load with the attendant risk of leaks. Flash arms may be bolted directly to the housing or accessory bar, though this increases the time spent preparing the equipment and does not allow the

flash to be held away from the camera. A better type of system is one similar to the Oceanic Products system, which provides an accessory shoe onto which the flash arm can be slid and clamped.

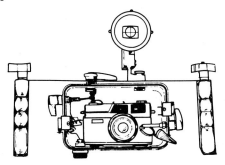

Figure 4.8. A simple accessory bar can aid the mounting of accessories and improve the handling of the complete camera system

The flash arm is the accessory that has caused more problems than any other, as the arm must be able to be adjusted in any direction, but must stay in place once adjusted. An arm construced on the ball and socket principle can be easily adjusted, but once the components become slightly worn it will not stay in place under load. An arm which can be locked at a number of points, for example using a tongue-and-groove arrangement, is not capable of the necessary freedom of adjustment. Friction clamps are unsatisfactory underwater as the water itself tends to act as a lubricant and, if these devices are adjusted on the surface, they can lock solid when submerged in cold water because

Figure 4.9. The usefulness of a camera is governed by its accessories. In this case lenses, viewfinders, an exposure meter, a close-up outfit and other accessories result in a very versatile system

the temperature causes the components to contract. They also tend to wear with repeated use and so become slack and difficult to adjust correctly.

One solution is to build a rigid arm for each application. The flash unit will then be firmly positioned for close-up or general photography at certain distances. However, this solution limits versatility. Until the perfect flash arm is developed the general conclusion seems to be that you should choose a ball-and-socket arm if the flash unit is light and a tongue-and-groove arm if the flash unit is heavy.

Focusing lights

At night, or when using a camera with through-the-lens focusing in low ambient light, some form of artificial illumination will be necessary, both to focus and to compose the photographs. The lamp may have a power rating of about 100 W, with a beam wide enough to allow picture composition with wide-angle lenses, and give light for 45 min or more. Because of the need for a large battery capacity the lamp will of necessity be larger and heavier than a flash unit, and should be used in conjunction with a robust flash arm. Because of the limited duration of the illumination it is important not to leave the lamp running continuously, but to use it only when actually photographing.

An attractive form of lamp gives only a pencil beam; attached to the flash unit it gives an indication of where the flash is pointing. Although such a lamp is insufficient for photography at very low light levels or at night, it is valuable in marginal conditions which allow the subject to be composed with through-the-lens viewing, but do not give quite enough light to focus accurately. It also has applications when photographing fish (see pp. 92–96).

Summary

When purchasing a camera, consider its use as a complete system rather than as a separate part. Plan the system as a whole, with each accessory adding to the versatility of the camera without impairing its ease of handling or performance. Accessories are meant to help the photographer, to allow him greater freedom to photograph the subject, and to extend the range of subjects and treatments available to him.

5

FILMS

Film formats

Each camera, or interchangeable film magazine, is made specifically to take one size of film, which may be available in different lengths. The film is normally suplied in light-tight cassettes, cartridges or spools for daylight loading. Some sizes are available in bulk lengths for darkroom loading. Cameras are commonly classified according to their film format.

Film formats suitable for underwater use vary from the 110 format (13 × 17 mm) to 120 size, for 6 × 6 cm or 6 × 7 cm negatives. Some magazine cameras in these sizes accept 70 mm film. Larger formats are seldom used because they use sheet film in individual pieces. Movie camera formats suitable for underwater use range from 8 mm to 70 mm. The 16 mm and larger formats are used only for professional productions, because of the cost of film and associated equipment.

Still formats

Format	110
Image size	13 × 17 mm
Availability	Cartridges of 12 or 20 exposures
Comments	Cartridges are simple to load and do not need to be rewound. They are usually injection moulded and so the film is not held as accurately as by a sprung machined pressure plate. This reduces the quality that can be obtained by the format. Only a small range of film types is available.
Format	126
Image size	29 × 29 mm
Availability	Cartridges of 12 or 20 exposures
Comments	The predecessor of the 110 format, with similar qualities. It is becoming less popular than the latter because of the smaller size of the 110 cameras. Only a small range of film types is available.
Format	Half-frame 35 mm
Image size	18 × 24 mm
Availability	24, 40, 48 or 72 exposure cassettes, or bulk lengths up to 30 m (100 ft)
Comments	The half-frame format uses standard 35 mm film. It is not in common use as the small image size results in some sacrifice of quality. Cameras are similar in size to full-frame 35 mm cameras, so have little advantage in size or weight.
Format	35 mm
Image size	24 × 36 mm
Availability	12, 20, 24 or 36 exposure cassettes, or bulk lengths up to 30 m
Comments	The 35 mm film format is the most popular among amateur and professional photographers. It represents a compromise between image quality and portability. Film is available in a large variety of emulsions.
	More cameras, lenses and accessories have been developed for this format than any other.
Format	120 and 220
Image size	60 × 90 mm, 8 exp (16)
	60 × 70 mm, 10 exp (20)
	60 × 60 mm, 12 exp (24)
	45 × 60 mm, 15 exp (30)
	(Number of exposures given by 220 film is in brackets)

Availability	Rolls of standard length on spools. A take-up spool is needed in the camera.
Comments	120 film is attached at its leading end to a length of backing paper, which serves as leader, trailer, lightproof and anti-halation backing. Older cameras establish frame intervals by numbers on the backing paper viewed through a small window in the back of the camera.
	120 is the most commonly used film size for medium-format cameras. It is available in most emulsions, including a number intended specifically for professional use.
	220 film uses a similar spool and is twice the length. This is possible because paper is used only for the leader and trailer rather than as a continuous length. The paper ensures that the film is not fogged when loading but its absence as a backing ensures that each layer is thinner. Cameras which can use both 120 and 220 film have an adjustable pressure plate to allow for this change in thickness but it means that 220 film must not be used in cameras which are manufactured for 120 film only. Historic processing difficulties have restricted the popularity of 220 film. It is hence not available in the same range of emulsions as 120 film.
Format	70 mm
Image size	As for 120
	Standard 5 m cassette gives 90 45×60 mm frames, 70 60×60 mm frames or 60 60×70 mm frames.
Availability	Cassettes with 5 m of film or bulk lengths (normally 30 m).
Comments	The most useful type of film for medium format use underwater. A 5 m cassette provides enough film to cope with most dives. A limited number of emulsion types is available, but the film size is gaining popularity as more manufacturers produce equipment capable of using it.

Movie formats

Format	Super-8, Single-8
Image size	4.22×5.65 mm
Availability	Super-8: Cartridges containing a 17 m length of film
	Single-8: 15 m on spools
Comments	Super-8 is the most popular film size for home movies. This format is capable of somewhat higher quality than older 8 mm formats, as the frame area is 40% larger. Cameras are available with built-in sound-recording facilities using magnetic striped film. Single-8 is less common than Super-8, and cameras are much less widely available.
Format	Double-8 (Standard-8)
Image size	3.6×4.9 mm
Availability	A 7.5 m length spool giving effectively 15 m of film
Comments	The format is no longer in common use. The film is 16 mm in width, and has double perforations at half the pitch of regular 16 mm film. It is exposed on one half of its width, then the feed and take-up spools are reversed; the other half is then exposed. The film is split and joined after processing so that it can be viewed in one length.
Format	16 mm
Image size	7.5×10.3 mm
Availability	Spools of 30 m, 60 m or 120 m
Comments	This format is reserved mainly for professional productions. A much wider range of emulsions is available than for smaller movie formats.

Other movie formats include 35 mm and 70 mm but these are reserved solely for feature films or prestige TV productions. They will not be commonly encountered in underwater photography.

Table 5.1 gives the running times of standard movie film lengths.

Table 5.1. Running time for movie cameras (in seconds)

	18 fps	24 fps	36 fps
Super-8	198	148	99
Standard-8 (Double-8)	218	163	109
Single-8	198	148	99
16mm (30 metres)	218	163	109

Running times include film lost in loading and unloading.

Types of film

All films fit into one of two classifications; negative or reversal. A negative is an intermediate step in the production of a print. It gives a result in which all the tones of the subject are reversed, e.g. black is reproduced as white and white as black. In a colour negative film colours as well as tones are reversed and are reproduced as complementaries; thus red, green and blue appear in the negative as cyan, magenta and yellow respectively, and vice versa. A dark red object is reproduced in a colour negative as a light cyan.

The appearance of a colour negative is further altered by an overall orange cast. This is used to correct for the secondary absorptions of the dye layers and to improve colour reproduction. For example, a magenta dye does not absorb just green light but also some blue and red light and hence colour reproduction is distorted. Similarly a cyan dye absorbs some green and blue light in addition to red. Yellow dye is almost spectrally pure. A yellow mask is produced to correct for the imperfections in the magenta dye and red mask to correct for the cyan dye. This combination of yellow and red produces the overall orange colour.

Colour negative film is intended primarily for the production of prints. The colour sensitivity of the paper is balanced in such a way that the orange mask is not reproduced. A reversal film is intended primarily for the production of transparencies or *diapositives* for projection. When processed, the result is a direct reproduction of the subject. Blacks are reproduced as blacks, whites as whites, etc. A colour reversal film also reproduces colours directly so that red, green and blue appear respectively as red, green and blue. However, as no intermediate colour-masking technique is possible, theoretically, colours are slightly less faithful to the original than in the negative-positive process (though this is seldom evident). Although reversal films should be chosen if transparencies are required and negative film if prints are required, either choice does not exclude obtaining the other result: transparencies may be printed on colour reversal print material such as Cibachrome, or re-photographed on colour negative stock to produce an *internegative* from which prints or further transparencies can be made. Negatives can also be printed on colour positive stock to produce transparencies. The disadvantage is that these processes are usually more expensive and may produce a result of lower quality than obtained by using the correct film for the desired result in the camera.

As negative films are only an intermediate stage in the production of the finished photograph they can be given a low inherent contrast, so that they have more latitude in exposure and colour balance than reversal films. If a negative has been exposed incorrectly or used in lighting conditions of incorrect colour temperature, then the resulting density and colour balance can be to a large extent corrected at the printing stage. Black-and-white negatives often yield an acceptable result if underexposed by as much as two stops or overexposed by up to five stops, depending on the characteristics of the individual material. Colour negatives have less latitude, but will still give passable results when underexposed by up to one stop or overexposed by up to two stops. It must be emphasised, though, that correct exposure is the only way to achieve the very best results.

The exposure given to reversal films, and the colour temperature of the light to which they are exposed, must be exact if good results are to be obtained. In practice, exposure within one half-stop of the ideal produces acceptable results. Light of the wrong colour temperature always introduces colour casts.

If lighting conditions are difficult or have not been encountered before, bracket exposure about the exposure that is estimated as being correct. One-stop increments are suitable for colour negatives, but reversal material, with its much higher inherent contrast and limited latitude, requires half-stop increments. If you can afford to make only one exposure, err on the side of overexposure for a negative and underexposure for a transparency. This ensures that all the subject information is recorded on the film even though the final result may be a little dark in each case. Even a severely underexposed transparency can often be persuaded to produce an acceptable result when duplicated to a lower density.

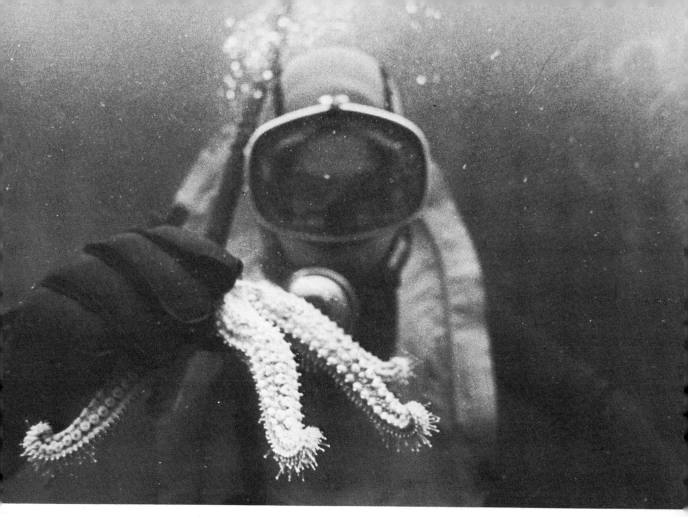

An underwater portrait can be produced with even the simplest camera

Film sensitivities

Different films have different sensitivities to light. Colour films are balanced to give optimum results with light of a particular colour temperature (see pp. 30–31). Even black-and-white films of different types respond to colour in different ways. The early films were sensitive only to blue light. Even now, orthochromatic films, sensitive to blue and green light, are available. They record red as black, so distorting the tonal reproduction of normal subjects and they are reserved, for example, for copying illustrations. Panchromatic films are sensitive to the whole visible spectrum, and are standard for general-purpose black-and-white photography.

The sensitivity of a film to light is expressed in terms of a film speed. This is governed by strict standards agreed by National and International committees. The International Standards Organisation (ISO) standard is now slowly replacing all other methods of expressing film speed. This is a dual system, incorporating both an arithmetic and a logarithmic standard. The first figure is the arithmetic standard and is identical in practice to the American Standards Association (ASA) and British Standard (BS) systems. In this system a doubling of the film speed represents a doubling in film sensitivity and an exposure decrease of one stop. For example, ISO 400 film has twice the inherent sensitivity of ISO 200 film. The second figure is the logarithmic system and is identical in practice to the German DIN standard. In this system an increase in three units represents a doubling in film sensitivity. For example, an ISO 19° film has twice the inherent sensitivity of an

ISO 16° film. Films will hence be marked as ISO 50/18° or ISO 400/27°, for example.

Films are often referred to as being slow, medium or fast. Films that are normally classified as 'slow' have an exposure index below ISO 50/18°. Medium-speed films have an exposure index between ISO 50/18° and 320/26°. High-speed or fast films have an exposure index of 400/27° or more. To achieve the highest-quality results in a given situation choose the slowest film that will give an adequate shutter-speed/aperture combination for the subject to be photographed by available light (or an adequate aperture for flash). Although fast films allow the use of faster shutter speeds, or smaller apertures (and more depth of field), for given lighting conditions they do so only at the expense of quality. To make a film more sensitive to light the individual particles of light-sensitive silver halide in the emulsion must be made larger. The result is a more obviously granular appearance. Though more sensitive to light, the emulsion resolves less fine detail, and may not give such good tonal gradation as a slower film.

Storage of film

Both excessive temperature and excessive humidity can have an adverse effect on film. If unused film is stored incorrectly it may suffer changes in speed or colour balance, and may when exposed and processed show local irregularities over its surface. Colour film is more sensitive than black-and-white to incorrect storage. Humidity is often more responsible than temperature for these detrimental effects. Films are supplied by the manufacturers sealed in moisture-proof packing. The humidity inside these packs is ideal for storage, so they should not be opened until immediately before use. Film should always be stored in cool conditions. As long as the packs have not been opened, storage in a refrigerator or deep-freeze will keep the film in good condition almost indefinitely. It is important, however, that film stored under such conditions should not have had the seal of its storage container broken, allowing the ingress of air of high humidity.

Once moist air has penetrated the packing, cold storage is worse than useless. The lower the temperature, the higher the relative humidity rises, until moisture condenses on the film, ruining it.

Kodak recommend that if a film is to be stored for longer than two weeks it should be at a temperature of less than 13°C. If it is required to be stored for a long time, or is intended for critical use, it should be stored in a deep-freeze in the range −18°C to −23°C. An example of 'critical use' is when film is used for the compilation of a tape-slide presentation. A slight difference in colour balance or density between different transparencies of the same subject can prove objectionable, so the films used should be as nearly identical as possible. Films of the same emulsion batch number, stored under ideal conditions, given the same exposure, and processed at the same time or under precisely controlled conditions, should have identical colour and density response.

When films have been stored in a deep-freeze, or even a refrigerator, they must be given time to warm up to room temperature before opening. Kodak recommend at least 1 hour when a film has been in a refrigerator and four hours if the film has been in a deep-freeze. Failure to comply with these recommendations before opening the sealed film pack can lead to condensation on the emulsion surface. This may cause irregular defects to appear on the film and may actually result in physical damage to the emulsion if it is loaded into the camera in this partially wet state.

Manufacturers produce film separately for the amateur and professional markets. Film intended for amateur use is bought from the manufacturer by wholesalers and passed to retailers. It may be on the shelf for a long time before purchase, and stored again before use. In the majority of cases the film will not be stored under ideal conditions. The film manufacturers estimate the average length of time the film is stored before use, and manufacture materials which will 'age' to ideal specifications in that time under normal shelf conditions. The changes are slight, hardly detectable except under laboratory conditions. The film will thus not be within specification one day and outside it the next. In fact, the period extends over many months; but the film will be changing inperceptibly all the time. Photographs taken of the same subject under the same conditions a year apart may thus show differences in colour and density.

These small differences in colour and density are not acceptable to the professional photographer, particularly if he is taking fashion photographs or producing work for a commercial or scientific purpose where colour reproduction is critical. Professionals normally purchase their film in bulk;

and their storage is controlled far more precisely. Most professional film is stored under ideal conditions and so is not expected to alter after it is supplied. The manufacturer can thus aim at exactly the colour balance and emulsion speed that he wants and 'age' the film before distribution.

It is important that all film is processed promptly after exposure. Delays cause the latent image, the invisible image formed on the film by light, to start to decay, resulting in speed losses. The three different emulsion layers in a colour film all have slightly different characteristics and so will be affected in different ways. Different speed losses in each colour-sensitive layer will cause colour casts as well as underexposure.

Many amateurs keep film in their cameras for several months or even years, never managing to 'finish it off'. So film intended for snapshots has to retain its latent image for a long time, even at the expense of optimum image quality. Professionally used material, on the other hand, is usually processed within hours of exposure. Thus the latent-image keeping properties of 'professional' films need be much less rigorous. In fact some must be processed within a week or so of exposure to ensure the best results. For longer periods, exposed films should be refrigerated.

Professional films do not give extra quality unless they are correctly stored and used. If they are incorrectly stored they will in fact give results inferior to amateur film stored in the same way. For this reason, amateur films are usually the best choice on expeditions.

Avoid leaving film in hot places such as on a window-ledge or in a car, especially the glove compartment or boot. A film left inside a camera is just as susceptible to damage as when it is in its original packing. Do not leave a camera in a housing lying in the sun. The housing can act like a small greenhouse, causing temperatures inside it to rise very rapidly. Also avoid changes in temperature. A film left at a constant temperature in a cool place keeps far better than one that is repeatedly refrigerated and thawed on the off-chance of being used.

X-rays

A more recent threat to unprocessed film, particularly in view of the tightening of security at airports, is that of fogging by X-rays. Hold luggage as well as hand luggage is scanned by X-rays at airport controls; the effect is detrimental to both unexposed and exposed unprocessed film. Although machines are alleged to be safe to pass films through, this is not always the case. For example if the operator does not immediately recognise a metal object as a camera or film cassette he is likely to increase the intensity until he does, by which time the film has been fogged. Always carry all film, exposed and unexposed, by hand and inform the airline operator when checking-in that you are doing so. They will either make special arrangements to have the film taken to the aircraft, or inform the security guard accordingly. As long as you are polite, and explain that the films are important and irreplaceable, you should have no problem. Remember that even security guards are human; but they do have a job to do, and are kept very busy at a modern airport.

The lead 'X-ray-proof' bags that can be purchased for film protection when travelling are not recommended. As well as adding unnecessary weight, they attract the suspicions of the security guard, who naturally wants to see what is in them; he increases the intensity until he can – and that is the end of your irreplaceable shots.

Storage of transparencies and prints

For maximum permanence, negatives, transparencies and prints should all be stored in a cool, dry, dark place. At room temperature, the colours of transparencies and prints can be expected to remain substantially unchanged for up to ten years. Black-and-white prints and negatives are stable, as long as they have been properly washed after fixing. Valuable transparencies and negatives may be sealed in moisture-proof containers and stored in a refrigerator at approximately 2°C; this can add up to ten years to their life. Storage in a deep-freeze at between −18°C and −23°C will enable them to be stored for an indefinite period. As with unexposed film, allow sufficient time for the package to warm up before breaking the seal of the container.

Prints, especially colour prints, will fade in time when on view in a room. Chromogenic colour prints are affected more quickly than black-and-white or Cibachrome colour prints. Cibachrome prints use a dye-destruction process with azo dyes, unlike the chromogenic materials which form the dyes from colourless couplers. To ensure colour prints remain in good condition for as long as possible, keep them out of direct sunlight. An ultraviolet absorbing spray obtainable from

photographic dealers increases their life, but in order to avoid damage to the print follow the manufacturer's instructions precisely.

Long exposure in a projector decreases the life of a transparency. Ensure the cooling mechanism of the projector is working effectively and that the heat filter is always in place. Do not be tempted to use a projector lamp of more than the recommended wattage. Some transparencies are returned from the processors in card mounts, but this is not good way of protecting valuable shots.

Figure 5.1. The correct way to mount and mark up a transparency

Card mounts are easily bent and can become jammed in projectors, causing damage to both mount and transparency. Plastics mounts offer more protection, with those that sandwich the transparency between glasses offering the best protection from fingermarks and other physical damage. *Anti-Newton's rings* glass mounts are the best to use because these have a slightly roughened surface, and do not form coloured interference rings when in contact with the transparency.

When mounting a transparency between glass, ensure all surfaces are free from dust and other impurities. Pressure exerted in the mounting process can cause dirt to become embedded in transparencies and grease from fingers can lead to

permanent damage. The transparency should be mounted with its emulsion or matt side facing away from the projector lamp. The white side of the mount should face the light source. Any labels should be on this side of the mount.

To ensure correct orientation, hold the transparency so as to view it correctly (with the emulsion away). Apply a mark or coloured spot in the bottom left corner of the mount (Figure 5.1). This is to indicate the correct way to load the transparency in the projector. In the magazine, all the spots should appear at the top right-hand corner, facing the light source; in this way the transparency will be the right way round on the screen.

Development techniques

While the best results are nearly always produced by keeping to manufacturer's recommendations for exposure and processing, variations in development may produce beneficial effects. The greatest use of a variation in development is to provide a means of manipulating film speed. Other effects are also possible but these normally accompany, or are secondary to, the change in film speed.

Alteration to the processing of colour films should be made only with reference to manufacturer's recommendations, as adverse secondary effects may nullify any possible gains.

The selection of developer for black-and-white films can greatly affect film speed, contrast, graininess and *acutance* or apparent sharpness. Most developers are formulated to obtain various compromises between the first three factors. High-acutance developers, on the other hand, are specially formulated to enhance the contrast of edges and fine detail and increase the apparent sharpness of the image. They achieve this at the expense of an increase in graininess.

Other black-and-white developers may be broadly categorised into one of three types; ultra-fine-grain, standard and speed-increasing. Ultra-fine-grain developers are formulated to produce a result in which graininess is low. This is normally accompanied by a decrease in film speed. Standard developers produce a compromise between film speed, contrast and graininess. The film is developed so as to achieve the manufacturer's recommended film speed, and the results are of good quality. Such developers can be used with a wide variety of different films. Note that most standard developers are called 'fine-grain'.

Speed-increasing developers produce a higher film speed, accompanied by a marked increase in graininess. If they are used to produce only a small increase in speed, then contrast will not be affected significantly. If a large speed increase is required, the contrast as well as graininess is considerably increased. In practice, the true increase in film speed is small, seldom more than 1½ stops.

Even though a speed-increasing developer has not been specifically used, an increase in development time over that recommended has the effect of increasing film speed to some extent. This is combined with increases in contrast, graininess and fog levels. Fog increases the overall density of the negative, and as it builds up it adversely affects film speed, contrast and printing time. Different developer-film combinations give different results, but the increase of fog always limits the possible increase in film speed.

Both developer and film should be chosen for their particular characteristics. If high-film speed is required, use a high-speed film. If grain size is critical, use a fine-grain film. Developers accentuate the inherent characteristics of the film; they do not change them. If extra film speed is required, high-speed film processed in a general-purpose developer offers superior results to those obtained by a medium-speed film processed in a speed-increasing developer. Similarly, a slow, fine-grain film developed in a general-purpose or a high-definition developer, will produce better images than a medium-speed film developed in a fine-grain developer.

Photography underwater tends to lack both contrast and light, so that increases in both film speed and contrast are helpful. An increase in development time is particularly advantageous, as the two effects normally accompany one another; as long as the effect is not taken to extremes, the build-up in graininess and fog will not be excessive. Start off by increasing development time by 10% for all underwater work. An exposure series

about the correct exposure, with half-stop intervals, will indicate any film speed increase which can be allowed for in the exposure of subsequent films. In black-and-white photography, contrast may also be increased at the printing stage, as paper is available in a range of contrast grades or with its contrast determined by filters. The same negative may be printed on different grades of paper, to see the most suitable contrast for that particular subject.

Remember that contrast decreases with increasing subject distance. Close-up photographs may not require any increase in contrast, so the technique should be regulated according to both the subject and the effect required.

Colour films are effectively made up of three layers of emulsion. The outermost layer is sensitive to blue light, the next to green light and the innermost layer to red light. Each emulsion produces a dye, complementary in colour to its own sensitivity, in an amount proportional to exposure. Thus the red-sensitive layer produces a cyan image, the green-sensitive layer a magenta image and the blue-sensitive layer a yellow image. Different proportions of these three dyes can produce an image in any colour. Each of these three emulsions responds in its own way to change in development procedure. Only the developer provided or recommended for a particular film ensures correct colour reproduction. If the recommended development time is increased there will be an effective increase in film speed, but colour errors may also result, particularly with colour negatives. Colour transparency films can have their speed manipulated to some extent by altering the time spent in the first developer, but this is always accompanied by some sacrifice in colour saturation. Kodak recommendations for E6 process films are given in Table 5.2.

The decision to uprate a film must be taken before exposure. The whole film must then be exposed at the new film speed, and processed

Table 5.2. Modified processing with Kodak Ektachrome E6 process films to produce acceptable transparancies at other meter settings. Only first development times are altered. All other processing steps and times remain the same.

Camera exposure	Meter setting Ektachrome 64	Ektachrome 200	Ektachrome 400	Approx. time in first developer
2 stops under	250	800	1600	11 min 30 s
1 stop under	125	400	800	8 min
Normal	64	200	400	6 min
1 stop over	32	100	200	4 min

accordingly, as individual frames cannot be identified and processed separately.

Chromogenic black-and-white films are capable of useful changes in film speed. They give a final result that is a dye image, like a colour film, rather than a silver image as in a conventional black-and-white film. They can be underexposed by up to two stops and still give a good image with normal development, and capable of accepting meter settings of more than ISO 1600/33°. Tolerance to exposure is even greater. Although the density of the negatives increases, graininess actually decreases. The film may therefore be exposed at different film speeds depending on the graininess required in the final print.

Summary

Once you have found a particular film and processing combination for each of your requirements, for example, high-speed colour-transparency, medium-speed fine-grain black-and-white, etc., stay with it. You will get to know the individual characteristics of each of these combinations, and you will be able to use them far more effectively than if you are constantly trying out some new combination in the hope of stumbling on the perfect solution.

Remember that it is better to choose a film that has been designed for a specific purpose than to modify the processing of a different type of film in order to fit that purpose. Relying primarily on known and well-tried methods does not mean excluding all others. If you want different effects you may find a different combination more suitable, but do try out the technique before you use it in an unrepeatable situation.

As you become familiar with your own camera and range of lenses, see that you also become familiar with selected films and development techniques so that you will know how best to apply your total knowledge to the production of better photographs in any given conditions.

6

PHOTOGRAPHY IN BAD VISIBILITY

Causes of bad visibility

Nothing can spoil a dive as much as bad visibility. After hours of planning, travelling, kitting-up and a long ride in a boat, the discovery that the underwater visibility only extends to arm's length can ruin all enjoyment. But all is not lost: equipment and techniques exist which permit successful creative photography in all but the very worst visibility.

Even the cleanest water is not as clear as air. Water is 800 times as dense as air, and the water molecules themselves interfere with the passage of light through the sea. Even though visibility in air can extend for many kilometres, even in perfect conditions visibility underwater rarely extends to 100 m.

Dissolved or suspended particles and microscopic organic matter living in the water further interfere with light transmission. Conditions may sometimes be so bad that it is impossible to see beyond the faceplate of one's mask. In such conditions photography is obviously not worth attempting.

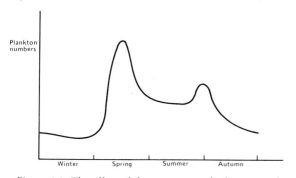

Figure 6.1. The effect of the seasons on plankton growth

Organic matter is one of the main causes of the reduction in visibility. The colder waters of the world are ideal breeding grounds for plankton, microscopic plant organisms that are at the start of the food chain underwater. Most of this plant life is found near the surface, as it needs to absorb solar energy in order to live. The numbers vary with the season and the local weather conditions (Figure 6.1). In the spring, the organisms multiply very quickly with the increasing hours of sunlight. This increase slows, then the number of organisms falls as summer approaches because of the lack of nutrients in the water. The warming of the surface water by the sun sets up thermoclines which limit the passage of nutrients from one water layer to another. Predators also increase as the plankton population increases, and make their impact on the population. In the early autumn the plankton population shows another increase. The thermoclines are broken up by rougher weather, allowing the supply of fresh nutrients. The numbers then begin to fall off again with the decreasing number of hours of daylight and the approach of winter.

Tropical waters have abundant sunlight all year round and it might be expected that they would have abundant plankton life and hence poor visibility. However, this is not the case, as the higher temperature keeps the thermoclines intact most of the year, denying the surface layers the necessary nutrients to support plankton growth, so that tropical waters remain clear.

Rivers are also responsible for cutting down visibility underwater; any coastal area or freshwater lake fed by rivers is likely to have bad visibility. Rivers constantly erode the land and deposit sediment when they reach the lake or sea. This sediment can then be picked up by tides or currents and transported many miles from where it was originally deposited. When a diver comes into contact with the bottom he may stir up clouds of heavier sediment, which take a long time to settle again, in addition to the lighter sediment already suspended in the water.

Industrial wastes, rotting vegetation, and turbulence which traps air bubbles, can also affect visibility. The problem is always greater in coastal waters than further offshore, but can never be predicted. Visibility at a given site can change from day to day, even from hour to hour. It can never be predicted accurately; only in tropical waters is it unlikely to cause problems to the underwater photographer.

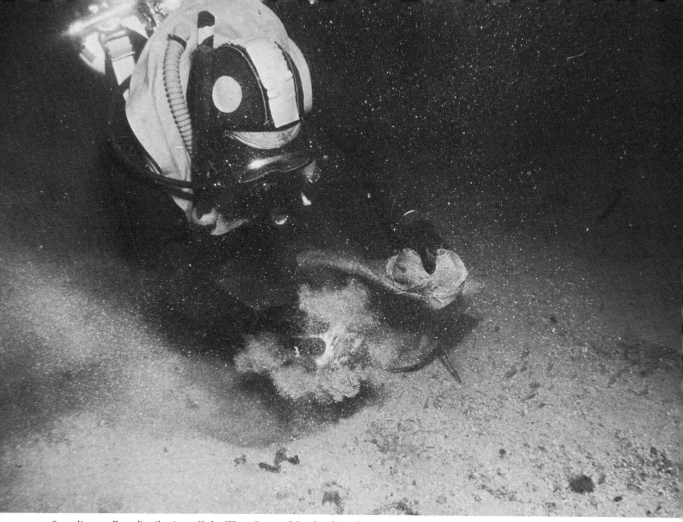

Sampling scallop distribution off the West Coast of Scotland. By keeping up-current of the diver any sediment disturbed does not greatly affect the photograph

Effects of bad visibility

In order to find a solution to the problems of photography in bad visibility, the factors that affect image quality under these conditions must first be considered. It has been shown (pp. 2–5) that light is scattered, reflected and absorbed, both by water itself and by the particles that are suspended in it. This has the effect of attentuating the imaging light and increasing the amount of stray light that reaches the film – the so-called flare – which degrades the optical image. The greater the number of particles suspended in the water, the more the imaging light is scattered, and hence the closer the subject needs to be approached in order to be seen clearly. This flare reduces the contrast

of the image as well as obscuring small detail. It is only necessary to compare two photographs of a landscape, one taken on a bright, sunny day and the other on a dull, cloudy day, to see which is more pleasing. The clouds diffuse the illumination in a way similar to water, and the resulting photograph is flat and lifeless.

The best solution to the problem is to replace the dirty water with clear water. On a small scale this can be done by attaching a cone of clear water to the camera lens (Figure 6.2). The dimensions of the cone, and thus the volume of water required to fill it, will increase with increasing angle of view of the camera lens and with increasing subject distance. A large cone will need to be rigidly constructed and will be heavy and cumbersome in use.

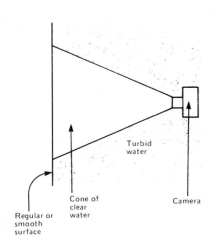

Front made of material to allow for some surface irregularity

Turbid water

Cone of clear water

Camera

Regular or smooth surface

Cone is filled with clean water. It needs to be of material strong enough to support the weight of the water contained out of the water

Fitting for camera

Figure 6.2. Principle of use of cone of clear water to overcome the effects of bad visibility

A further problem is in making contact with the subject. Unless this has a flat or regularly shaped surface, contact will not be easily made and dirty water will be trapped between camera and subject. This solution is thus applicable only to flat, smooth subjects viewed in small section.

With irregularly shaped subjects, and for those too big for the above method, the only solution is to build a habitat around the subject and to fill it with clear water (Figure 6.3). If the subject is small it may be possible to build the habitat in such a way that the camera is operable through its walls by means of suitably mounted heavy-duty rubber gloves. If it is large, or if the subject has to be photographed from many different angles, the diver will need to enter the habitat to achieve the desired results. The cost and the complexity of use of such clear-water habitats limits their use to commercial diving applications.

If dirty water cannot be replaced then its effect must be minimised. The only way to do this is to cut down on the water between the subject and the camera. By moving closer to the subject the contrast and detail will increase, although there will come a point where the field of view covers only a small part of the subject. Wide-angle lenses or lens attachments must be used to increase the angle of view to include the whole subject (Figure 2.5, p. 9).

Assessing the effect

To find the extent by which visibility affects photography, make some practical trials. Choose

a day when the visibility is moderate, say 3–4 m and a location with a sea bed where it is possible to dive without stirring up too much sediment. A location where there is a slight current is preferable as this clears any sediment that is disturbed. Ask your fellow-diver to stay at a convenient spot, then swim away to the limit of visibility, until only his form can be made out, without detail. Make a note of the distance. A tape measure held at one end by the subject will be helpful. Take a photograph from this distance, then move towards the subject, about 1 m at a time, taking further photographs and noting the distance each time. When you are 2 m away from the subject, decrease the interval to 0.3 m and continue to photograph until as close as possible. If conditions allow, carry out this trial by available light and with flash mounted both near and away from the camera. The processed photographs will form a series of decreasing subject distance. If all the exposures were correct, the quality of the results should improve with decreasing distance. Image contrast will increase and small detail become more apparent.

Carefully study the individual series and select the photograph in each case for which image contrast and detail first becomes acceptable. Express this distance as a fraction of the visibility. This figure will give a useful guide as to the maximum distance at which you can take satisfactory photographs in conditions of differing visibility.

A general guide is that available-light photography may be carried out at up to half, and flash photography at up to one-third, of the maximum visibility. If the flash is mounted away from the

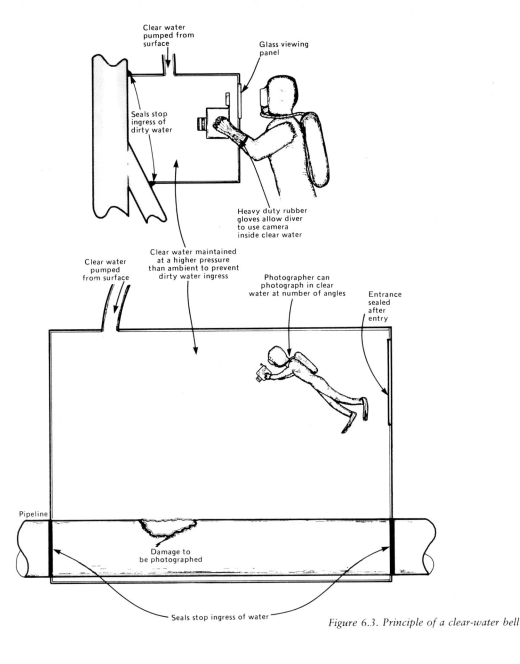

Clear water pumped from surface

Glass viewing panel

Seals stop ingress of dirty water

Heavy duty rubber gloves allow diver to use camera inside clear water

Clear water pumped from surface

Clear water maintained at a higher pressure than ambient to prevent dirty water ingress

Photographer can photograph in clear water at number of angles

Entrance sealed after entry

Pipeline

Damage to be photographed

Seals stop ingress of water

Figure 6.3. Principle of a clear-water bell

camera, rather than near it, better contrast and reduced backscatter will improve results. Establishing your own guide is not a waste of a dive. It provides a useful exercise in pre-dive planning, and in communicating with others underwater, as well as determining a valuable basis for underwater photography which may save you much film and disappointment later.

Wide-angle lenses and attachments

A wide-angle lens, or a lens attachment, is essential if large objects have to be photographed under conditions of poor visibility. A wide-angle lens gives the same field of view from close to the subject as a standard lens from farther away (see p. 9). The shorter the path of the light through the

water, the higher the possible quality of the result; but there are disadvantages. Wide-angle lenses are difficult to design and manufacture. Some of them are of very complex construction, particularly if well corrected. This increases the cost of such lenses, particularly as the angle of view of the lens increases. The greater the angle of views of a lens the more difficult it becomes to correct adequately. The most common fault associated with wide-angle design is *barrel distortion* (Figure 6.4). The image towards the edges of the frame is at a smaller scale than the image near the centre, so that a rectangular object produces an image that is distorted into a barrel shape. In certain lens designs there is no attempt to correct this; the image area on the film is circular, or the distorted image may fill the film frame. Such lenses are called respectively *fish-eye lenses* and *full-frame fish-eye lenses*. They can have angles of view up to 180° or more, and can prove very useful in photographing in extremely bad visibility, as long as the distortion they produce is acceptable.

Optical image

Broken lines show true shape of object

Figure 6.4. Barrel distortion

If wide-angle lenses are to be used successfully underwater, other problems associated with the design of the port in the housing, and their reproduction of the subject, must also be solved. Most housings or amphibious lenses have plane ports to protect the front lens element from water. Plane ports are easy to manufacture and are suitable for all lenses down to semi-wide-angle designs. Plane ports magnify the image by 1.33 when used underwater. This reduces the angle of view of a lens underwater by about 25%. It also affects the focusing scale of the lens correspondingly, the lens needing to be focused to three-quarters of the true

subject distance (see pp. 2–4). However, these figures are true only for light rays that enter the lens on or close to the lens axis. The further from the lens axis the light enters the optical system, the greater is the magnification.

←Optical image

Broken lines show true shape of object

Figure 6.5. Pincushion distortion

With anything other than superwide-angle lenses the light is not entering from a sufficiently large angle to make an appreciable difference to image quality. The extra magnification with superwide-angle lenses shows as *pincushion distortion* (Figure 6.5), and lateral chromatic aberration, which causes each colour of the spectrum to be imaged in a slightly different position. Objects are therefore imaged with a colour fringe, spreading from red on the inside to blue on the outside, the effect increases with increasing off-axis angle.

Dome ports

To correct for these defects, wide-angle lenses must be used behind a hemispherical or *dome port*. In principle, a dome port acts as a concave or diverging lens, producing a virtual image of the subject (Figure 6.6), on the water side of the port. A virtual image is one which cannot be fucused on a screen, but the camera lens can be focused on it to produce an image on the film. This necessitates focusing the camera lens so close that in most cases a convex supplementary lens is needed to maintain the full focus range. The power of the supplementary lens required may be calculated by the formula:

$$\text{Power in diopters} = \frac{1}{4R}$$

55

where R is the radius of the dome in metres. The power of the supplementary lens is independent of the focal length of the camera lens. A dome port gives perfect correction only with the lens it is specifically designed for. In some cases, a special correction lens is recommended rather than a simple supplementary lens.

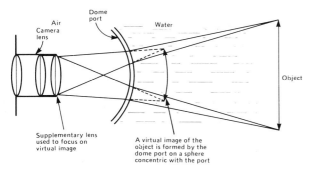

Figure 6.6. Optical principle of dome port

Dome ports have additional advantages. They restore the angle of view of a lens to approximately its value in air and, if the correct supplementary lens is used, allow the use of the original focusing scale of the lens for setting focus distances underwater. They are a very good and cheap way of achieving an acceptable degree of correction underwater with wide-angle lenses.

Optical ports

Another solution is to machine the front port of the housing in such a way that it restores the angle of view of the lens and provides optical correction. It is possible to do this for only one lens, so this solution is restricted to specialist applications. A very high level of correction can be achieved by this means but at considerable expense.

Ivanoff corrector

To try to provide a correction suitable for a camera taking a variety of lenses, the Ivanoff corrector was designed (Figure 6.7). The principle of this is as follows.

The port consists of two lenses. The first produces a virtual image which subtends the same angle at the camera lens as would the object itself if photographed in air, but this image is much closer to the camera than the object. The second lens allows the camera lens to photograph this

virtual image, and so the object is photographed exactly as it would be if it and the camera were in air. This ingenious design is expensive to manufacture and is used only for specialist cameras.

Water-contact lenses

Certain lenses designed specifically for underwater photography have their front element in contact with the water. These *water-contact lenses* give a very high degree of correction, but again are usually expensive. An example is the Leitz Elcan range of lenses. The 28 mm underwater Nikkor lens for the Nikonos is more reasonably priced.

Such lenses have the disadvantage that they can be used only for underwater photography and are, in general, reserved for specialist applications where the results justify the cost.

Lens attachments

To decrease the cost of underwater photography, a number of manufacturers have designed lens attachments which give a wide-angle effect when

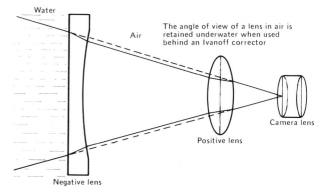

Figure 6.7. Principle of Ivanoff corrector

used in conjunction with a standard lens. These attachments are designed for use with the Nikonos camera (for other cameras, cheap wide-angle lenses are available for use inside housings). These attachments are of two main types; fish-eye and wide-angle.

Both types of attachment may be used with either the 35 mm or 28 mm underwater Nikkor lenses. With the 28 mm lens a wider angle of view is achieved with the wide-angle attachments, and the circular field of the fish-eye lens is reproduced smaller.

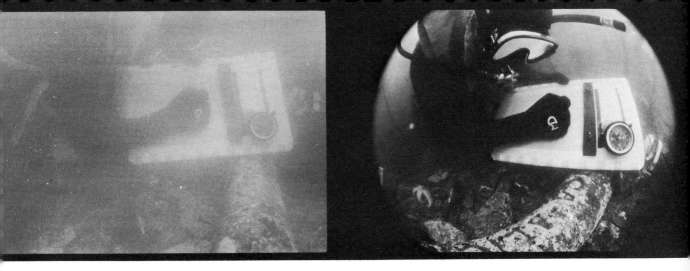

A wide-angle lens attachment can produce a photograph in conditions where a standard lens could not
Left: 35 mm lens at 2.75 feet *Right*: Vismaster fisheye at 1 foot (photograph courtesy of Geoff Harwood)

The disadvantage of using such attachments are twofold. Firstly, the optical quality can never be as good when using a lens attachment as when using a lens tailor-made for the purpose. The quality of such a device will, however, be adequate for most purposes. This is especially so if small lens apertures can be used. The second disadvantage is that the lens attachments require an exposure compensation to be made, usually of the order of 4× (or two stops). This limits their use in poor light.

Viewfinders

Wide-angle lenses cannot be used with frame viewfinders, as discussed on p. 35. It is often assumed with fish-eye and superwide-angle lenses that the angle of view of the lens is wide enough for the camera to be simply pointed in the general direction of the subject. However, few advanced photographers are satsified with so imprecise a method of framing. Some form of optical viewfinder is therefore required with all these lenses.

Perspective distortion

Perspective distortion is not a distortion in the optical sense. It is a consequence of the way the lens is used and the distance from which the resulting photograph is viewed. Perspective is the apparent relationship between the shape, size and position of visible objects. The eye judges the size of objects with reference to their perspective.

Consider the case when two objects of the same size, one behind the other, are viewed from the same position. The object that is farther away from the observer appears to be smaller, but the eye automatically makes an adjustment for the distances and separation; they are accepted as being the same size. Photography can distort the basic information that enables the eye to make this adjustment.

Figure 6.8. Dependence of perspective on viewpoint

$$\frac{ED}{AB} = \frac{DO}{BO} \quad \text{Therefore} \quad \frac{ED}{CD} = \frac{DO}{BO}$$

Hence the apparent heights of two objects are in an inverse ratio to their distances from an observer

Perspective changes with a change in viewpoint. This is illustrated in Figure 6.8. AB and CD are two objects which are the same size. O is the point from which they are observed. When viewed from O the apparent height of AB in relation to CD will be ED.

57

Since ABO and EDO are similar triangles

$$\frac{ED}{AB} = \frac{DO}{BO}$$

therefore

$$\frac{ED}{CD} = \frac{DO}{BO}$$

The apparent sizes of the objects will thus be in inverse ratio to their distances from the observer.

If the distance between the two objects is 10 metres and the distance from the nearest object to the observer is 10 metres, then the relative sizes of the objects will appear to be 1 to 2. If the observer moves to a point 90 metres from the nearest object the ratio changes to 9 to 10. If the objects are viewed from nearby, there will be a large apparent difference in their sizes; but this apparent difference decreases with increasing distance from the observer. From a nearby viewpoint perspective is said to be 'steep'; from a far viewpoint it is said to be 'flat'. Altering the distance from which a photograph is taken alters both perspective and image size. In bad visibility we need to move closer to the subject but keep image size constant by using a wide-angle lens. This introduces steeper perspective into the resulting photographs.

The only way to correct for this is to view the photographs in such a way that the apparent relation between objects as to their size, position etc., is the same as in the original scene. This necessitates viewing a contact print at a distance equal to the focal length of the taking lens and an enlargement at a distance equal to the focal length multiplied by the degree of enlargement. In most cases, especially with superwide-angle lenses, this is not practicable, and so perspective distortion is seen in such photographs.

Perspective distortion results in parts of the scene nearer the camera appearing larger than expected in relation to parts that are farther away. For example, a diver swimming away from the camera would appear to have enormous fins in comparison with the size of his body. The effect may be minimised by keeping the subject as nearly in one plane as possible. A different approach is to deliberately emphasise the distortion for visual effect, as was often done when superwide-angle lenses first appeared on the market, Above all, be aware of the effect, so that steep perspective will not ruin an otherwise perfect subject.

Lighting for bad visibility

Lighting must be very carefully controlled in conditions of bad visibility. Two main factors are involved: reducing the effects of backscatter and flare; and lighting the full field of view of a superwide-angle lens. Backscatter is manifest as numbers of tiny discrete point highlights in the photograph. It is caused by light reflected from large particles in suspension in the water; it can be particularly disturbing if the effect is spread over the whole frame. Flare shows itself as a general lack of contrast in the resulting photograph. It is caused by light reflected from much smaller and more numerous particles so that point highlights merge into an overall blanket of light. Flare is uniformly distributed over the format.

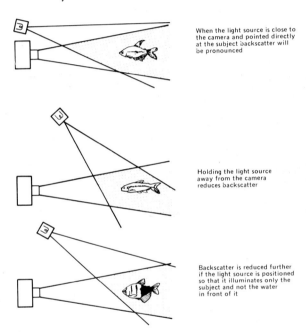

When the light source is close to the camera and pointed directly at the subject backscatter will be pronounced

Holding the light source away from the camera reduces backscatter

Backscatter is reduced further if the light source is positioned so that it illuminates only the subject and not the water in front of it

Figure 6.9. Effect of position of light source on backscatter

The effects of both backscatter and flare can be minimised by keeping the source of illumination as far away from the camera axis as possible (Figure 6.9). Most photographers tend to place it to the side, but as light naturally comes from above on both land and in water, lighting from above can give a more pleasing result.

It is important that the light is aimed at the subject. This is more difficult to achieve when the

Particles in the water illuminated by the flash spoil the reproduction of the subject. Keep the flash away from the camera axis and only illuminate the subject

source is remote from the camera; but it can be pre-set for a particular distance either before the dive or when safely on the sea bed. To shoot at variable distances, ask your fellow-diver to hold the light source in exactly the required position, leaving you to concentrate on the camera and subject.

The angle of view of the superwide-angle lenses can cause problems when it is necessary to photograph by artificial light. Only specialist underwater flash units have sufficient coverage to illuminate the whole of the field of view and multiple flash is usually essential to obtain uniform lighting.

Two-source lighting

Two matched light sources can be mounted one either side of the camera, to extend the field of view illuminated, without lighting the water in front of the subject by too large a degree (Figure 6.10). It is important that the light outputs of the two units do not overlap by too much, as if so, a different exposure will be required at the centre compared with the rest of the illuminated field (see pp. 29–30).

With continuous sources the accurate positioning of such units is more easily carried out than with flash as the illuminated area can easily be

seen. The positioning of flash units must usually be done by trial and error.

The use of two light sources in this manner requires careful preparation and a well-designed handling system. Although it can produce better results than a single light source of large angle of coverage, it is difficult to use effectively in practice.

This type of lighting should not be confused with the occasions when two lights are mounted in a similar fashion, say for movie photography. In this case, the light outputs are purposely overlapped to obtain more light rather than a uniform distribution of light over a large area.

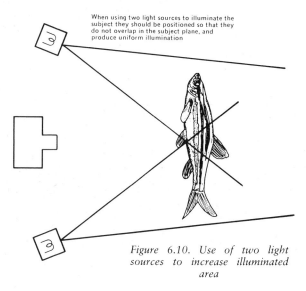

When using two light sources to illuminate the subject they should be positioned so that they do not overlap in the subject plane, and produce uniform illumination

Figure 6.10. Use of two light sources to increase illuminated area

A single light source cannot illuminate the field of view of a superwide-angle or fish-eye lens. The greatest effective angle of illumination that can be expected from a single source is about 90°, with the light spreading in a circular cone. Even at this angle the reflector has to be designed in such a way that more light is provided at the edge of the cone that in the middle, to avoid variation in exposure over the field of illumination.

Other solutions

Two alternatives to the use of multiple lighting exist. Provided there is enough available light for photography, fill-in flash can be used, with the light source illuminating only the central area of the subject. This is particularly effective in colour photography, as the central subject appears in full

colour surrounded by the blue of the sea. The second technique is to connect a number of flash-bulbs without reflectors. When these are fired they will illuminate the whole surrounding area uniformly. However, with this method much of the light is wasted. The exposure, and the effect produced, is largely a matter of trial and error; but the technique does permit photography in conditions that would otherwise make it impossible.

Diving practice

If wide-angle lenses are not available, close-up photography is nevertheless still possible. The poorer the visibility, the closer the subject has to be. Often bad visibility may force you to investigate subjects you would not otherwise have considered worth photographing.

When photographing on a sea-bed where it is easy to disturb the sediment and reduce visibility, plan the dive so that you swim into any current. The current will then remove any sediment, and you will be swimming constantly into clear water. Swimming into the current at the start of the dive is also good diving practice. If air runs short, or you become tired towards the end of a dive, it is far easier to return to the exit point of the dive with the current than against it. Always keep a close watch on your fellow-diver. He will have to keep close to you in order to keep you in view if the visibility is bad; and you always need to know where he is if you need assistance. Try to keep him down-current of yourself, so that he does not disturb sediment ahead of you and make photography impossible.

A short line connecting you with your companion can alleviate problems caused by his trying to keep you in view when the visibility in poor. A photographer needs space in which to operate, and can easily be disturbed by his fellow-diver constantly bumping into him. Keep the line fairly short, no more than five metres, to avoid snagging and tangling. It should not be tied on, but should have a quick-release fitting at either end for emergency use. The non-photographing diver should be made responsible for ensuring the line does not snag. He should keep slack in his hand, and be able to feel (but not restrict) the movements of the photographer, if he cannot see him.

It is very easy to become confused in bad visibility. Experience is necessary before diving in such conditions, to avoid a feeling of panic at becoming lost, disorientated or losing contact with

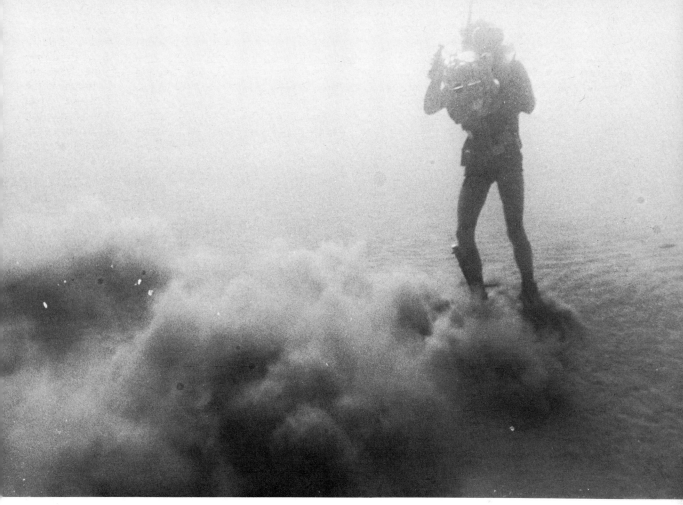

When photographing near to the sea bed be careful not to disturb any sediment

your fellow-diver. Take care that all safe diving practices are observed by both or you.

Summary

Bad visibility makes photography more difficult, but need not ruin all picture-taking opportunities. The use of wide-angle lenses and the choice of photographing only in close-up give ample opportunity for obtaining creative results.

Be aware of perspective distortion when using superwide-angle lenses; use them instead to your advantage. Above all, do not be put off a prospective dive simply because of bad visibility. The subjects are still there, if you approach their photography in the correct manner.

7

CLOSE-UP PHOTOGRAPHY

Coastal waters seldom have sufficient clarity to enable large underwater panoramas to be seen, let alone be photographed. Indeed, it is often difficult enough to keep a fellow-diver in sight without continually swimming with him like a remora with a shark. This situation can have advantages, however, as the underwater photographer must approach his subjects more closely, and so will realise that the sea contains many minute creatures and organisms that themselves make fascinating photographs.

Close-up photography is not limited merely to conditions in which the visibility is bad. Tropical waters offer countless subjects, especially in the vicinity of coral reefs. Subjects are often so well camouflaged that they can be seen only after they have made a slight movement or when the eye has become properly trained to pick them up. Stay in one position and watch – you may use up a complete film before moving on!

The techniques of close-up photography are straightforward. A novice with simple equipment will be able to achieve impressive and reproducible results because the main problems of underwater

Figure 7.1. The fitting of an extension tube, complete with framing attachment, to an amphibious camera will allow photography at close distances

photography, those of obtaining correct focus and exposure, are easily overcome. Even the technique of lighting becomes more simple as the area to be illuminated becomes smaller and closer to the light source. Very few cameras focus close enough with their ordinary lenses to be capable of taking close-up photographs. The standard lens of 35 mm format cameras usually focuses down to about 0.6 m to give a reproduction ratio of about 1:10.

The reproduction ratio is a comparison of the actual size of the object with the size it is reproduced on the film. For example, a reproduction ratio of 1:1 would reproduce the subject life size on the film, 1:2 half life size and 1:10 on tenth life size.

To reproduce a subject larger that at 1:10, it is hence necessary to use a close-up lens, extension tubes or bellows although the latter solution is not often used underwater except with certain specialist cameras in which bellows are an integral part of the focusing system.

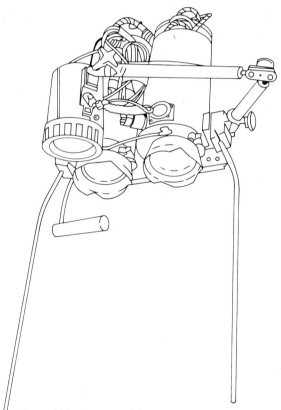

Figure 7.2. Two amphibious 70 mm cameras are mounted together for stereo photography. The probes indicate the correct focus and field of view and the cameras are triggered by means of the remote lead and trigger shown in front of the cameras. Such a system is in common use offshore

Close-up lenses

Close-up lenses are simple positive lenses, attached to the front of the prime lens. The converging power of each lens is normally given in *diopters*, i.e. the reciprocal of the focal length of the lens in metres. For example, a positive lens of focal length 0.5 m would have a power of 2 diopters (expressed as +2); a lens of focal length 0.2 m would have a power of 5 diopters (expressed as +5). The higher the number of diopters, the more powerful is the lens and the greater its ability to produce a closer plane of focus.

The close-up lens reduces the focused distance, so that the focusing scale is no longer appropriate. If the camera lens is set to infinity then the close-up lens reduces the plane of focus to the equivalent of its focal length. With a 2-diopter lens, for example, the focus becomes 0.5 m. As the the camera lens is focused closer, the plane of focus is brought closer still to the camera; the exact distance can be found with reference to tables that accompany the close-up lens when purchased. The effect of the close-up lens on the camera lens is independent of the focal length of the latter.

A second, and even third, close-up lens can be added to the first. The use of two or more lenses has a cumulative effect, and the focused distance achieved is based on the sum of their individual powers expressed in diopters. If a 1-diopter lens is added to a 2-diopter lens, the combination will act as a 3-diopter lens. The optical quality of the combination is inferior to that of a single, more powerful, lens. More than one lens may cause the corners of the picture to be cut off. If a combination of lenses has to be used, the most powerful of them should be mounted next to the camera lens.

Close-up lenses are an easy and cheap means of extending the versatility of a camera without affecting its operation. Their major disadvantage is that they adversely affect the optical performance of the camera lens to which they are attached. This effect increases with increasing power, so that the closer one wishes to photograph, the poorer the optical performance becomes.

It should be pointed out that all focus distances should be referenced and measured to the film plane and not to the front of the lens. A film plane marker will be found on most advanced cameras and ensures a stable reference point independent of lens design, focusing mechanism or accessory lens from which to measure the plane of focus. In the absence of a marker, measure from the back of the camera.

Extension tubes and bellows extensions

Extension tubes and bellows extensions are fitted between the camera body and the lens, effectively extending the focusing mount of the lens and so allowing it to focus closer. Bellows can be adjusted over a wide range. They are used infrequently underwater because their physical size is difficult to accommodate in a housing and they cannot be used with an amphibious camera. Optically they operate in the same way as extension tubes, so the use of both can be dealt with together.

The reproduction ratio or magnification that is achieved is a function of the length of the extension tube and the focal length of the lens. It can be expressed by the following relationship:

$$M = \frac{X + f}{f} - 1$$

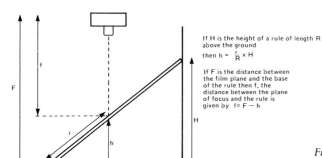

If H is the height of a rule of length R above the ground

then $h = \frac{r}{R} \times H$

If F is the distance between the film plane and the base of the rule then f, the distance between the plane of focus and the rule is given by $f = F - h$

Figure 7.3. Finding the plane of focus of a close-up system underwater

where M is the magnification, X is the length of the extension tube, f is the focal length of the lens and both x and f have the same units.

For example, if a 10 mm extension tube were used with a 50 mm lens the magnification would be

$$M = \frac{10 + 50}{50} - 1 = \frac{6}{5} - \frac{5}{5} = \frac{1}{5}$$

The subject would be reproduced 1/5 life size or with a reproduction ratio of 1:5.

Exposure compensation

Although it is simple to take close-up photographs with the use of extension tubes they do have the disadvantage that they affect the exposure. If the exposure is measured with a through-the-lens metering system, then there will be no problem, but if an external light meter or flash is used then exposure compensation will have to be made.

The exposure compensation necessary can be expressed as an exposure factor which can be applied to either aperture or shutter speed. The exposure factor is given by:

$$E = \left(1 + \frac{X}{f} \right)^2$$

where E is the exposure factor, X is the extension, f is the focal length of the lens and both X and f are in the same units.

For example, if an extension of 50 mm were used with a 50 mm lens, then the exposure factor would be:

$$E = \left(1 + \frac{50}{50} \right)^2 = 4$$

In use the aperture would have to be opened up by two stops to let in four times as much light or the exposure would have to be increased by four times. For example, 1/125 to 1/30 second.

It is probably that, in making these calculations, the values arrived at are intermediate between the shutter speed or aperture values marked on the camera. While intermediate apertures can be set this is not usually the case with shutter speeds. In most situations underwater, the shutter speed will be dictated by the need for flash snychronisation and so it is more usual to make adjustments to the

aperture. Most lenses can be set only with an accuracy of half a stop and so all figures should be rounded up or down to the nearest half stop. The exposure latitude of the film will be more than sufficient to make allowance for this.

Exposure factors for a number of commonly encountered lens/extension tube combinations are given in Table 7.1. They assume that the lens is set to infinity.

Table 7.1. Exposure factors for a number of commonly encountered lens/extension tube combinations. In all cases it is assumed that the camera lens is set to infinity.

Size of extension tube (mm)	Focal length of lens (mm)			
	28	35	50	80
10	1.8	1.6	1.5	1.3
15	2.3	2.0	1.7	1.4
20	2.9	2.5	2.0	1.6
25	3.6	2.9	2.3	1.7
30	4.3	3.5	2.6	1.9
35	5.0	4.0	2.9	2.1
	Exposure factors			

When using extension tubes or bellows, it is best to set the prime lens to infinity and to rely solely on the extension to obtain the necessary focus. This is because most lenses intended for general photography are computed to given their peak optical performance at infinity and setting them to a closer focusing distance reduces this performance. Focusing them closer also adds to the extension and so could affect exposure at close distances, even through the effect is negligible at normal taking distances.

Cameras functions could also be affected by the use of extension tubes not specifically intended for the camera and lens in use. The correct function of modern cameras depends on a series of pins, protruding from the lens mount, mating with their camera body equivalents. These control, for example, the stopping-down of the aperture from viewing to taking aperture and given essential exposure information to a built-in through-the-lens exposure meter, such as the maximum aperture of the lens and the aperture that it is actually set to. Extension tubes or bellows can interrupt this exchange of information. Consult the

*Above – Fish are one of the brightest underwater subjects. In clear water flash leaves this fine specimen standing out against a dark
 ground*

Over page, left, top – Static marine life is often highly coloured, offering a myriad of subjects in shallow dives

 bottom – Bottom-dwelling fish often stay still, camouflaged to all but the keenest eye

*Over page, right, top – Working close to the sea bottom allows fish and their surroundings to be illuminated as brightly, showing the
 animal in its natural surroundings*

 bottom – Corals and other static animals can form a camouflage even for a colourful fish

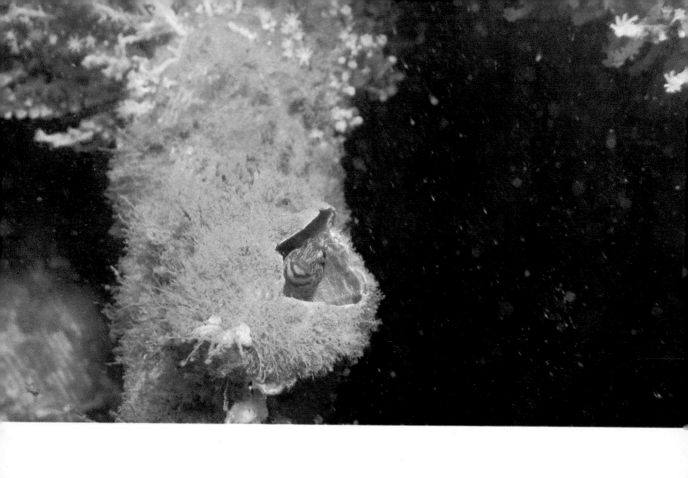
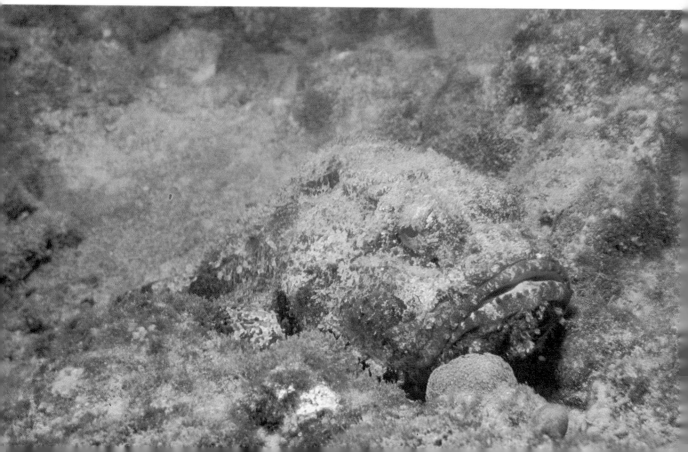

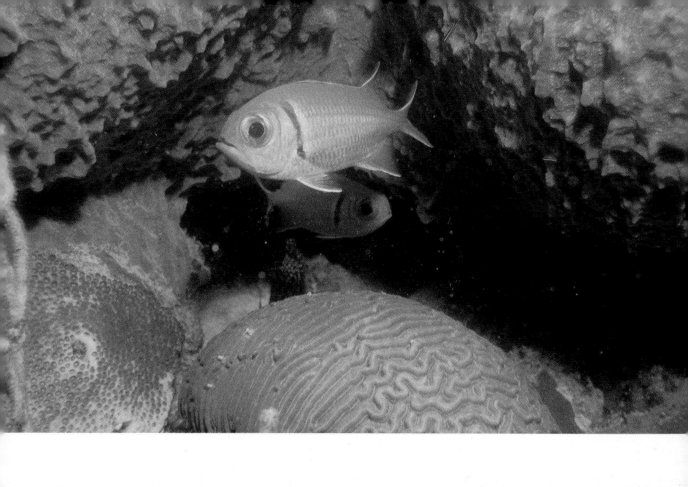

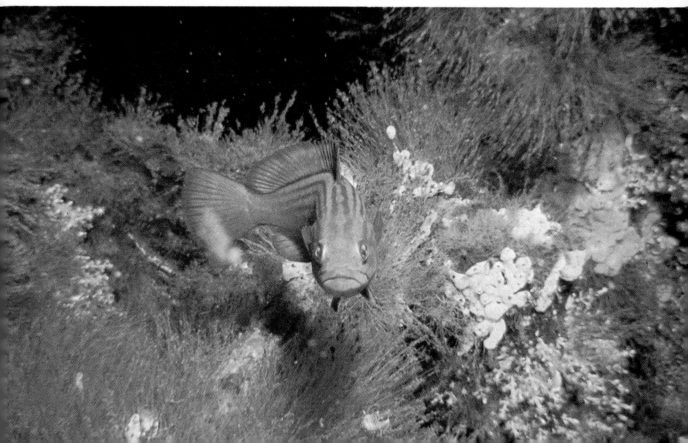

Above – Working divers often encounter murky conditions. The water diffuses light to give an overall hazy effect

Opposite – Close by with bright lighting, the diver stands out starkly as he measures the thickness of a steel support with an ultrasonic probe (Seaphot)

Over page, left – Divers and marine life can mix, but take care that you can keep clear of any potential trouble (Seaphot/Peter Scoones)

right – A wide view, with the sun above, can create a special underwater feeling (Seaphot/Peter Scoones)

Next page – Water/air surfaces reflect light below as well as above. Careful positioning creates a surreal effect (Seaphot/Peter Scoones)

manufacturer's instruction manuals to confirm that the combination that you wish to use will function correctly. Note that, if the extension tube or bellows mates correctly with the metering system in a camera, through-the-lens metering takes all extensions into account directly.

Macro lenses

Macro lenses have extended focusing mechanisms and can focus from infinity to a reproduction ratio of 1:2 in one continuous movement. Where this is the largest scale required, the use of a macro lens obviates the need for extension tubes and gives great versatility. They are designed to give their best optical performance when focused on comparatively short distances.

Macro lenses are available for many cameras intended for land use, although they tend to be of standard or long focal lengths. This means that they are not particularly suitable for general underwater photography, although the necessary longer stand-off for a given magnification can be useful in close-up situations as lighting can be more easily positioned, and sensitive creatures photographed without undue disturbance.

Close-ups with the Nikonos camera

Many close-up accessories have been designed for the Nikonos in addition to the close-up outfit marketed by Nikon itself. All of them employ a *stand-off frame* which establishes both the plane of focus and field of view. As the Nikonos does not have through-the-lens viewing, parallax is a major consideration in close-up photography. In addition, the closer subject distance means less depth of field and more critical focus. The use of a stand-off frame overcomes both these problems, as well as indicating the field of view precisely.

The Nikon close-up kit consists of a high-quality, twin-element close-up lens which can be attached to the 28 mm, 35 mm or 80 mm underwater Nikkor lenses. The close-up lens mounts directly onto the camera lens in such a way that water floods the space between them. It cannot be used with the 15 mm underwater Nikkor lens because the physical dimension of the lenses are incompatible. In any case, the 15 mm lens focuses down to 30 cm without supplementaries.

The effect of a close-up lens on focus is independent of the focal length of the camera lens. With the Nikonos close-up outfit the planes of focus will hence be identical if the close-up lens is used with any of the three lenses it is designed for, provided all three lenses are focused on infinity. When the lens is focused on infinity, the plane of focus is indicated by a stand-off rod which protrudes from a fixing point on the underside of the close-up lens.

Although the plane of focus is identical for all three lenses, the field of view is not; the longer the focal length, the greater is the magnification. Thus the field of view increases with decreasing focal length of lens. The field of view given by each lens with focus set to infinity is:

80 mm	55 × 79 mm
35 mm	109 × 164 mm
28 mm	144 × 216 mm

A frame is fitted to the end of the stand-off rod to indicate the field of view. To avoid mistakes, each frame is marked with the appropriate focal length of lens.

A further rod, attached to the camera accessory shoe, allows the system to be clamped rigidly in place. The whole unit may be attached and detached underwater, allowing a choice of close-ups or general photography in the same dive.

Similar accessories are made by different manufacturers; these usually have a fixed frame to indicate the field of view and thus can be used with only one lens. They often have the additional disadvantage that they cannot be dismantled for transport.

Close-up lenses for the Nikonos have the advantage that they can usually be attached and detached in the water, although you should ensure there is a facility to equalise the pressure between the camera lens and the supplementary. If not, then the close-up lens must be attached at the depth that it is desired to be used at, and removed whenever changing depth. Such lenses have the disadvantage that they cannot give a very great magnification, and degrade the optical performance as the magnification increases.

Calibration of close-up attachments

Although it is possible to fit simple screw-on close-up lenses to the screw mount on the front of the underwater Nikkor lenses, this is not to be recommended without taking into account two important factors. The first is simply that if the lens is attached on the surface no water will be

able to flow between the camera lens and the supplementary lenses, and there will be a risk of implosion, or at the very least of cross-threading the supplementary lens, when it is subjected to pressure. This can be overcome by mounting and removing the lens at the depth photography is to be undertaken. Alternatively, the Nikon underwater 35 mm lens hood can be used, as this has a screw thread for mounting other accessories while allowing water to flood the space behind them.

The second factor is less simple. The power of a close-up lens is given assuming that it is to be used in air. Because water has a higher refractive index than air, the power of the lens is reduced by a factor depending on the refractive index of the glass. In general it is reduced to about a quarter of its original power. For example, a 2-diopter lens becomes only 0.5 diopter underwater, thus focusing on 2 m rather than the expected 0.5 m (with the camera lens set to infinity).

Finding the plane of focus

The best way to ascertain the precise plane of focus is to take a photograph of a rule or other scale. Estimate the approximate plane of focus by assuming that the power of the lens or lens combination has been reduced to one-quarter of its nominal value. If the camera lens is set to infinity, the lens combination will now be focused on a distance equal (in metres) to the reciprocal of the revised power of the lens in diopters.

Set up a rule or scale with accurately defined markings underwater (Figure 7.3) and move the camera to the calculated distance from the centre of the rule. Remember to measure to the film plane marking on the camera to ensure reproducible results. Use the largest possible aperture, to give the smallest depth of field, for more easily interpreted results. Repeat for different focus settings if required. Always remember to record all settings and subject distances. You will not be able to analyse the developed photographs without all the relevant data.

The results should show a small portion of the rule as sharp. If this sharp portion is the one that the camera was centred on, then the calculations and lens settings are correct. If it is nearer than this, then the accessory lens is more powerful than predicted and so will focus closer than calculated. If it is farther away, then the accessory lens is less powerful and will focus farther away than calculated. For the exact distance, look for the centre of

the sharp zone of focus, and measure the vertical distance from this to the film plane. If this distance is always used, say by attaching a rod to the accessory shoe of the camera, focus will always be correct.

By photographing a test chart underwater, you can also ascertain the field of view at this distance, and build probes or a frame to indicate this in subsequent photographs.

If you use simple screw-on close-up lenses, you will probably need to use a combination of these to restore the power lost by using them in water rather than air. Do not forget to allow for pressure compensation between them, as well as behind them, to mount the most powerful lens nearest the camera lens and to beware of vignetting.

Extension tubes

Tubes are also available for the Nikonos. Most are designed to be used only with the 35 mm underwater Nikkor lens as this gives the best compromise between reproduction ratio and ease of use in the water. As with the close-up lenses, these extension tubes are also fitted with framing devices and probes to overcome focus, parallax and viewing problems. They have the disadvantage that they cannot be attached or removed underwater. Once fitted you are committed to photographing only in close-up. Remember, too, that they are an integral part of the pressure housing and have to have their own O-ring seals. Do not be tempted by cheaper versions; a cheaper tube could cause a flooded camera, which would nullify the initial saving. Extension tubes allow for photography at higher magnifications but only with commitment to close-up photography for the whole dive.

Cameras in housings

SLR cameras can be adapted very easily for close-up photography. A close-up lens or extension tube may be fitted inside the housing and the field of view and focus can be seen by viewing through the camera. When purchasing extension tubes check that there is enough space inside the housing to allow them to be attached. With some housings it is possible to purchase extension ports to allow for the fitting of extension tubes or the enlarged focusing movement of a macro lens.

When using a SLR camera in the close-up mode, the technique for focusing is different. Rather than

Underwater photography plays an essential role in the inspection of offshore oil and gas installations. The weld has been marked out so that any items of interest can be readily relocated (photograph courtesy Sub Sea Offshore Ltd.)

looking through the camera and altering the focus control until the image appears sharp, you should pre-set the focus to the desired scale and then move the camera back and forwards, about the estimated focus position, until the image appears at is sharpest. This is because it is difficult to judge focus exactly in poor light.

The ideal solution for close-up photography with a SLR is a macro lens. It is unfortunate that wide-angle macro lenses are not manufactured because of the expected low volume of sales relative to other lenses in the manufacturing range. Even so, a camera fitted with a macro lens approaches the versatility of choice of the Nikonos fitted with close-up lens which is detachable in the water. The Nikonos has the advantage that the lens will be of a wide-angle design while the macro lens has the capability of focusing nearer. The choice is dependent on the subject to be photographed and personal preference.

Twin-lens reflex designs overcome some of the problems inherent in close-up photography by providing a pair of supplementary lenses of each power, one each for the taking and viewing lenses, inside the housing. These lenses are often mounted on a sliding mount so that they may be positioned over the camera lenses or moved to a storage position by an external control. The camera can therefore to used for both general and close-up photography on the same dive.

Photography is used offshore to ensure that pipeline connections have been correctly installed and are in good condition (Photograph courtesy of Sub Sea Offshore Ltd.)

A stereo pair of corrosion in a weld taken with photogrammetric cameras. The markings on the photographs are caused by a reseau plate mounted in the cameras. Using photogrammetric techniques the defect was able to be sized in all three dimensions to an accuracy of 0.1 mm

Although such designs overcome the problems of focus and field of view, that of parallax still remains.

Bellows often cannot be used inside a housing because of their physical size. However, some cameras have a bellows mechanism built into the camera body behind the lens mount. The lenses intended for use on such cameras have no focusing mount, as they are focused by means of the bellows. Extended close focus in thus possible without the addition of any attachments. This method provides a compact and versatile solution to the requirements of close-up photography underwater.

Other cameras in housings are more difficult to adapt for close-up photography. If they do not have interchangeable lenses, only close-up lenses can be used. If the camera does not have through-the-lens viewing, then focus, parallax and the indication of the field of view also cause difficulties. Home-made stand-off probes or frames will have to be made, usually by trial and error, to ensure consistent and reproducible results underwater. In general such cameras are not suitable for close-up photography.

Summary

A camera fitted with probes to establish the plane of focus and field of view can have many advantages. It is quick and easy to use and can easily be positioned in areas of difficult access where it may be impossible to see to focus through the lens. The camera can also be used more easily with one hand, even at arm's length.

Fish and other small creatures are sometimes not as frightened when a camera fitted with probes is pushed towards them as when the camera is closely accompanied by a large, bubble-blowing diver. A SLR system does, however, have the advantage that its positioning is not restricted or obstructed by the probes and, if a macro lens is used, it may be used at a variety of different distances. The advantages and disadvantages of the two systems are evenly balanced in practice and a choice can be made only according to the individual tastes of the photographer.

Lighting for close-up photography has not been discussed, as it will be dealt with in Chapter 9. Artificial illumination is essential for most close-up applications, to ensure the subject may be photographed with adequate depth of field and also because, while a blue cast can be acceptable for some general photography, it is not acceptable for close-up photography.

With the correct equipment close-up photography underwater is both simple and effective. The range of subjects available in waters of even the worst visibility makes the technique popular and rewarding. It is a technique that the most inexperienced of underwater photographers can quickly master and can use to produce impressive results.

8

PHOTOGRAPHING DIVERS

This chapter and the following two are concerned with the practical aspects of underwater photography. A number of different subjects and approaches to these subjects are introduced, in such a way as to simulate the pre-dive planning and equipment selection that form the basis of any serious underwater photography. In each chapter the subjects are presented in order of complexity and so offer a convenient course whereby you may familiarise yourself with various aspects of underwater photography, and should be confident of achieving results at each stage.

Vision

Certain aspects of diving are applicable to all categories of subject. The most important of these is how a diver sees underwater.

Walking along, a person tends to look principally at what is directly in front of him (Figure 8.1). Although his central vision extends ahead, his peripheral vision extends to a very large angle at the sides, above and below. If an item of interest enters this field of vision, he rotates his eyes or head in order to investigate. Underwater, things

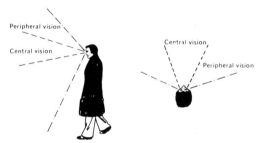

Figure 8.1. When holding his head in a natural orientation a walker normally looks straight ahead

are different. In water, the orientation of the body differs from that on land. Instead of being upright, a diver's body is very nearly horizontal so, if he were to hold his head in the same orientation as on land, he would be looking predominantly downwards (Figure 8.2).

When wearing a mask underwater the effect of refraction is to cut down the main field of vision by 25% and effectively remove much peripheral vision. The constraints of equipment make head movement more difficult, and eye movement is restricted by the angle of view allowed by the

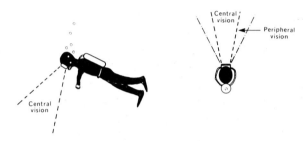

Figure 8.2. When underwater the main field of vision is downwards. The area of main vision is reduced by refraction and the area of peripheral vision is reduced both by refraction and by the mask

mask. When diving the view is reduced to a kind of tunnel vision. This is not in itself a restriction, as a diver can move his body extremely easily underwater. What is important is that vision is largely downwards. A diver tends to look constantly at the sea bed in front of him and miss subjects above or level with him.

How often, when you were learning to dive, did you hear experienced divers talking of what they had seen underwater, when you thought that the sea bed had been barren? This was because they had learnt to see in a different way when underwater. Experienced divers do not swim aimlessly over the sea bed, but stop, change their orientation, investigate areas of interest and move on to find others. Many sea-creatures are to be found living under overhangs and among rocks and will be missed by a diver swimming overhead. Rock arches and natural formations of seaweed or other marine growth offer ideal settings for photographing divers. Learn to look for such things, swim amongst the weed and rock formations on the bottom and as you start to see more interesting

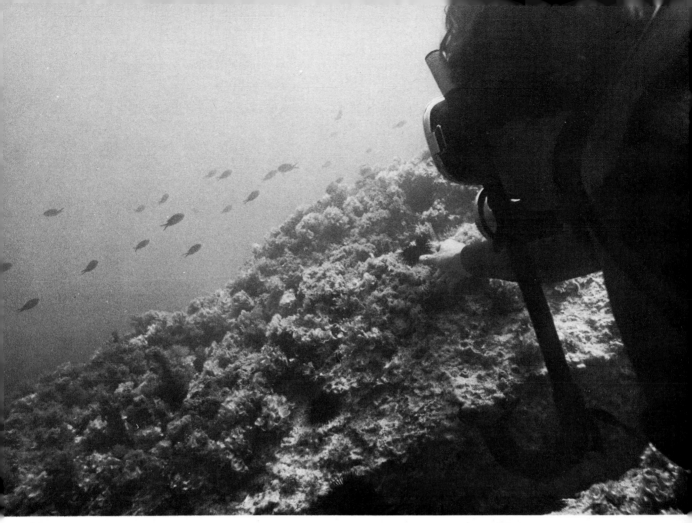

Photographing over a diver's shoulder can lead to variations in the photography of marine life. In this case the diver attracts fish with food

subjects so will your photography become much more successful.

Composition

Composition in photography is a large subject. To study it fully you need to refer to specialist works; but the application of certain simple rules will enable you to present your subject matter and its environment in a harmonious balance.

A good photograph should have a recognisable subject. Its purpose should be to show that subject in the best possible way. A photograph of a coral reef is almost always improved by the inclusion of a diver or brightly coloured fish; but this does not necessarily mean that the subject should dominate the background. A pleasing balance should be reached, and only you can be the judge of this.

One of the most common faults is to fail to use the whole of the film area available for the composition. It may be that you are not approaching the subject closely enough, or possibly that you are framing it incorrectly. The difficulty of framing underwater with cameras other than SLR types accentuates this problem.

Beginners often place the subject matter squarely in the centre of the frame which makes for uninteresting photographs. Where possible, use the *rule of thirds* in composition. This is a simple principle whereby four imaginary lines are drawn on the film to divide it into thirds both horizontally and vertically (Figure 8.3). If the main point of interest in the subject is placed on one of the four

points of intersection of these lines, the resulting composition will be pleasing to the eye. This principle originated in the art of ancient Greece, and it has stood the test of time.

Compose the photograph so as to draw the viewer's attention to the point of interest. In Western culture we read from left to right and from top to bottom; subconsciously we tend to scan a photograph in the same way. A photograph in which the main point of interest is at the intersection of thirds in the bottom right-hand corner will appear more stable than if it is at any of the other positions, as it is here that the eye tends to comes to rest when scanning a picture. If the subject is placed at the top left-hand intersection the photograph will appear more dynamic, as the eye will reach this point quickly, then move away to consider the rest of the photograph in its normal scanning manner.

Figure 8.3. Area with the same proportions as the 35 mm format divided according to the rule of thirds

Do not allow the eye to be drawn out of the picture. A diver looking at a subject outside the field of view will draw the eye away from the content of the photograph in the direction in which he is looking. Similarly, a fish moving out of the picture will lead the eye out in the same direction. Always allow plenty of space in front of any moving subject.

Balance the photograph by positioning minor subjects so as to complement the position of the main subject but not detract from it. Natural rock arches, plant and fish life all add to a composition and build up the impression of unity and atmosphere.

Although human perceptual processes concentrate on one subject at a time, the background or other contrasting subject being more or less ignored, the camera cannot do this. No doubt you will have seen beginners' efforts where the photographer has been engrossed in the subject to the exclusion of the background, resulting in telegraph poles growing out of people's heads or rivers flowing in one ear and out of the other. Train yourself to consider all objects within the field of view of the camera lens, and compose the picture in such a way as to use them to complement, rather than distract from, the subject.

A photograph of a diver in very clear water can easily give the impression that he is really on land. The bubbles formed when air is exhaled can be used to indicate that this is not so. Most photographs of divers are improved by showing the bubbles; however, it is important that they do not hide any subject detail. It is best to wait until near the end of the exhalation before making the exposure.

Preparation

Before diving to photograph a particular subject, you should be familiar with all camera controls and functions and be able to use them without looking at them (remember that although it is necessary to concentrate on taking photographs, you should not do so to the exclusion of normal diving safety procedure). You should have carried out a full set of tests to establish the guide number of the flash underwater, its angle of coverage, the effects of parallax and of visibility on the general quality of the photograph. Confidence in the use of the camera, and familiarity with its performance, will enable you to devote more time to the creative possibilities of photography underwater.

Make sure that your fellow-diver is correctly and tidily dressed. An old or frayed wetsuit, rusted air cylinders, straps that are too long or loose, or a harness that does not fit properly, will spoil what would otherwise have been an excellent photograph of him. Black wetsuits do not photograph well, but if your subject has no other the application of coloured tape to the seams will help. Make sure that all your diving equipment is suitably prepared and in good order. An incorrectly adjusted harness or uncomfortable backpack can be a nuisance and possibly a danger, and will certainly distract your attention from the project. Ensure your buoyancy control apparatus is working efficiently. All underwater photographers should be masters of buoyancy control, as its correct use enables mid-water positions to be held without effort, reducing physical exertion and lessening the risk of stirring up sediment.

Five projects

Divers can be photographed in a wide variety of situations with even the simplest photographic equipment; they offer one of the best ways to start off your underwater photography. A good fellow-diver will always be helpful and cooperative, particularly if he gets prints of all the best shots!

Each of the following projects in this and subsequent chapters is laid out in four parts; objective, location, equipment and discussion. The *objective* specifies the desired result. The *location* specifies the type of area where the objective is likely to be most readily achieved. The *equipment* is the minimum needed to achieve the objective. The *discussion* outlines subject possibilities, areas that can be investigated and difficulties that have to be overcome. To be of value, the projects need careful thought in both planning and analysis of the results. The projects are graduated in difficulty, beginning with the easiest. Even if you have had some experience of underwater photography you may still find the easier projects rewarding. You can carry them out in either black-and-white or colour.

Half-figure photographs

Project 1

Objective

To obtain half-figure photographs of a diver by available light.

Location

This must be in shallow water. Choose an area where the scenery is interesting and the water is calm and unaffected by strong currents. A bright, sunny day is preferable, as the extra light in the water will allow more flexibility with shutter-speed/aperture combinations.

Equipment

Almost any equipment is suitable. As all your photography will be from fairly close to the diver, visibility need not be very good. However, the camera lens must have an angle of view sufficiently large to include the half-figure of the diver if poor visibility compels you to go in close. If the camera has interchangeable lenses, a 35 mm lens (for the 35 mm format, or equivalent for other formats), is most suitable if visibility permits. It will allow sufficient stand-off to avoid disturbing the subject, while still giving an adequate angle of view for this particular treatment, and the results will not exhibit perspective distortion.

Discussion

Using the camera on its own, without having to worry about artificial light, will allow familiarisation with its use to be achieved more quickly. Any problems encountered in handling or operation will be more easily recognised and pinpointed. Photograph in shallow water, as long as you are not buffeted by wave action or currents, as this will ensure a higher intensity of ambient light, and more colours present in the resulting photographs. Select a film of sufficient speed to stop subject movement and to give adequate depth of field. This will be related to lighting conditions above water but a minimum speed of ISO 200/24° is recommended for temperate waters. Tropical waters are clearer and the light intensity higher, so allowing the use of a slower film.

Give your subject something to do. Photographs of him just sitting on a rock will be of little interest to anyone, no matter how good they may be technically. Give him a spare camera to pretend that he is photographing marine life in close-up, or pose him so that he is looking into holes for crabs or lobsters. Communication is difficult underwater, and much time can be lost trying to indicate your ideas to a confused subject, so compile a list of ideas before entering the water. Sketches, ideally made on an underwater slate board so that they can be referred to or amended during the dive, are invaluable. They introduce the aspect of planning ahead. If you enter the water to obtain a photograph of a particular type you will obtain good results more frequently than if you swim around aimlessly looking for a suitable composition. Learn to maximise the potential of each dive and not to return to the surface with unused film in the camera.

The photographs will be of more interest if they are taken full-face or three-quarter-face. Profiles of divers are seldom attractive. Position the subject so that he is facing the light as then his face inside his mask is more likely to be illuminated and so provide additional interest. Do not allow the subject to look directly at the camera. The most interesting results will be obtained when he is looking at something within the field of view. Hands are often forgotten but they can be used to create additional interest, for example, pointing out a secondary subject such as a fish or marine

growth. If hands are used in this way, the subject's attention should be directed at what he is doing. Thus, if he is examining marine growth he should be concentrating on this and not looking elsewhere. Never allow the subject to look out of the photograph; everyone will wonder what was so interesting for him to be looking in that direction.

For this project, keep the subject as still as possible. See that he is aware that each pose is not necessarily over with one photograph, but that you will probably want to take several for each pose in order to study the effect of different angles and possibly to bracket exposure.

Try to take all the photographs from about the same distance. This will allow common controls to be pre-set, so that you will need only to check them from time to time for possible movement. Photographing from a single distance hence allows you to concentrate more on subject treatment and not use valuable dive time altering camera controls. Make sure the background does not distract the eye from the subject, and that you fill the frame with an interesting and well-balanced composition. Be ambitious; only people who make mistakes find out how to avoid them in the future and at the same time discover how to be creative. Think about what you are going to do, discuss it with your fellow-diver and then dive to see if your ideas work. Keep a notebook on the surface to write your immediate post-dive reports; on-the-spot ideas and impressions can prove a gold mine when analysing past photographs and planning new ones.

Using artificial light

Project 2

Objective

To obtain half-figure photographs of a diver by artificial light.

Location

This time you can use a deeper, more interesting location than the one you used for Project 1. An abundance of marine life always provides useful secondary subjects and more opportunities for interesting pictures. Learn to use naturally occurring props to the best effect.

Equipment

A flash source must now be added to the equipment. It should be mounted on an articulated arm to allow the investigation of lighting from different angles.

Discussion

The discussion for Project 1 is also relevant to this project. The only difference is the employment of artificial illumination. As before, plan the composition of each of your proposed pictures, and sketch the positions that your subject will take up. A quick rehearsal on the surface will save valuable dive time. Careful planning always leads to more effective use of a dive.

Give your subject some tasks to do, as before. In addition to static positions, try shooting a series showing him feeding a fish or trying to lure a lobster out of its hole with bait. Such series add life to slide shows or exhibitions and there is often one outstanding picture within the series. It need not always be made from a single camera position. Variation of viewpoint adds interest and provides greater variety of visual content.

The positioning of lighting needs careful thought. Visibility considerations will make it necessary to mount the flash well away from the lens axis; but this does not mean that it has to be at the side. Lighting from above also provides a way of minimising the effects of bad visibility, and can result in a more natural rendering of the subject. Natural light comes from above and we accept shadows below an object more readily than shadows to the side of it.

Lighting from the side or from above can cause the unlit side of the subject to be in deep shadow. If the diver is looking in the general direction of the camera, the side-lighting can result in only half of his face behind his mask being illuminated. The answer is to turn the diver slightly more towards the light source and so illuminate more of his face inside his mask. When your subject has taken up a satisfactory position and you have decided from which angle you will shoot, adjust the lighting to illuminate the most important part of the subject matter and avoid throwing shadows across large areas (Figure 8.4). When using flash, remember that it takes time to recycle; you cannot take photographs as fast as you can by available light. Always wait for the 'ready' light to glow before shooting.

If you have a SLR camera and are viewing through the lens you may not see the flash fire. In order to ascertain that the unit is working correctly, check that the 'ready' light is glowing before the photograph. If it is extinguished immediately

A poor lighting arrangement; shadows will
be thrown over the main part of the subject,
i.e. the divers head and the fish he is feeding

A better arrangement; but now the light is
too near the lens axis and backscatter will
result

The best lighting set-up; the light is away
from the camera axis and is illuminating the
main part of the subject without throwing
it into shadow

*Figure 8.4. Bad lighting arrangements can cause unwanted
shadows and backscatter*

after taking the photograph and glows again after
a short interval, all is well. Test the equipment
when you make the initial windover exposures
after loading the camera.

Full figure photographs

Having familiarised yourself with the use of
camera and flash underwater you will now be
ready to use this combination to attempt a more
advanced project.

Project 3

Objective

To photograph the full figure of a diver in such a
way to add scale and interest to the underwater
landscape.

Location

Choose the location primarily for its attractive and
interesting sea bed. Kelp beds, rock overhangs,
boulders strewn around or coral reefs are all good
locations. They must look attractive on their own,
but compositions will benefit from the presence of
a diver. As you will be shooting from farther away
than in the previous projects a stable, sediment
free sea bed or a slight current to remove any
disturbed silt will prove useful.

Equipment

Unless the visibility is exceptionally good, only
cameras which can take wide-angle lenses will be
suitable for this project. A 28 mm lens, or better
still a 24 mm lens (for the 35 mm format, or
equivalent for other formats), allows you to re-
duce the subject distance in order to keep contrast
and quality high while still allowing the wide field
of view required. A lens of wider angle of view is
of no advantage unless the visibility is particularly
bad as this will increase the chance of perspective
distortion in the resulting photographs. You will
need a flash unit that matches the angle of view of
the lens. This should again be mounted on an
articulated arm. If ambient light conditions allow,
the flash will also be used in a fill-in mode, so an
exposure meter, either built into the camera or as
an accessory, is needed.

Discussion

Planning is again essential, but because the diver
must be dynamic if his movements are to be
reproduced authentically, a greater reliance must
be placed on directions given while you are both in
the water. Work out a system of signals. Try them
out first on the surface to ensure they are correctly
remembered and interpreted. A suggested mini-
mum of signals required is as follows: You, I,
Here, There, Go round, Swim back, Stop, Start,
Look at interesting object, Blow bubbles.
 The 'You', 'I', 'Here' and 'There' signals may be
made by simply pointing a finger in the appropri-
ate direction. 'Go round' is best illustrated by a
rotational movement of the hand in the horizontal
plane in the direction in which the movement is to
be made. 'Swim back' can be illustrated by an up
and down movement of a free arm to suggest the
motion made when finning or may be illustrated
by pointing at a fin. 'Stop' can be a hand held palm
towards your companion as with a traffic police-
man, while 'Start' can be a beckoning movement
with the hand. 'Look at interesting object' is
illustrated by pointing to your eyes and 'Blow
bubbles' by a hand wavering and rising above
your head. In this way it is possible to build up a
purely visual means of communication to aid
photography.

Another very simple way of showing your fellow-diver what you require him to do is to actually swim through the action required, illustrating the location of all the stops and movements required. However, this uses up valuable dive time and risks stirring up sediment. An intelligent subject should by now have become familiar with the actions that make the best pictures and with an adequate pre-dive briefing should be able to carry them out without too much direction.

If the diver is looking at something rather than merely swimming along, the pictures will usually be more interesting. Again, shoot full-face or three-quarter-face to show more of the diver and so add interest. Look for ways to 'frame' the picture. Shooting through weed or a rocky passage can help to balance the composition and to provide a means of focusing attention on the subject.

A strong point of visual attraction in a picture is provided by the glow of a torch. As well as creating visual interest, this can be used to draw attention to a particular object, as the eye will tend to follow the direction of the beam, having been attracted to its light. The output from a hand torch will not affect the exposure. The torch will also serve to attract fish and other marine creatures, which are inquisitive about unusual lights in the sea. Its use can thus provide an attractive bonus.

Artificial light can provide an ideal exposure only in one plane, which is perpendicular to a line through its axis. Although the exposure latitude of most films spreads this plane somewhat, photographs taken by artificial light nevertheless tend to lack depth. Using the light source in a fill-in mode (see p. 29) greatly increases this depth and hence the interest of photographs produced in this project. Artificial light can be used in a fill-in mode only if there is enough ambient light for photography and should provide just enough fill-in to restore colour. The effect may be limited to the foreground so that the diver appears to be emerging out of a blue haze into a colourful world; or it may be used to restore the colour all around the diver. If the flash is placed behind marine growth or rock that is intended to 'frame' the picture, it will render this in silhouette. Use fill-in flash in differing proportions with ambient light to find which ways fit in best with your personal approach to underwater photography.

Planning is of particular importance in this project; side views of a diver swimming next to you or disappearing into the distance are merely a waste of film. Unless you specify precisely where you want your subject to swim, you will be constantly trying to catch up and overtake him to achieve the desired result, a difficult task when you are encumbered with equipment.

The diver in relation to his environment

Project 4

Objective

To take photographs in the direction in which the diver is looking, either from above or to the side of him, to illustrate how the sea appears to him as he swims along, and to show how individual creatures and plant life respond to his presence. To make use of the diver's exhaust bubbles to create special effects.

Location

Any interesting sea bed with plentiful marine life.

Equipment

A wide-angle lens as for Project 3 will prove most useful, although a standard lens can be used if visibility is adequate or if photography is restricted to shorter distances. Artificial light will be essential in all but the clearest and shallowest water conditions, and an exposure meter will be necessary if the light source is to be used in a fill-in mode. Superwide-angle lenses can be used for special effects.

Discussion

In this project the diver is used as a means of introducing the underwater landscape. He is used to provide scale and interest but in a quite different way from Project 3. In some cases only part of his head and a hand need be visible.

This time you need to take your photographs from the reverse direction, i.e. from the rear, or a three-quarter rear view, to be effective. Even though the whole of the diver will not appear, a wide-angle lens is necessary, its short focal length giving the depth of field required to keep both the diver and the subject that he is examining sufficiently sharp. Superwide-angle lenses are of use only for special effects, as they produce severe perspective distortion, especially if the photograph includes part of the diver's head with his arm

stretching out in front. His hand will appear ridiculously small compared with his head.

Start with the diver in a static position, examining an object in front of him. Compose the picture so that the diver will be reproduced on the film from approximately the waist up, entering the frame from either of the lower corners. If the composition is such that the object of interest is on the opposite side of the frame, towards the top, the eye will naturally be led into the picture towards it. To achieve his you must have a slightly higher viewpoint than your companion.

Any artificial lighting must be from the opposite side of the subject. Lighting from the subject's side of the camera will create shadows over the object at which he is looking and will also lead to considerable differences in exposure along his body. This can cause the parts of him nearest to the camera to be severely overexposed (Figure 8.5).

Poor lighting arrangement. Different parts of subject are at differing distances from the flash and are unevenly illuminated Improved arrangement. All parts of the subject are approximately the same distance from the light source and so are uniformly illuminated

Figure 8.5. A poor lighting arrangement can cause uneven illumination

Precise buoyancy control will be necessary when photographing the moving subject. It will be necessary to swim slightly above and to one side of him to obtain the same result as before, and you will need to adjust your buoyancy to become exactly neutral. If you are heavy you will be constantly sinking and interfering with the movement of the subject. You can easily collide with him, and this is not only annoying to both of you, but also wastes time. By swimming above rather than to the side of your subject you will find that the bubbles of his exhalations break over you. This can be used for creative effect. The bubbles should be photographed just as they emerge from the regulator and begin to rush towards the surface. If the photograph is taken a little late the bubbles will engulf the camera and the picture will be spoilt. By moving a little farther back and to one side they can be used to frame the photograph.

In this case, photograph the bubbles towards the end of the exhalation so that there is a good stream of them – but not so late that they are 'frozen' above the diver, with no indication of where they have come from.

The effects created by bubbles are fascinating, uncontrollable, and unexpected. For best results, ask your subject to exhale slowly forming a long continuous stream of bubbles, rather than one short burst. It is always worth including bubbles in your photographs, as they add just the touch of life and movement that transforms the picture.

As less of the body of your subject appears in the photograph, so the emphasis becomes changed from 'diver in an underwater landscape' to 'underwater landscape with a diver'. Static shots of just your companion's head and arm, stretching out to hold food for a fish, are always effective. The direction of the arm leads the eye into the photograph towards the main subject; its presence provides both scale and link between the familiar and unfamiliar. This type of composition is mainly suitable for static situations, as it is extremely difficult for two divers to swim close together without impeding one another's movement.

Fill-in flash can be used most effectively when photographing from this angle. Aim the flash at the sea bed just in front of the diver, and you will transform it and all the life that it contains into bright colour. If the diver is not illuminated by the flash he will appear to be swimming into this pool of colour. In good visibility you can use super-wide-angle lense to create splendid panoramas. To minimise perspective distortion, the subject should be kept as nearly as possible in one plane. This may be difficult with this type of composition; but if the subject is photographed from slightly further round than the three-quarter view or from above, keeping him in the centre of the frame, the result will be acceptable. For preference, photograph him framed from the waist upwards, as the presence of part of his body and air cylinder leads to a more natural acceptance of the effects.

Silhouettes in creative photography

By now you should be well acquainted with photographing a diver underwater and working well with your fellow-diver. Until now the aim has been the achievement of an accurate representation of the diver in his underwater environment; the next project is concerned more with visual effect.

Project 5

Objective

To produce silhouettes of a diver in a variety of situations, for purely creative effect.

Location

Most of the silhouettes will be photographed near the surface, so shallow water or a sheltered area in deeper water is advisable. Good visibility and sunshine are necessary for this exercise; so this may necessitate diving further away from the coast, and on a sunny day.

Equipment

A simple camera with a standard lens is suitable for this exercise, although a wide-angle lens may prove more useful if the visibility is less than excellent. Most of the photography will be based on available light, so an artificial light source is not essential, but a built-in or accessory exposure meter is required.

Discussion

A silhouette shows only the shape of the object, reproduced black against a light background. To appear as a silhouette the subject must be photographed against a strong light: skylight, sun, or artificial light source. When using skylight, an exposure reading should be taken with the meter pointed directly at the surface. If the camera is set for this exposure the pattern of the water surface around the diver will be well reproduced and the diver will appear black. No artificial light is needed. Unless the photography is being carried out in a shallow area where you can rest on the bottom, buoyancy control will be essential. You will need to remain motionless at a uniform depth below the surface in order to concentrate on the photography.

Silhouettes are seldom very interesting without action. Try photographing a diver as he rolls off the dive boat into the water, and if the visibility allows, photograph the whole boat with divers rolling off on both sides. Divers decompressing on a shot-line also make an interesting subject in silhouette, particularly if there are several of them. The changing relationship of their shapes leads to varying patterns of light and dark and offers many creative opportunities.

This technique can also be applied to boats passing overhead or to water-skiers, but beware of potential hazards. Stay deep! If you are caught in turbulence and sucked to the surface you could collide with the boat or skier, resulting in serious injury.

Using skylight for silhouettes is possible underwater when the water is clear or the skylight intense. Many interesting photographs can be taken among rocks or on wrecks using this technique.

Silhouettes created by the sun can be startlingly effective, especially in colour. It is best to carry out such photography as near as possible to the surface and in good visibility, in order to minimise absorption and diffusion of the light. Base your exposure on the surface of the sea to one side of the sunlight. Do not point the meter directly at the sun, or the resulting photograph will be dark with the exception of a white area imaging the sun. Exposure estimation may be difficult in practice, and it is advisable to bracket exposures quite extensively. Keep a record of what you are doing, so that when you find the effect you desire you will be able to tell exactly how you obtained it.

Although a photograph of a diver floating on the surface in silhouette with the sun behind him can of itself be quite effective it is preferable to introduce action into the picture. Direct the subject to swim straight out of the sun towards you. The shapes that he makes as he swims down are always interesting. Bubbles from his exhaust become even more alive when lit from behind in this manner. If possible, try to arrange that the anchor rope leads out of the sun; this provides a link between diver and light source, and strengthens the composition. Instead of shooting the full-length figure of the subject, go close up and photograph just his head with a stream of bubbles escaping to the surface. As an alternative, try shooting him full-length through your own exhaust bubbles. The possibilities are limited only by your imagination.

If conditions do not allow natural light to be used you can use artificial light. In some cases this may need a third diver to position the light source on the far side of the subject, if it cannot be rested or wedged in position on the sea-bed. The light source may be placed pointing away from or directly at the camera. If it is pointing away from the camera the background will be illuminated as

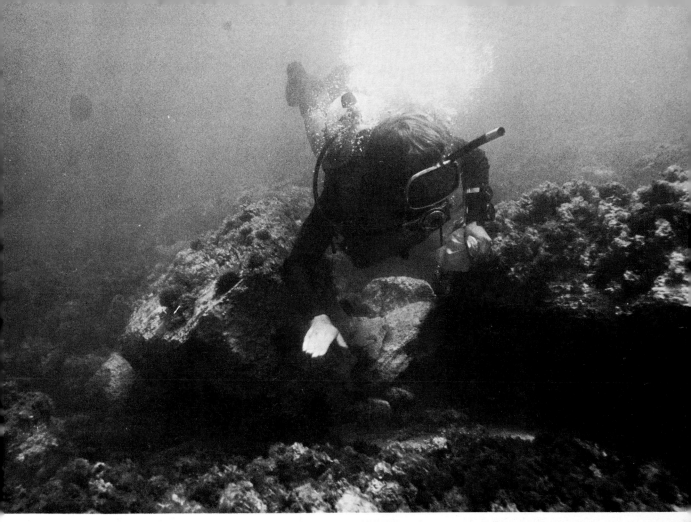

When photographing divers start with a simple pose

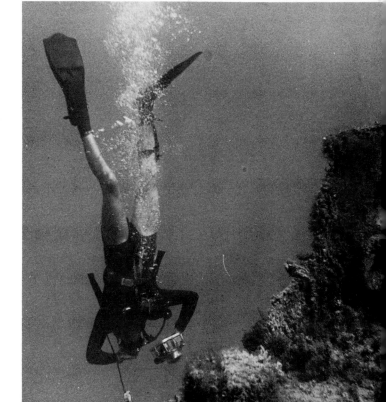

Water allows gravity-defying movements, as
illustrated by this diver exploring a wreck

normal. The flash exposure must be calculated for the background, not the diver, so that he appears as a silhouette against the illuminated background. If the flash is pointed towards the camera, although no direct rays are allowed to enter the lens because of the position of the diver, the effect will be dramatic, and similar to the effect of a silhouette using the sun. Exposure in this case is more difficult to estimate. Base it on half the distance from the light source to the camera, and bracket it.

Unless the flash has a long synchronisation lead, you may have to use a slave unit (see p. 29). A secondary flash mounted on the camera will be needed to trigger this. It must not be powerful enough to illuminate the subject but only to trigger the main light source. The power can be reduced with a neutral density filter or diffusing material. Some slave units are sensitive enough to pick up a flash that is not directed straight at them, so the camera flash may be pointed just outside of the field of view of the lens. If the slave unit is insufficiently sensitive, use the camera flash to illuminate the area ahead of the diver ensuring there is only just enough light to fire the slave unit.

Conclusion

Having become accumstomed to a variety of techniques, try different variations on them. The projects have been based on the photography of only one diver; the next stage is to tackle more complex creative situation in which several divers are present. This introduces more problems in planning and communication and more satisfaction when you obtain a really successful picture. Experiment, look at the work of other photographers, above all study the way divers behave in the water. Although photographs of sea creatures and underwater landscapes can be beautiful and dramatic, non-divers often find difficulty in appreciating them to begin with. With pictures of divers, this is not so. Divers in their environment are always an excellent way to introduce an audience to the underwater world.

9

PHOTOGRAPHING MARINE LIFE

Marine life abounds in all waters, warm, temperate or cold. Tropical waters are renowned for their colourful corals, sponges and exotic fish; but life in colder water is no less interesting. Well-developed fishing industries and pollution around industrial coasts have reduced, and in some cases almost exterminated, some populations underwater; but other life still flourishes. In areas remote from large centres of population, or where fishing is restricted by underwater hazards, a broad selection of marine animals and plants may be found.

Many creatures make themselves inconspicuous, either to avoid predators or because they are themselves predators. Such creatures remain invisible to the diver unless he knows where, and how, to look for them. The underwater photographer needs to study marine biology in order to understand the habits of his would be subjects and to photograph them successfully.

As man becomes more conscious of his environment and more conscious of the need for its conservation, so the study of marine life will bring a new awareness to diving. If you remove marine life for food, respect the need to preserve specimens of this life for others, to allow it to breed and maintain its population levels. Catch only what you need, and do not remove under-size specimens, or females with eggs. Unless conservation is practised as well as preached, there will come a time when there are no more subjects for the underwater photographer.

Five projects

This chapter contains five more projects, this time concerned with the photography of marine life. As before, they are graded in order of difficulty.

Classification of marine life

Biologists classify marine life into two kingdoms: plant and animal. For the underwater photographer, it is more practical to classify it by its mobility (or lack of it), as many animals, for example hydroids, coral and sea-anemones, live like plants, permanently attached to their resting places. There are also a number of animals which are restricted in their movements, such as sea-urchins, sea-anemones, sea-slugs and starfish; it is convenient to group these with this category. Those which can move freely, such as fish, crustaceans and scallops plainly demand quite a different approach.

Static and slow-moving subjects

Static subjects are easy enough to find, as they need to position themselves where they will receive a supply of food and other nutrients from currents or tides. Such subjects are the best introduction to the photography of marine life. To help choose and find various subjects for each of the exercises, a brief introducion to selected types of marine life follows. This is not intended as an accurate discourse on the plants or animals, but as a guide for assistance in their photography.

Sea-urchins

Sea-urchins are found on practically any dive around the coasts of the world. They are spherical in shape, about 20 to 120 mm in diameter and are covered with sharp spines which can become embedded in human flesh and break off, causing a great deal of pain. They vary in colour from the pale green and violet specimens found around the North European coast to the small black variety common in the Mediterranean. The are to be found attached to weed, rocks, or buried in the sand, and always provide a good subject for photography. As sea-urchins move only very slowly there is no need to hurry when setting up the camera. To improve the composition, they may be repositioned if gently removed, and held in the desired place until they reattach themselves – but beware of the spines.

Marine growth must be monitored on offshore installations to ensure that it does not reach unacceptable levels. All marine growth must be removed before any inspection takes place (photograph courtesy of Sub Sea Offshore Ltd.)

Hydroids

Hydroids are plant-like in appearance but are actually animals. Like plants they attach themselves to convenient resting places such as rocks or weeds. They vary from only a fews millimetres to perhaps 20 cm in length, and are delicate and colourful in appearance, often having brightly coloured 'flower heads'. Although they tend to grow in colonies, individual specimens can be found. The translucent quality of these creatures is emphasised by backlighting.

Sea-anemones

Sea-anemones are varied and often brightly coloured animals. Individual specimens vary in shape and size, and can shoot out tentacles with which they trap their prey. Such movements can make interesting series of photographs. They are not normally more than a few centimetres in diameter

and length, but certain tropical varieties can, however, grow much larger; one species grows up to 1.5 m in diameter.

Sea-squirts

Sea-squirts are cylindrical semi-transparent animals, 10–15 cm in length. They are found on rocks, man-made installations or in mud, living singly or in groups and often with the lower parts of their bodies fused together. They make interesting and unusual photographs particularly when backlit to emphasise their translucence.

Sea-cucumbers

Sea-cucumbers are not particularly attractive creatures, but they make interesting photographs. They have a thick, leathery body which is roughly cylindrical in shape, ranging in length from a few

To illustrate how the choice of background can affect the composition. On the left the subject is floating in mid-water, being carried by the current. Photographing it from above against a rocky background causes poor subject differentiation. By photographing from a lower angle the water becomes the background (right) and so ensures that the subject is reproduced more effectively

centimetres in temperate waters up to about a metre in tropical water. One temperate species grows to about 15 cm in length, and ejects white sticky threads to confuse or entangle aggressors. Although they move about the sea bed by means of tube-feet, the movement is slow.

Starfish

Starfish are almost as common as sea-urchins around temperate coasts, but in greater variety. They can be subdivided into *sea-stars,* which have wide arms, each with a vental groove housing tube-feet, and *brittle-stars,* which have a disc shaped body and long flexible arms. They are generally 10–20 cm diameter. The feeding action of sea-stars is interesting to photograph as they hold themselves over such delicacies as mussels in unusual shapes and patterns. Often colonies of sea-stars may be found ravaging mussel beds, although individuals appear almost anywhere. Typically, Starfish have five arms but this is by no means universal. They can regenerate lost arms, and examples are often found where one has been lost and is growing again. They are extremely colourful and their oranges and yellows provide a strong visual contrast against the muted colours of

the sea bed when they are photographed by artificial light. Their movements are normally very slow.

Project 6

Objective

To photograph static marine life using a variety of lighting techniques.

Different shapes are best accentuated by different lighting techniques. To reproduce a subject in its most pleasing form, variations on direct frontal lighting must be used. Three widely encountered shapes are the spherical shape of, for example, the sea-urchin, the delicate three-dimensional shape of a hydroid, and the flat, almost two-dimensional sea-star. The photography of creatures of these three basic shapes form the subject matter for this project.

Location

Any location is suitable as long as the required marine life is present and in attractive surroundings. Shallow water and absence of currents or tides allow longer dive times and greater comfort.

83

Learn to recognise marine life and to know their habits. This anemone is not displaying its tentacles and so a better photograph could have resulted if the photographer had been patient

Sea-squirts are found in many and diverse places

Starfish are commonly encountered in British waters. Their colour and slow rate of movement make them popular subjects

Brittle starfish are less brightly coloured than their relatives but can still provide an interesting close-up subject

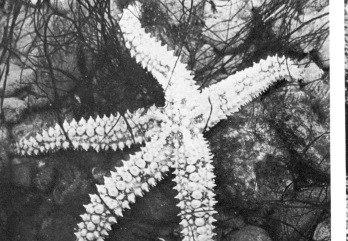

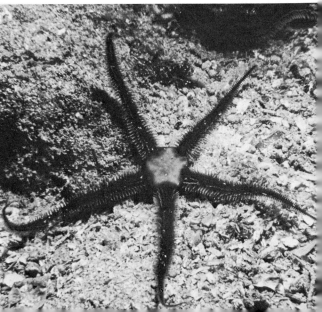

Visibility does not have to be very good, as the subject has to be approached closely because of its small size. The better the visibility, the more the different lighting techniques that can be used without the need to consider backscatter and lack of contrast.

Equipment

The camera must be able to focus close enough to reproduce the subject at a reasonable size. A 35 mm lens (for the 35 mm format, or equivalent for other formats) will normally allow close enough focusing while still allowing a reasonable subject distance so that lighting may be easily positioned. A focal length that is longer rather than shorter is often an advantage when photographing this type of subject, as it allows greater control of lighting and background. The greater camera distance gives greater freedom for placing lights; and, with a distant background, the longer focal length offers greater scope for differential focusing. The light source should be capable of being positioned remotely from the camera; a flash unit should have a long synchronisation lead. It is important that no strain is placed on connections.

It is a good idea to have a small sheet of matt-finished metal (aluminium or stainless steel), or flashed opal acrylic, about 30 cm square, to act as a reflector. Acrylic sheet is preferable, as it is lighter. A metal sheet can be suspended from an inverted plastic container which is partially filled with air to give neutral buoyancy at the depth it is used. More air will have to be added with increasing water depth to allow for the increase in pressure, and less when it is used near the surface; the latter can be allowed for by punching holes in the side of the container just below the level of air required to balance the weight of the metal sheet. Such a device will also prevent overfilling of the container.

Discussion

Most underwater photographers operate with only one flash unit which in many ways restricts lighting possibilities. Professional studios, on the other hand, work with a minimum of three light sources. Thus the underwater photographer must experiment with his single light source to produce attractive lighting situations. The experience will be far more beneficial than studying conventional studio lighting.

The photographs taken in the previous projects have all inolved comparatively large subject distances. Water acts as a very efficient diffuser, so over these distances the light from the single source becomes diffused, the forward-scattered light illuminating the shadows. In close-up situations the light source is not diffused, as its path through the water is so short. The subject is also nearer the background, so that the shadows are more dense and obtrusive. Unless they are carefully controlled this can detract from the subject.

The output of a light source can be diffused by placing layers of textile or opal acrylic material over it. Although effective, this has the disadvantage that it reduces the light output of the unit.

A diffused light source produces soft-edged shadows, but it does not alleviate the blackness of the shadows themselves. To do this it is necessary to use a reflector to 'bounce' light fom the main source into the shadows. It should be placed on the camera side of the subject, but on the side opposite to the light source, just outside the field of view of the lens. Careful adjustment will ensure maximum effect (Figure 9.1).

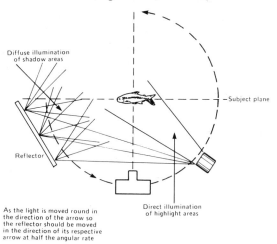

Figure 9.1. Reflector position for different types of lighting

The use of a coloured reflector results in coloured shadows and possibly some coloration of the mid-tones. This effect can be used for creative effects if carefully controlled.

Many lighting arrangements are possible for close-ups. There are four main types: frontal lighting, sidelighting, backlighting, and lighting from above.

Frontal lighting will produce small shadows. The closer the light source is to the lens axis the

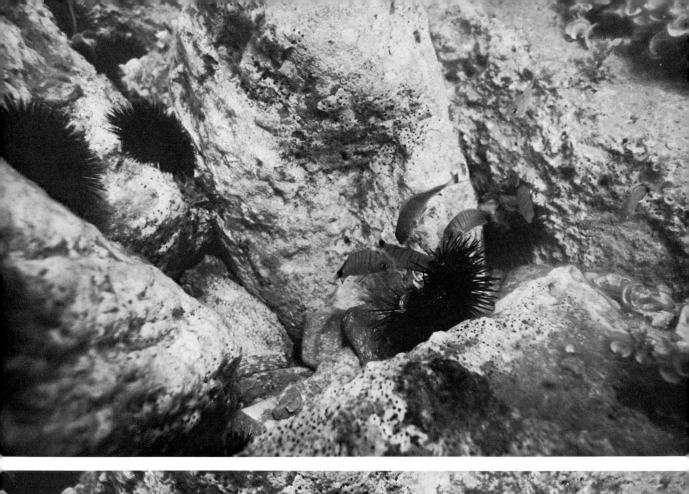
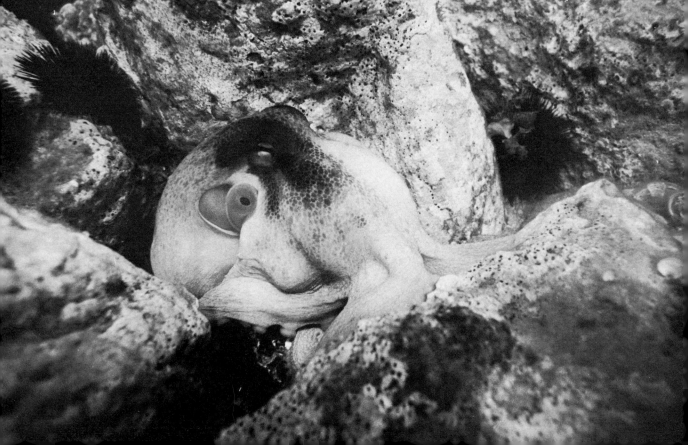

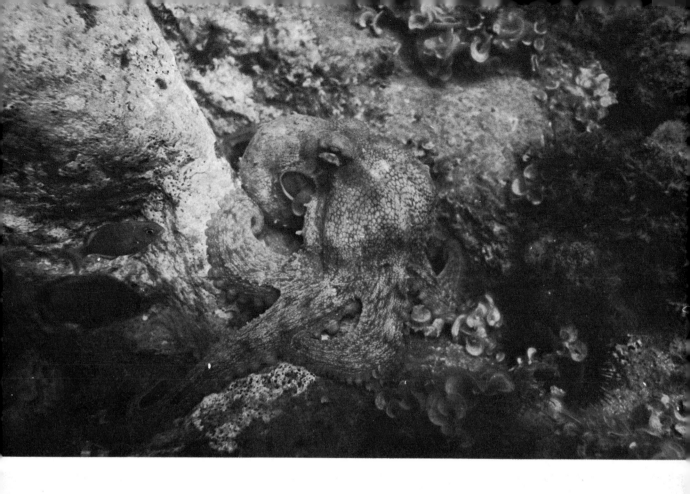

Always be on the lookout for a series. Here an octopus leaves his hiding place and changes his camouflage in a bid to escape being photographed

smaller will be the shadows. A ring flash mounted round the lens of the camera approximates to a light source on the lens axis and provides almost shadow-free lighting. In general this type of lighting is uninteresting, as it gives no 'modelling' (a term used to describe the three-dimensional effect given by the combination of light and shadow). The use of a ring flash is more appropriate to scientific photography rather than creative pictorialism. Frontal lighting aggravates the effect of poor visibility by emphasising particles suspended in the water, and by increasing backscatter and reducing contrast.

Sidelighting is more suitable than frontal lighting for underwater photography. Its use is dictated both by the design of underwater photographic equipment and by the constraints of visibility. The farther away the light source is from the lens axis the longer the shadows become, and the more strongly the texture of a surface is emphasised.

A reflector will lighten the shadows and make detail in them visible.

Backlighting comes from well behind the subject so no direct light falls on its camera side. Backlighting can be used to emphasise the outline of an object by creating a halo effect around it. It emphasises the apparent fragility of translucent subjects, such as sea-squirts. It is particularly effective in showing the delicate nature of hydroids and sea-lilies. The use of a reflector on the camera side, to fill in the shadow areas, can produce a less dramatic, though equally pleasing, effect.

Avoid pointing the light source directly at the camera. Position it so that it illuminates the object from the side, or from slightly above or below, so that it does not spoil the effect by appearing in the picture or producing a flare spot. Exposure estimation is more difficult when using backlighting, as the effect should produce a bright ring around the subject. Bracket exposures, and keep a careful note of the type of backlighting and the correct exposure, to help you to make decisions in the future.

Lighting from above gives an effect which approximates to natural light in the sea. It produces an effect similar to sidelighting in that it emphasises texture and it is often the only type of lighting that can be used where access to the subject is difficult. *Zone lighting* gives a pleasant effect. Hold the light source so that it illuminates only the subject, which thus appears in a pool of light against a dark background. This technique is particularly useful when the background is distracting or when the subject requires extra emphasis. Zone lighting also produces attractive effects when used in a fill-in mode. The subject appears in a pool of full colour while its environment is in shades of blue.

Try these different forms of lighting for yourself. Use them all, varying the position of the source to obtain the various effects. Use a diffused source or reflector to see its effect, and note the type of subject for which each type of lighting is most suitable. Remember to keep notes at the time on an underwater slate. When you examine the resulting photographs and choose the best ones you will know exactly how the effect was achieved. It is of little use producing a fantastic effect if it cannot be repeated at will.

Marine life close up

Much marine life is very small, but is often interesting and colourful. If you simply swim over the sea bed in the hope that a subject will appear, you will never see these small creatures; they must be searched for over small areas. They are almost always to be found hiding or living in a protective environment where they can obtain food. For example, *nudibranchs* (see below) can be found in hydroid colonies or on weeds, *blennies* may live in empty barnacle shells and *hermit crabs* live in whelk or other shells which they carry on their backs. Although some of these small creatures may be capable of rapid movement, most of them move at a gentle pace and may 'freeze', their natural camouflage making them almost invisible. They do not usually move far, and are therefore relatively easy to photograph. Typical examples of these creatures and their habitats are as follows:

Nudibranchs (sea slugs)

These are among the most beautiful and brightest coloured animals in the sea. They are normally to be found feeding on hydroids, sea-squirts, barnacles, weed or sea-anemones and can be seen in a variety of colours and sizes; generally they grow only to about 2–3 cm in length. They are slow-moving and undisturbed by a photographer.

Prawns and Shrimps

Prawns and shrimps are related to the larger crustacea, the crab and the lobster, but their habits

are quite different. They are normally found in shallow water, in rock pools or in muddy sand. They have to be approached carefully, as they can move rapidly; but they make fascinating subjects. Photography of prawns and shrimps can be regarded as a real challenge, and one which brings much satisfaction when successful.

Hermit crabs

Hermit crabs are also related to the larger crabs and lobsters but as they have no hard shell to protect them they make use of a shell that has been left by another creature. They inhabit a variety of cast-off shells and no two are exactly the same. The shells may be covered with small sea-anemones and hydroids, and give the impression of a walking sea bed. The creatures are widely distributed, particularly on sandy flats, but as they are only about 2–6 cm in length, they are often difficult to find, particularly when camouflaged with other marine growth. The crab retreats into its shell as soon as it senses the diver; thus shells that are in fact inhabited may appear to be empty. It is alway worth waiting for a moment by an apparently cast-off shell to see if it is inhabited. Do not pick it up; you will disturb the occupant. Just wait, camera at the ready, and often the natural inquisitiveness of this creature may provide you with a good photograph.

Blennies

Blennies are tiny fish, rarely more than 6 cm long, which inhabit shallow waters. They are found worldwide and all make good and often patient subjects. They are found in sheltered nooks and crannies in rocks or inhabiting empty barnacle or other shells. They seldom move far. They are little disturbed by the photographer, though they are in fact capable of rapid movement. Their expressive features make them endearing subjects; often a fish will 'pose' for the photographer, showing as much interest in him as he does in the fish.

Project 7

Objective

To photograph small marine life in extreme close-up, using different lighting arrangements.

Location

Similar to that used for Project 6.

Until you have mastered the techniques of photographing small moving subjects it is advisable to remain in shallow water to conserve air supplies. Most of the more suitable subjects for extreme close-up photography are found in shallow water, as it is warmer and receives more sunlight.

Equipment

The camera must be capable of taking a supplementary lens, or extension tubes. A SLR camea is desirable as it affords through-the-lens viewing and focusing. Any other type of camera requires a probe or frame assembly to indicate the plane or focus and field of view. Even with SLR cameras, probes are useful, as they save time by eliminating the need for focusing and composition through the camera lens. They do, however, have the disadvantage that they can frighten the more timid creatures. The close-up device is best fitted to a standard or longer-focal-length lens. A 50 mm lens is ideal (for a 35 mm camera), as this allows an adequate subject distance for lighting, and avoids disturbing sensitive subjects by approaching too closely. The light source should be easily positionable, and either a diffuser or reflector will be necessary.

Discussion

Although in shallow water there may be enough available light by which to photograph, it is still advisable to use an artificial-light source to bring out the natural colours of the subjects. A flash also ensures that the movements of a subject are effectively frozen.

The lighting experience gained in Project 6 will come in useful for this project. A brief examination of the subject should suggest appropriate lighting angles and reflector positions. When using extension tubes, do not forget to make the necessary exposure compensation (see p. 64).

In addition to selective lighting, *differential focus* may be used to emphasise the subject. When photographing in close-up, the light source is close to the subject, leading to the use of a small lens aperture. Closing down the aperture leads to an increase in depth of field, which can render the background as sharp as the subject. If it is cluttered or distracting it will detract from the subject.

Using a larger aperture, and adjusting the light intensity accordingly with a neutral density filter or by moving the light source further from the subject, will restrict the depth of field and so render the subject sharp against a blurred background, so that it stands out from it. However, when photographing in extreme close-up the depth of field is severely restricted. At even the smallest aperture the background will be out of focus, and the extra exposure required to compensate for the lens extension will demand a relatively wide aperture despite the close lighting.

You can often produce effective photographs by shooting only part of the subject. Photographing a detail of the 'flower head' of a hydroid or a small patch of coral or sponge can lead to a picture that is in every way as interesting as one of the whole. Look for interesting detail: a piece of rock, part of a weed, or the tentacles of an anemone. An individual subject in this way becomes not one, but a variety of separate subjects.

When using a SLR camera for extreme close-ups, pre-focus, then move the camera until the subject is sharp on the screen. Do not position the camera first, then attempt to focus with the focus control, as the plane of focus is much more difficult to judge in this way. Probes are often very helpful as the camera can be pushed slowly toward the subject without looking through the viewfinder. To a marine animal, a diver in the distance pushing a camera is less disturbing than a noisy bubble-blowing diver creeping up right behind a camera.

Extreme close-up photography allows the photographer to see in new ways, to be aware of smaller subjects and of more detail in larger subjects. By looking for suitable subjects he will also become far more alert to the life that is supported in the water, life that is never seen when swimming over the sea bed. It becomes visible only on detailed inspection, and once found is so fascinating that it is almost addictive.

Crustaceans and other larger creatures

Although non-divers will often be unable to recognise sea-squirts, hydroids or blennies, everyone can identify a crab or a lobster. Even though they might be confused by the difference in colour underwater they will certainly recognise the shape of a prized culinary delicacy. For this reason, photographs of crabs and lobsters are always popular.

Crabs

The familiar edible variety of crab grows to about 15 cm across the shell, and its flat shape makes it very easy for it to hide under boulders or rock overhangs. Occasionally one can be seen making its way across a sandy bottom, when it may be photographed easily, as it tends to rear up and wave its claws menacingly rather than rush away to safety. If it feels threatened it will scuttle away; once it has reached the safety of rocks it can seldom be photographed in its entirety. The most that is visible is two eyes and a pair of claws, challenging the photographer to approach just a little closer and meet his fate.

Crabs are not only found in rocky areas. *Spider crabs* are most likely to be fount in kelp beds, where they attach themselves to the swaying *Laminaria* fronds. These crabs are much less flat than edible crabs, and have an almost spiny finish to their shells. They grow to about 15 cm across their carapace, and make good photographic subjects. The smaller *swimming crab* and *shore crab* are more likely to be found in rock-pools or shallow water. They move fast, and rarely stop to pose for the photographer. Their greenish colour and small size make them less popular subjects than larger crabs.

Other types of crabs live partially buried in sand or in mussel beds. In general their undistinguished nature and size make them specialist subjects mainly of interest to marine biologists. However, one small crab of interest to the underwater photographer inhabits sponges. These crabs use their hindermost two pairs of legs to hold a piece of sponge over them to act as camouflage. They are comparatively easy to photograph, and their antics are often amusing, as they seem to think their umbrella renders them invisible.

Occasionally, a female crab may be found with bright orange eggs attached to her lower body. In the interests of conservation you should treat such a crab with respect, as she carried the means by which the species survives.

Lobsters

Most divers, on seeing a lobster for the first time underwater, are somewhat taken aback by its appearance. It is blue, rather than the more usually associated orange colour. This change in colour occurs when it is cooked. Most lobsters live in rocky accumulations, hiding themselves in crevices and holes. It is extremely difficult to lure them out

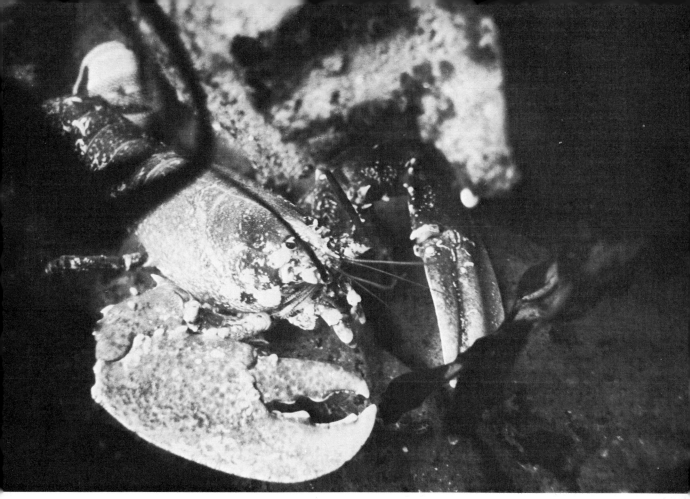

Lobsters are always rare subjects and have to be carefully approached to optimise photographic opportunities

of these holes but occasionally they may be seen walking over the sea bed in search of food; it is then easier to photograph them. They grow to about 50 cm in length.

Other members of the lobster family include *crayfish*, and *spiny lobsters* or *crawfish*. Crayfish are found only in fresh water and have not developed the large pincers of the lobster. Spiny lobsters also lack the pincers of the lobster but they have strongly armed antennae which can be used in defence. *Squat lobsters* are much smaller than the clawed variety. They rarely exceed 15 cm in body length, and have long but undeveloped claws. They hold their tail neatly tucked under their body. These small crustaceans are often aggressive and may be found peeping out from under stones and rock overhangs. Although they will not come out into the open, they do not retreat far into their habitat when approached. Even then they soon re-emerge, popping out their antennae, claws and eyes first. They make amusing subjects and if you feed them with small pieces of fish or other bait you will obtain a fascinating series of photographs.

Conger eels

Conger eels live in a habitat similar to that of lobsters; when examining holes in rocks or other dark places, you may come across one. Its snakelike appearance and fearsome teeth make it a forbidding creature and photography of conger eels is not for the nervous. Its reputation for aggressiveness is derived from its behaviour when hooked on a rod and line, but you should approach it cautiously and steadily and not provoke it. That small head can have well over a metre of body behind it. If treated carefully, and possibly attracted out of its hideout with a snack, the conger eel is an awesome subject.

Scallops

While looking for sand crabs, or swimming between rocky outcrops in search of other subjects, you may see *scallops*. These are much in demand for food, so it is possible that frequently dived areas will be fished out, but if you do find one, they are worth a careful study. Scallops lie on sand or muddy surfaces but bury themselves rapidly to hide from predators. They propel themselves from their hideouts and move across the sea bed by expelling jets of water. They may move like this every minute or so and photographs of this provide a good return for your patience.

Project 8

Objective

To obtain successful photographs of crabs and lobsters.

Location

A suitable location is not easy to find; if other divers are asked they will not often be helpful, fearing an invasion of their fishing grounds. If you assure them that you are only interested in photography they may perhaps be persuaded to reveal locations. Overfishing in popular areas has often severely depleted stocks, and it may necessary to dive deep in order to find suitable subjects. Beware of the dangers, and do not allow your enthusiasm to override safety considerations. There is no guaranteed way of finding crabs and lobsters, so unless the site chosen promises a relatively high probability of success, choose a location where alternative subjects are to be found.

Equipment

As for Project 6. The reflector may be an encumbrance, especially with a moving subject. If your fellow-diver knows how to position it correctly, this can save time and effort, but remember to brief him thoroughly before the dive. Once in the water, it may be too late.

Discussion

If you find a suitable subject, it is unlikely that it will remain in a good position for long. In order to get at least one shot pre-set the camera and lighting to a set distance, chosen so that it will reproduce an average subject at the right size on the film. When you find a subject, move the camera quickly into this position and take a photograph at once. If the subject remains still then additional photographs may be taken with different settings, but if camera adjustments have to be made, carry these out well away from the subject, then approach again for another photograph. When making such adjustments do not concentrate solely on the camera; keep an eye on the subject, or it may decide to disappear while your concentration is elsewhere. Similarly, do not remain close while you wait for the flash to re-cycle. Retire, then approach again when you are ready; this is a less provoking action, giving the subject more confidence and confirming that it is not being unduly threatened.

If you cannot find crabs or lobsters, divert your attention to the alternative subjects that are always around. The best photographs of crabs and lobsters are often obtained purely by chance in a totally untypical location; besides, it is always a disappointment to leave the water with no film exposed.

Fish

Fish make challenging subjects. Photographing fish is perhaps the most difficult task the underwater photographer ever attempts. There is no easy way to photograph fish; but there are a number of methods which will make the task slightly less difficult. Fish come in all sizes, from the smallest stickleback to marlin and sharks. To the underwater photographer, fish can be divided into four main groups: bottom dwellers, inhabitants of rocks, weeds and wrecks, open-water dwellers and tropical reef fish.

Bottom-dwelling fish

Many bottom-dwelling fish tend to be flat, and well camouflaged. They lie motionless in the sand or mud waiting for food to appear, and if disturbed retreat rapidly to safety. Other bottom dwellers, such a *dogfish, weevers* and *scorpion fish,* are not flat.

Bony flat-fish, such as *plaice, sole* and *dab,* can be recognised because both eyes and the mouth are on the top of the body. Other bottom dwellers, such as the *sea scorpion,* and the grotesque *angler fish* whose mouth is nearly as wide as the fish is long, are less flat. *Cartilaginous fish* such as *rays*

and *skate* also have flat shape, but can swim through the water with a flapping motion, as if flying.

Approach bottom-dwelling fish cautiously, controlling your buoyancy so as to keep just above the sea bed, to minimise disturbance of sediment. Move into the current so that any sediment you do disturb will be quickly dissipated. Fish usually face into the current, so that movement in this direction allows you to approach the fish from behind. Watch carefully for the eyes just visible above the sand, as their superb camouflage and their habit of burrowing slightly into the sand make these fish almost invisible. This can help the photographer, however, as they appear to believe they are invisible, and will allow a close approach before taking flight. This allows time for at least one photograph, as long as the camera has been pre-set.

In tropical waters bottom-dwelling fish have to be treated with great care. The *stone fish* is exceptionally well camouflaged and has venomous spines on its back. It will not move if threatened but relies on its spines to protect it; if it is accidentally rested on there will be painful consequences. *Weever-fish* are a similar danger. Although they are not flat-fish they burrow in the sand leaving only their venomous spines exposed. Familiarise yourself with the fish to be found in the area of the dive, so that you will be aware of what signs to look for and know how to detect camouflage patterns. Being aware of the habits and behaviour of any dangerous species will minimise the risks.

Rock-, weed- and wreck-dwelling fish

There are many types of fish that inhabit areas where rocks, weeds or wrecks may offer a safe refuge. Common types are *bream, wrasse, pollack* and *goby*. These fish range considerably in size from one species to another, but all share a common dislike of the diver. The larger species such as wrasse will swim at about the limit of visibility, keeping a watchful eye on the diver, while smaller varieties such as gobies usually retreat to safe hiding places.

It will prove impossible to photograph fish if they are chased. They are well adapted for their environment, man is not, and at most this behaviour will result in a photograph of a distant tail fin with their future approach being even more wary. Most fish are, however, curious, and if the diver remains stationary they may move closer to investigate. Do not make any sudden movements or they will disappear in an instant. Their curiosity may be accentuated by placing a tasty morsel of food within camera range, pre-set the camera on the expected position of the fish as it darts in to take the food and trust to quick reactions and good judgement to obtain the desired photograph.

Fish are usually attracted to a light source. A small pen-light torch attached to the camera or flashgun can attract curious subjects. If the torch is attached to the flashgun and set so that when the subject is in the correct position it illuminates it roughly in the centre, you will have a rough means of focusing and composing without using the viewfinder. A light on the flash also encourages the fish to look at it rather than directly at the camera, and gives a three-quarter view with correspondingly better composition.

Fish are often more approachable if there is a slight current running. Fish dislike swimming in a current as much as a diver, and tend to gather on the lee side of rocks and other obstructions. In addition to making their movements less tiring, eddies formed by the obstruction often deposit particles of food in these areas of slack water, and the fish are often unwilling to vacate them even when a diver arrives.

Remember when photographing any fish to keep movement slow and deliberate. Try not to look at the fish directly, but keep them in view out of the corner of your eye. Any sudden movements are guaranteed to cause panic and a flurry of tail fins disappearing into the distance. To a fish, bubbles represent sudden movements; so if a subject is almost in the correct position, try to hold your breath. This may not be good diving practice, but it can make all the difference between a good photograph and none at all.

Open-water-dwelling fish

The fish that inhabit open water are the most difficult of all to photograph. The first difficulty is that the diver is in mid-water and must have precise buoyancy control to remain in position. The positioning of food to act as a lure is also more difficult, as it tends to float away. The use of a light remains the best way of attracting such fish. Focusing and exposure by artificial light also become more difficult, as distances cannot easily be estimated when there is nothing for reference. Photography under such conditions is a real challenge.

Bottom-dwelling fish rely on camouflage to escape observation and so can be approached relatively closely before they take fright

The choice of subject matter is large. Shoals of *bass, mullet, mackerel* and *garfish* are often encountered, but opportunities for such photography must be taken when found, as they are unlikely to be present when desired. Other subjects such as shark and tuna may be photographed on the edge of drop-offs from tropical reefs, where a close aproach is not necessary because of the good visibility.

In tropical waters, *barracuda* make good subjects. They often swim just below the water surface, and it may be necessary to swim though a shoal of barracuda to reach the sea bed. Although they look ferocious they are not a threat to a diver unless provoked. They are very inquisitive and will often circle a diver, keeping tantalisingly out of range of a camera and making brief, high speed, sorties for a closer look. They are often attracted to light and to shiny objects and have been known to attack glinting equipment, mistaking it for a small fish. Such objects can be used to attract them for photography.

Other creatures that provide good subjects, although not fish, are *dolphins, porpoises* and *seals*. When these are encountered underwater it is always worthwhile trying to photograph them, but they do not often appear; seize what opportunities arise, and deal with them on their merits.

Tropical reef fish

Diving on a coral reef is an unforgettable experience, particularly if you are accustomed to diving in cold murky waters. The sun shines, the water is warm and the fish too numerous to count. Both the marine life and environment abound in colour. For the underwater photographer this is paradise.

Tropical fish show little fear. It is easy to approach within shooting distance if your movements are slow and deliberate; scraps of food in the water will normally attract so many fish as to make the photography of individuals nearly impossible. The setting up of marine parks and protected areas on many reefs has done much to cut down on spearfishing and so the fish have little to fear from divers. The variety of life that can be seen swimming around the reefs is endless: *angelfish, butterfly fish, groupers, parrot fish, puffer fish, soldier fish, surgeon fish*; but these are only part of the marine life. Hidden in crevasses and between the coral heads, even within the marine growth itself, are many more species. *Damselfish* live among the tentacles of large sea-anemones, impervious to their stings. *Moray eels,* even more ferocious in appearance than their cold-water cousins, inhabit holes in the coral. *Stonefish* lie almost invisible in coral rubble. With life flourishing everywhere, all the underwater photographer has to do is to wait for subjects to swim into view. Selected fish may even be followed (but never pursued), to obtain a desired setting. Most of the fish are so intent on their own business that they are not disturbed by the presence of a diver, unless approached too closely. Parrot fish and butterfly fish are too intent on feeding on the coral itself to be disturbed, and can easily be photographed after a gentle approach. Pre-set the camera for the desired distance, then slowly move in until the focus and composition are satisfactory.

A torch mounted on the camera is of use only in deeper water, as in the shallows the ambient light levels are usually too high for it to be effective.

Project 9

Objective

To obtain photographs of commonly encountered fish.

Location

Any location where fish are found is suitable; but bear in mind the factors already discussed. If it is desired to photograph specific species, then suitable locations should be selected with reference to specialist books or expert advice.

Equipment

Appropriate equipment choice depends on the size of fish to be photographed. For small fish a 50 mm macro lens is probably best (for a 35 mm camera).

Larger fish should be photographed with a 35 mm lens. A wider-angle lens demands a closer approach and brings the risk of disturbing the fish. A longer-focus lens is unwieldy and suffers from restricted depth of field which demands more precise focusing. On the other hand, such a lens avoids the necessity of approaching the fish closely, and may be more suitable for a shy species.

An exposure meter is also needed to work with fill-in flash. Some form of artificial light is needed to bring out the full range of colours in a fish, and flash is particularly useful for still photography, as it freezes the movement of the subject, resulting in sharper pictures.

Discussion

Keep the lighting simple when photographing fish, as your whole attention will need to be concentrated on approaching and framing the subject. The additional requirements of the more complicated lighting arrangements would result in opportunities wasted. Use frontal or side-lighting to bring out all of the fish's colours. Bear the composition of the photograph in mind, so that shadows can be minimised. For example, if the lighting is from the camera left, shoot the fish swimming towards you at 45° to the lens axis from left to right. This ensures that its whole body is uniformly illuminated and will give a better picture. To avoid a series of pictures in which the fish are all in the same position with the same lighting, change the lighting from one side of the camera to the other. If this is impossible light from above the camera as this will allow more versatility in composition.

When fish are moving rapidly, as they often do, it is nearly impossible to keep them in focus at all times. Pre-set focus and lighting to a set position in front of the camera and set the aperture to give a zone within which the subject appears acceptably sharp. Take the photograph when the fish is in the zone. This technique will result in a far greater success rate than by attempting to follow focus. However, the increased depth of field may mean that the background becomes sharp enough to be obtrusive. This effect can be minimised by photographing the fish from a slightly lower viewpoint, so that it is set off against a uniform background of sea. When flash is used, the fall-off in light intensity will lead to the fish standing out against a dark background. Although this leads to a good reproduction of the fish it does not give any atmosphere to the composition. A picture of a fish

without its environment can have some impact if the fish is highly coloured; but a fish within its environment with usually make a more effective photograph. The background is also minimised if the fish is photographed swimming over the top of or round the side of a rocky outcrop. If the angle is chosen carefully, the fish can still be shown against a background of sea, but the small part of its environment that also appears in the picture will give more authenticity. When photographing the fish in front of its environment choose a lighting angle that avoids casting a shadow on the background. If it does so, try enticing the fish a little farther away from the background so that its shadow does not fall within the field of view.

Zone lighting (see p. 88) from the side or above can also help to minimise the effect of a background. The subject itself is illuminated, but no light is permitted to fall on the background; in the picture the subject will stand out against black. The use of extreme lighting angles can also lead to striking effects. Lighting from below can often give a fish a menacing appearance. Zone lighting can also be very effective used in a fill-in mode. The fish will be reproduced in full colour against an undistracting blue background. This is often the best way of ensuring a good reproduction of the colour of the fish in its environment without a distracting background.

Be patient, and remember to let the fish come to you. Once they have become accustomed to your appearance they will approach you. Patience is the most useful item among all your accessories.

Photography at night

Having concentrated on the basic aspects of underwater photography and mastered all of these, fresh subject opportunities will be required. Marine life is often shy and difficult to photograph during daytime but at night things are very different. Species that hide throughout the day come out at night to feed. The torch you have to carry will attract many creatures that are too shy to be approached in daylight, and a diver who cannot be seen is less frightening.

Project 10

Objective

To obtain photographs of marine life at night.

Location

A suitable location will have abundant marine life, easy accessibility, and freedom from tides or currents that may take the diver away from his surface support; above all, it should be familiar. Night transforms the underwater world, although to the diver it brings extra hazards. For example, the risk of disorientation is much greater, and this can lead to the onset of panic. A familiar environment is reassuring, and the location of subject areas of potential will be known. However, the beauty and the peacefulness of this world can also lull the diver into a false sense of security. On no account dive at night without rigorously observing safe diving practice. Assistance at night is always more difficult to obtain than in daylight. Above all, ensure that there are spare underwater torches. They are the only way to find your way about, and are essential for signalling when on the surface.

Equipment

The equipment selected depends on the subject to be photographed. By now you should be familiar with the types of equipment best suited to the treatment of different subjects. In addition to camera and lighting equipment, a focusing lamp is needed to provide enough light for focusing and composing the photographs. An underwater torch does not give a spread of illumination suitable for composition, although it does give enough light for focusing (see p. 31).

Discussion

The risk of losing your fellow-diver, becoming disorientated and swimming away from the surface support is much greater at night. Ensure your diving companion stays with you at all times and keeps track of the direction in which you are both swimming. He may also be able to provide extra light on a subject for focusing and he can use his torch as the means of attracting marine life for you to photograph; so stay close and safe.

Marine creatures behave differently at night. Fish become more inquisitive, and can be approached more closely. Crabs and lobsters come out of their habitat and search for food. Under cover of darkness the creatures of the undersea world gain confidence. When they are caught in a beam of light they will usually freeze for a few seconds before they make for refuge. If the camera is pre-set, you can approach a subject quickly and

take your photograph as soon as it is framed and in focus. There is seldom enough time to go through the business of setting up camera and lighting and adjusting the focus, so a pre-set camera is essential.

Subjects should be chosen that are difficult or impossible to photograph in daytime. Do not waste time photographing creatures such as sea-anemones or other creatures that can be readily photographed in daylight. Look for subjects that have not previously appeared, or are more approachable at night, so that the opportunities gained by diving at night will not be wasted.

Summary

Having learnt the basics of photographing marine life, it is up to the individual to perfect existing techniques or develop new ones to extend the range of subjects or the treatment of more common ones.

For example the introduction of such props as a mirror can often lead to interesting series, as fish move in to inspect what they consider to be an intruder. Only by learning the habits of the various creatures can their actions, and hence their photographic possibilities, be predicted.

10

PHOTOGRAPHING WRECKS

Throughout history many thousands of ships have been lost at sea. Most have been lost in coastal waters and have been broken up by waves and current, but in some cases a form, still recognisable as a ship, survives. These wrecks act as a focal point for the gathering of marine creatures. Their surfaces are soon covered with marine growth of various types, and they provide a habitat and refuge for many sea creatures. As the colony becomes established the larger predators are attracted, and soon the wreck is part of the ecological system of the sea.

Wrecks are useful to the underwater photographer for a number of reasons. They are a convenient site on which to photograph marine life, as many species and varieties are to be found close together. In themselves they make impressive subjects that a non-diving audience can easily appreciate, and they may be valuable for historical reasons. Although steel wrecks are more likely to have survived the ravages of the sea, wooden wrecks may be found in a good state of preservation, protected by sand and mud. They sometimes hold treasures of great archaeological as well as monetary value, and prove to be of considerable historic significance. Photography offers one of the means through which their underwater secrets can be shared by all.

A wreck dive is still not a common occurence. The sea is large enough for the sight of a wreck underwater to be an occasion to look forward to. Often this will have been the result of many weeks of searching and, in the case of wrecks of historical value, delving into archives. The fact that a ship has been wrecked usually implies that the area is dangerous and possibly difficult to reach; so care must be used in any approach. Before concentrating on how to photograph a wreck, it is necessary to consider how to find one, and how to approach it safely.

Finding a wreck

Wrecks may be located using charts or other published details, or by research in archives. The whole of the British coast and many other areas of the world can be studied with reference to Admiralty charts. These provide such information as navigation channels and beacons, landmarks and depth of water; in addition they mark the position of wrecks known to be navigational hazards. Different symbols are used to indicate different types of wrecks, and the meaning of these is given by a key. Further information about marked wrecks can be obtained by approaching the organisation which prepared the chart.

Such charts do not always indicate wrecks that make interesting dives and do not by any means indicate all the wrecks within the area. They show only sites they may cause danger to shipping, and it is likely that, if this is so, some attempt will have been made to reduce this hazard, for example, by razing or blowing up the wreck. In many cases little is left but a few rusting steel plates on the sea bed. Local knowledge will often tell you what is to be found, and may save disappointment. Where the indications are in deeper water or away from main shipping lanes, there is more likelihood of finding a wreck in better condition. The chart will provide the necessary references to locate important wrecks. These are often buoyed to keep ships well clear of the area.

The best way to locate wrecks that are of specific interest is to refer to a specialist book on the subject. Many such books have been written, with both national and regional information. They usualy give the location, nature and brief history of the ship. As they are written primarily for divers, they are full of useful tips on how to find the wreck, the best time to dive on it, and any hazards to avoid. The disadvantage is that such wrecks tend to be popular. If they are easily accessible and can be located without advanced navigational equipment, it is likely that there will be a queue of boats full of divers waiting to dive on the site. Wrecks are normally large enough to accommodate a number of divers at one time, and a careful choice of the time of the dive can avoid possible overcrowding. However, the most popular wrecks are often barren. Even though regulations exist to the contrary, souvenir hunters may

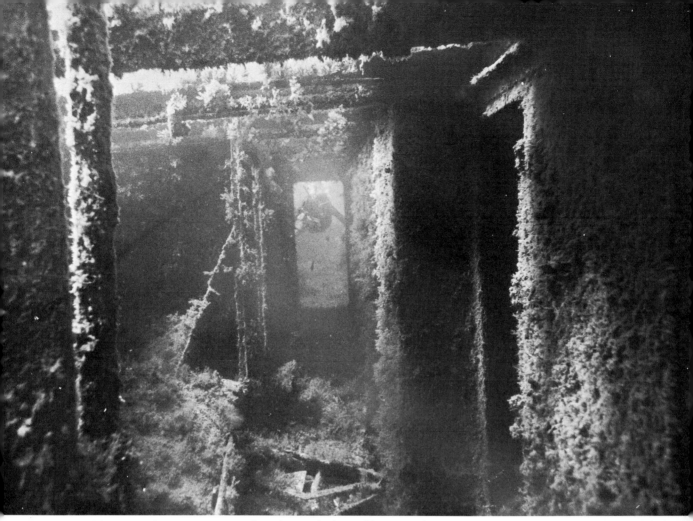

Wrecks abound in picture-taking opportunities. The inclusion of a diver adds a point of interest and the association with the subject being underwater

have removed all loose fitings destroying much of the character of the wreck.

One of the most satisfying achievements is to find a wreck that has never been dived on before. After months of reading and digging into archives, the final sighting of the object of the research is cause for celebration. It is generally only historical wrecks that have to be searched for in this manner, as modern wrecks are usually well documented. Magnetometers, echo-sounders and sidescan sonar have greatly aided such investigations; but a simple and often more reliable method is simply to check with local fishermen, who are only too aware of the sites where their nets have become entangled, and these will be well worth an exploratory dive.

Searches for wrecks, both modern and ancient, are usually well documented. Practically every investigation that has been carried out in modern times has been the subject of a book or at least a magazine article, and such documentary evidence can become the basis for subsequent searches.

Approaching a wreck

Once you have found a wreck, approach it with caution. Even wrecks that are popular dive sites hold many potential dangers, and you should always take a great deal of care to avoid any personal risk. For example, corrosion gradually weakens all metal structures, to the point where even the weight of a diver underwater will cause fracture. Stories have even been told of underwater photographers placing their cameras on a

solid-looking surface while they examined some item of interest only to find a hole in the plate and no sign of the camera when they returned to it. Test all structures before trusing to their soundness, and be extra careful when entering places where there is only one exit.

Silt can also be a major problem. If it is disturbed, visibility can quickly fall to zero in a confined place. This can cause disorientation and the risk of becoming lost. This is reduced if you have a safety line, as you always should when entering a wreck; but beware of sharp edges that could sever this link with the open sea. The creatures that inhabit a wreck may also constitute a hazard. Although conger eels and other large fish seldom attack divers, their sudden appearance and apparent ferocity may result in a moment of panic and a wrong decision. A ship may be a familiar and safe environment on the surface of the sea, but it becomes hazardous once it is on the sea bed.

No matter how tempting, do not remove anything from a wreck. The law of salvage is very complex; in some countries the removal of property from a wreck site may be treated as a serious offence. Try to ascertain the identity of the owner of the wreck, and ask permission to dive on it. In British waters wrecks may be owned by the Crown, by insurance companies or by private individuals. Some are even designated as war graves and should not be dived on. It is important to know of any special requirements before a dive. Such enquiries form as important a part of pre-dive planning as finding out where the nearest emergency facilities are located in case of accident. The local coastguard or police station should be able to provide the necessary information.

Before diving on a wreck familiarise yourself with accepted safe diving practices. Obey these, avoid all unnecessary risk and your diving will be both safe and rewarding.

Four more projects

The different aspects of photographing wrecks are introduced by means of an additional four projects.

Marine life on wrecks

Project 11

Objective

To photograph marine life on a wreck.

100

Location

Choose a wreck that has been on the bottom for a number of years, as in such cases marine life will have become firmly established. New wrecks do not have the variety of marine life that is found on older wrecks.

Equipment

Having followed through previous projects, you should now have established your individual preferences for equipment for each type of photographic task. This exercise necessitates a compromise in terms of equipment, as you will need to shoot a large range of subjects using the same equipment. Versatility in the keynote; the final choice is yours.

Discussion

The sea is full of surprises; often the underwater photographer will come across a subject that is rare, or even unique. He must always be on the lookout for such subjects, and must learn to obtain the best technical quality possible with the equipment he has. The subject may never be seen again, and if he has to surface to obtain additional equipment there is no guarantee that it will be there when he returns. The philosophy of the press photographer must be adopted in these circumstances: at least one photograph must be obtained no matter what the conditions. If you do find such subjects, and it is likely in the course of time that you will, the choice of equipment and technique may not be as important as with commonly encountered subjects. Your subject itself will be enough to provide the necessary impact. Unusual techniques or effects may even detract from the subject itself. Hence it is useful to practise photographing a variety of subjects with equipment that may not be entirely suited to the task.

The various techniques for photographing marine life have already been discussed. Learn to use equipment to the limits of its design; this will help you to appreciate the full capabilities of your equipment. You may even be able to design useful accessories to extend the versatility of your existing equipment.

Diving on wrecks presents a large variety of possible subjects. The fact that objects are man-made, and are easily recognised, increases the

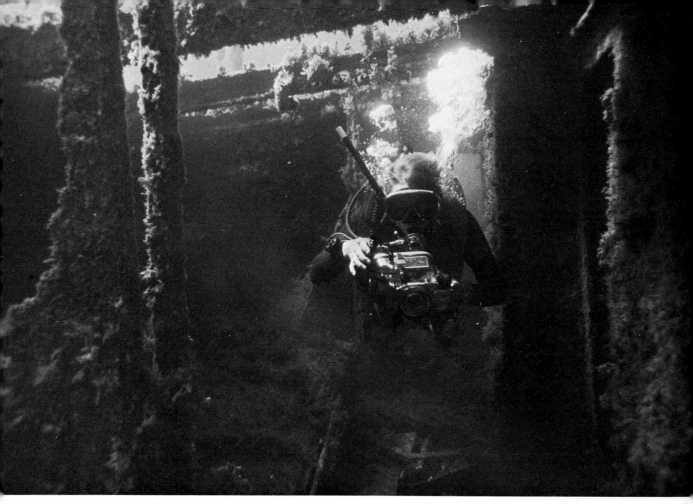

Compare this photograph with the previous one. The position of the diver now leads to this being a photograph of a diver in a wreck rather than a wreck with a diver

likelihood of your finding them again on returning to the same location with more approriate equipment on a subsequent dive. It is also interesting to study the effect of the passing of time on an area, to monitor a static animal as it grows, perhaps suffers attack by a predator, then is replaced by another organism. Such long-term studies make interesting series. New surfaces are often quickly covered by hydroids, which may then be attacked by nudibranchs. The elimination of the hydroid colonies leaves the surface free for other organisms to settle and to grow, and the series progresses. Instead of flitting from one area to another, or from wreck to wreck, try studying just one readily accessible site exploiting all subject possibilities and learning more about the behaviour of marine life, before moving in search of new material.

In order to find and to photograph the various forms of marine life encountered on a wreck it will be necessary to explore it thoroughly. This may not be possible on a single dive, indeed it may take weeks to explore a large ship in deep water. As familiarity increases and interesting locations are found, many possible photographic situations may come to mind. These will not be situations that occur spontaneously but need to be created by your imagination and from your experience. The successful photographer should cultivate the ability to set up a situation and to photograph it so that it appears to be occurring naturally. Creative thought, careful planning and thorough organisation are needed. The production of good work gives a sense of achievement and evokes great satisfaction.

A tour of a wreck

Project 12

Objective

With the assistance of a diving companion, produce a series of photographs that take the viewer on a tour of a wreck.

Location

Any wreck site that is readily accessible.

Equipment

As it is unlikely that the complete series of photographs will be able to be completed on one dive the equipment can be varied; its choice will depend on the treatment you wish to give each subject.

Discussion

This exercise will need a creative mind, thorough planning, and careful liaison with your fellow-diver. You will need to become completely familiar with the wreck, so that you will be able to envisage how each photograph can show the subject matter effectively and impart maximum impact. A rough plan of the ship, and a sketch of the pictorial effect required at each location, is essential. Transfer the final versions of the locations and sketches to an underwater slate; this will save a great deal of time and misunderstanding when diving to take the photographs. If your fellow-diver is the person who accompanied you through the projects in Chapter 8 he will be aware of your approach to photographing divers underwater, and familiar with your hand signal code. This will reduce the amount of briefing necessary and save time during the dive.

It is unlikely that you will be able to complete the series in a single dive. If the photographs are to be a unified series, they must have *continuity*. The subject must be wearing the same equipment for each dive, and the resulting photographs put together in such a way that it appears that all the action took place during one dive. The subject of continuity is discussed more fully in terms of movie photography in Chapter 11, but many of the points discussed there are relevant to this project.

The diver can be used to add both scale and interest to the wreck. Photographs of parts of the ship are of themselves usually of little interest. Most audiences are familiar with ships' companionways, davits, hatches and the like and photographs of them underwater will have little impact. The introduction of a diver to these scenes immediately transforms the subject matter, generating immediate interest. Subsidiary subjects, such as fish and marine growth, should also be integrated into the composition and the resultant combination will give the photograph the required impact. Care must be taken when using a diver in this way. Do not allow his figure to dominate the composition, or it will become a series of photographs of a diver rather than of a wreck. Although the diver will be a primary point of interest he must not dominate the composition.

Not all shots should be general views. The diver may be used to introduce smaller items of interest such as the ship's name plate, small items of cargo, machinery or of the crew's personal possessions. Any item that is photographed in such a way is immediately given scale and a link with being underwater. The investigation of the cargo or of marine life can also benefit from the use of a diver. Ask him to hold objects for you to photograph. Show him examining them, or indicating objects that are difficult to make out, such as well-camouflaged fish. Try to vary your approach so as to add variety to the compositions, and avoid the photographs becoming repetitive.

If visibility is good you can use two or more divers in the composition. If you do, make sure they contribute to the composition by carrying out tasks that are complementary to one another. If they are carrying out separate tasks the photograph will have two main points of interest which will compete, and so detract from the harmony of the composition. Arrange the photograph so that, for instance, one is taking the other's photograph, or assisting with the opening of a door or hatch.

Presentation of photography

If the photographs from Projects 11 and 12 were taken on the same site, then they may be combined to form a slide sequence illustrating the wreck. In this case it may be useful to add some further photographs without any other divers present. This will break up any monotony in presentation and help to build the atmosphere of the show.

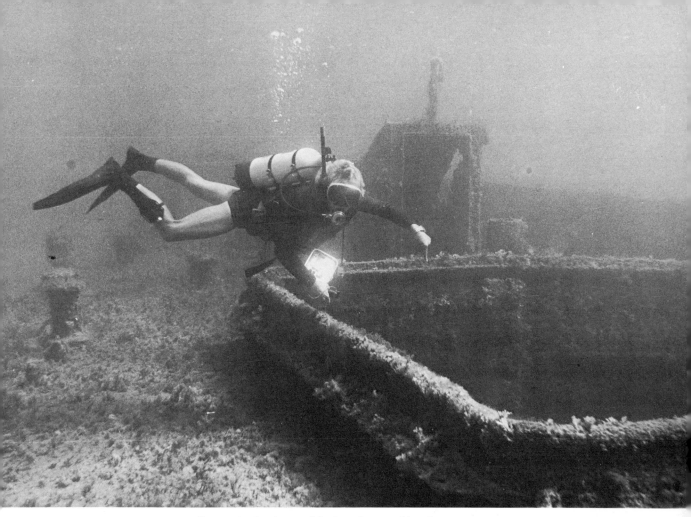

Communication is essential when photographing divers

The addition of recorded commentary and music, and possibly a second projector so that slides may be cross-faded or snap-changed, can add greatly to the smoothness and effectiveness of a show. Such *audio-visual presentations* can often be more effective than a movie in telling a story, and are a valuable method of presenting an extended theme.

Photographic surveys of wrecks

It is possible that at some time you may be asked to make use of your photographic skills for other than purely artistic purposes. You may be asked, for example, to undertake a photographic survey of the wreck of a small vessel for insurance or salvage purposes, or to take photographs of the excavation of an ancient wreck by archaeologists. A different approach must be used for this more technical type of photography.

Here, creative lighting technique and original viewpoints must give way to a straightforward approach, with high technical quality. In order to keep a consistent approach, these two hypothetical tasks will be treated as two further projects, and the problems analysed in the same way as before.

A photographic survey for salvage purposes

Project 13

Objective

To produce a photographic survey of the wreck of a small boat.

103

Location

May be anywhere.

Equipment

The purpose of such a survey will normally be to establish whether there are any large areas of damage that may prohibit or complicate a salvage attempt. Photographs of a more general nature, showing the position of such damage, its extent and the orientation of the boat with respect to the surrounding sea bed, will thus be of more use than detailed close-up shots showing only parts of the damage. A wide-angle lens will therefore be necessary, with appropriate lighting and other equipment. Artificial lighting will be necessary even though the available light may be adequate for photography. Hull damage is usually the most critical, and likely to be in shadow. Photographs may also need to be taken inside the vessel, necessitating the use of a light source, and it is as well to be prepared for such an eventuality.

Discussion

Photographs of the subject must be taken in a logical manner, as it is important to know exactly where each photograph was taken. Swim round the wreck, to gain an impression of the overall situation, then start to take your photographs, beginning at a recognisable position such as the bows. Work round from this position, taking all the general photographs that are necessary. If you go clockwise, as seen from above, you can identify your camera positions on an imaginary clock face, e.g. 3 o'clock, 5 o'clock, etc. If all the photographs are taken in this manner, without chopping backwards and forwards to different parts of the vessel and without attempting any closer shots of items of particular interest on your first time round, the whole circuit may be readily reconstructed without constant reference to writtent notes. So complete the photography of the outside of the hull before proceeding with any further photography. If it is necessary to take more detailed photographs of a particular area, do this after its position has been established by the first series of photographs. Take any necessary close-up shots last of all, having established their precise position by a more general shot.

When you come to the more detailed photographs, remember that a single photograph of an object is unlikely to show every facet of it. As with all other subjects that demand detailed coverage, damage must be photographed from several angles. Complete coverage requires the taking of photographs from square-on, from both sides and from above and below. This may not be necessary in all cases, but it is better to take too many photographs rather than too few, as long as there is enough unexposed film in the camera to ensure that all aspects of the vessel's situation can be covered.

The use of a scale in such photography is useful as it gives an immediate reference to the size of any damage. If an accurately marked rule is not available, a diver's knife, or other object of recognisable size, is better than nothing.

Keep lighting simple at all times, predominantly from the front or just to the side of the subject, in order to show as much detail as possible. It is important to consider whether the light will cast shadows that will obscure any important parts of the subject. You may hence need to change the light source from one side of the camera to the other, as required.

When carrying out such a survey do not surface until you have used all the film in the camera. There is bound to be something further to photograph which could prove important later. The pre-dive briefing should have indicated the main points to be covered, but if you find anything else you feel may be important, then photograph it. No briefing can ever be 100% complete without knowing exactly what is to be found and that after all, is why you have been asked to make the survey.

A survey for archaeological purposes

Thoroughness is equally important when photographing an underwater archaeological site. Even the smallest piece of information could be the key to understanding the historical significance of an ancient wreck, so each find must be carefully recorded. Archaeological sites are normally subdivided into referenced areas, so that the exact position of finds is easy to record. The photography of finds must fit into these specifications and any others that have been imposed by the archaeologist in charge. A methodical approach must again take precedence over creativity in all but any publicity photography that may be called for.

Project 14

Objective

To provide photographic coverage of an archaeological investigation of a wreck.

Location

Again, it could be anywhere.

Equipment

The equipment will depend largely on the size of the finds and the type of coverage required, but will normally fall into one of three categories:

General photographs will be needed to show the overall nature of the site and to give an accurate impression of the condition of the wreck as a whole. A wide-angle or superwide-angle lens will be needed for this, also for recording any large objects of interest that are found.

Detailed photographs will be needed of all finds. Some of these finds are likely to be small, and suitable close-up equipment must always be available.

Publicity shots will always be required. These are likely to show divers working, unearthing, or examining the finds or some newly discovered artefact. The range of photography in this case would be similar to that discussed in Chapter 9, with the need for similar equipment.

These three requirements indicate a wide selection of equipment to cater precisely for each need. Compromises may be made, but the demands of a thorough and comprehensive coverage can stretch both the photographer and his equipment to their limits.

Discussion

Every photograph that is taken needs to be referenced. The precise location and orientation of each photograph and the dimensions of the subject matter are of paramount importance. The size of an object is easily indicated by including a rule or other scale in each photograph; but its position is more difficult to include visually. It may be sufficient to keep an accurate record of the location of each photograph on an underwater slate, but if the photographic coverage is extensive then some other means of indentifying the object will prove more reliable.

Give each object a reference number, and write this along with position reference, date and time on an underwater slate; include this in the field of view of the photograph. It may even be possible to use a data back on an encapsulated camera so that some of this information could be printed directly onto the film. Extra housing controls would allow this information to be altered or updated as required. Whatever your system, ensure it is agreed upon with the other members of the archaeological team; if it is not compatible with their referencing system then it will only cause extra work. Stick to the one system for the whole of your work and keep the system as simple as possible. It will be easier to remember and will allow more of the dive time to be used for taking photographs and less for writing and recording data.

General photographs that show the overall nature of the site can be the most difficult of all. Visibility considerations will influence your approach and you may have to give a good deal of thought to this. A wide-angle or superwide-angle lens will be necessary to ensure that an adequate panorama of the site is included in each photograph. Its use will increase the depth of field and angle of view, but lighting difficulties may restrict its usefulness. It has been seen (p. 76) that the use of artificial light limits correct exposure to a plane, which the exposure latitude of the film can slightly expand. The subject will be overexposed in front of this region and underexposed behind it. Artificial lighting is thus not really suitable for a panorama. If at all possible, you should expose these panoramic photographs by available light. They do not need to be colourful and often the monochromatic blue rendering increases the atmosphere and produces a very effective result. A small amount of fill-in flash may be used to bring some colour into the foreground, but it is best kept to the minimum.

If the site is flat and visually uninteresting, the inclusion of a diver working in the background can enliven the composition. Such an effect should only be used where it does not hamper the purpose of the picture; it must still be primarily a photograph of the site.

The recording of artefacts is comparatively simple. Photographs will have to be taken, using the scale and referencing system adopted, to show the location of each object within the grid system, plus close-up detail of its initial appearance. Once such photograhs have been taken, additional coverage may be required as the object is carefully removed

from its resting place. Small objects may be re-photographed after removal to a more suitable background, or in the hand of another diver. Larger objects may need lifting bags to facilitate their removal, and you will need to be able to take photographs at various stages of such an excavation.

Keep the lighting simple, and set it up with the reproduction of detail in mind. Use a reflector to avoid dense shadows. Photograph each object from several angles to ensure complete coverage. The more photographs you take from different angles, the more complete the coverage will be. On the other hand, make sure that each photograph does depict the subject from a different viewpoint, so that all the photographs will be of value. Consider how many photographs you will need in order to show a third party precisely what the object looked like underwater, remembering that he will be able to see it only through your photographs.

Archaeological sites offer opportunities for exciting publicity photographs. You may be able to take these while the individual divers are working, but work quickly, and do not obstruct them. They will be more concerned with carrying out their work than with having their photograph taken, and you will need their cooperation to set up some extra photographs to supplement the working shots. These should allow an outlet for your so far frustrated creative instincts!

When taking publicity shots, remember that photographs showing the whole of a diver tend to be less interesting than those showing only face, hands and part of the body. When photographing at close quarters the contrast is higher, colours brighter and the activities more easily interpreted. Full-face photographs showing a diver examining objects of interest are always interesting. Look out for effects created by the use of underwater tools. Air-lifts or water-jets may stir up sediment, but if you take your photographs immediatly they are started up you will get some dramatic shots before visibility deteriorates. Photographs of a diver carrying out some unusual activity are always worth pursuing.

Summary

The entire spectrum of subjects for underwater photography has now been introduced. By learning via the projects and choosing from the approaches discussed you will be able to deal with almost any underwater subject. It is hoped that these fourteen projects will have helped you to develop a personal approach so that having mastered the technical aspects of underwater photography, you will be able to interpret the various subjects in your own way and impose your individual style on the resulting pictures. Only you can judge whether the result achieved is the result desired. From now on you can develop your own projects so that you may continue to produce photographs of ever-increasing quality, interest and impact.

11

UNDERWATER FILM-MAKING

Water enables movement to be fully extended in all three dimensions. Movie photography allows movement to be recorded; the combination of diving and film-making enables a whole new range of creative photographic ideas to be formulated and investigated.

Equipment

Although the techniques of film-making differ considerably from those of still photography, the basic principles of underwater camera and accessory design remain the same as those introduced in previous chapters. Only productions intended for wide distribution demand a 16 mm or larger format, and discussions of equipment will be concerned mainly with features associated with the 8 mm formats. However, many of the points covered are also applicable to larger formats.

A movie camera tends to have more camera functions than a still camera: zoom lenses, power zoom, fade and dissolve controls are now becoming commonplace. Film-speed controls, allowing slow-motion, speeded-up or time-lapse photo-

Figure 11.1. A simple housing for a movie camera

graphy are also available; but filming underwater is best kept as simple as possible. The underwater cameraman has enough to consider without having to plan and record all his effects in the camera. Housing designs reflect this philosophy; few camera functions are controllable. Amphibious movie cameras restrict their features to the minimum necessary to expose the film. This does not mean that underwater films cannot make use of basic and visually essential effects, but that these effects are produced at the editing rather than the taking stage. When choosing a movie camera for underwater use, it can therefore be of a simple design, but that does not mean of poor quality. An electric motor film drive is a necessity, and indeed will prove to be of far more use than a clockwork drive. Zoom lenses are neither essential nor even particularly useful. Their action can be effectively duplicated by the diver because of his freedom of movement in the water. Their design does not readily allow for the option of a very wide angle of view; a zoom lens underwater is largely restricted to use at its widest angle of view. Unfortunately, most movie cameras are sold with a non-interchangeable zoom lens. It is therefore advisable to choose a camera with a lens of which the minimum focal length is not more than 8 mm. Table 2.1 (p. 9) gives a comparison of typical focal lengths and angles of view of lenses for different movie film formats. It will be noted that movies are normally made using lenses of considerably narrower angle than those chosen for still work. The 'standard' focal length lens for a movie camera used on land has a diagonal angle of view of some 30°, as opposed to the 45° − 50° angle that is usual for still cameras.

The so-called 'existing light' (XL) cameras also offer some advantages underwater, because of the low ambient light levels. To understand the principle of their operation it is necessary to be familiar with the mechanism of the shutter of a movie camera. This works on a principle quite different from that of a still camera. The shutter itself is a sector of a disc which rotates behind the lens of the camera (Figure 11.2). When the shutter is open the

film is stationary, and while it is closed the film is advanced to the next frame. The size of the open sector is limited by the efficiency of the mechanism that moves the film; in conventional cameras it has been standardised at 170°. If the open sector is enlarged and the speed of rotation remains the same, more light will pass to the film. XL cameras have openings of 220° – 230°. Variable-aperture shutters are available on some cameras, but these are not as a rule coupled to built-in exposure metering. To maintain exposure levels with different shutter settings the lens aperture has to be adjusted. Most shutters are of fixed angle, and virtually all recent cameras have built-in meters which adjust the lens aperture to suit the light level. Naturally, these meters are calibrated to take account of the shutter angle and framing rate.

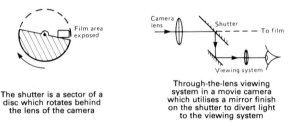

The shutter is a sector of a disc which rotates behind the lens of the camera

Through-the-lens viewing system in a movie camera which utilises a mirror finish on the shutter to divert light to the viewing system

Figure 11.2. Principle of a shutter in a movie camera

Through-the-lens viewing is commonly achieved with the use of a beam-splitting prism or semi-silvered mirror which bleeds off a small portion of the light from the main lens, or occasionally with a mirror-finished shutter which reflects light into the viewing optical system when in the closed position.

Lighting is an important consideration when making films. A continuous light source is essential, but the choice is restricted to self-contained or surface-supplied units. The advantages and disadvantages of both types of lighting were discussed earlier (p. 31). When starting movie photography, it is best to rely on available light, in conjuction with a self-contained lamp for close-up shots only. In this way you can master the techniques before becoming concerned with surface-supplied lighting.

The role of video

Video is making a great impact on the movie scene. The increase in quality in recent years, combined with the advantages of greater sensitivity in conditions of low ambient light and instant replay, has led to its acceptance in many applications where movie photography was once considered the norm. At one time practically all television work outside the studio was on film, but now video cameras are used to record it. Electronic news gathering (ENG) has almost totally taken the place of film for TV news broadcasts. Professionally, video is used more than film underwater. An umbilical from the surface to the camera provides power for both camera and lights, which can be of much lower intensity than that required for movie photography. The umbilical also carries the video signal to the surface where it can be viewed in 'real-time' and recorded. This umbilical is not particularly inconvenient, as most professional divers already have air and communications links to the surface via an umbilical and an additional one makes little difference.

Video is slowly but surely making inroads into underwater filming for pleasure as well as for profit. Small cameras are already available for home use and recorders could be encapsulated and carried on a diver's back. A small umbilical to the surface-support boat, with the recorder and lighting power supply on the surface, may prove to be an even better solution. Nevertheless, whatever gadgetry may become available for home use, in order to produce productions that are both entertaining and informative it is necessary to follow certain basic principles which remain independent of the nature of the recording medium.

Film technique

Although it is possible to take a still camera on a dive in an unknown location and bring back a selection of photographs each of which is impressive on its own, you cannot carry out a similar exercise with a movie camera. A film consists of a series of events, viewed one after the other. These events need to appear to take place in a logical order, and if the film is to be based on a theme, or relates a story, the audience must be able to connect this series of events together in a time sequence. This concept is called *continuity*, and it is the key to success in the making of both films and videotapes.

From the start it is important to overcome the impression that a film is just a series of still shots joined together. If both camera and subject movements are not to be used to produce pleasing visual effects within the context of the overall film

continuity, then it is better to stay with still photography and produce slide-sound presentations.

Principles of continuity

To understand the meaning of continuity, consider the following example: the film is to show a diver entering the water from a boat and swimming down the anchor line to the sea bed.

One way to obtain continuity, but a way that is guaranteed to put an audience to sleep, is to keep the camera running throughout the whole of the action. This would certainly ensure a complete and continuous record of the action but would be monotonous and lack impact. The sequence would also be much too long. A better way to document the action would be to divide it up into a series of well-defined shots from different angles. Some shots will be with static camera positions and others will follow subject movements but they must all combine to give the impression of continuous action.

Consider the following treatment:

SHOT 1 Diver is sitting on the side of the inflatable boat. Camera position is on the same side of the boat. Diver puts on mask, places regulator in mouth, gives OK signal to dive marshall.

SHOT 2 Dive marshall gives OK signal to diver.

SHOT 3 Diver falls off boat and camera moves with him as he hits water.

SHOT 4 Camera underwater. Diver falls through air/water interface towards camera; camera moves with diver as he takes his bearings and moves towards and down the anchor line.

SHOT 5 Camera moves with diver down anchor line keeping above and behind him. Bubbles from exhalation ripple past camera.

SHOT 6 Static camera position from side. Camera pans to show diver making his way down anchor line.

SHOT 7 Camera assumes the position of the diver's eyes to show the sea bed slowly appearing as he continues down anchor line.

SHOT 8 Static camera position at bottom of anchor line. Diver gradually coming nearer and growing in size.

SHOT 9 Static camera position from side. Diver seen to arrive on bottom and start to look around.

SHOT 10 Camera assumes the position of diver's eyes surveying the bottom.

SHOT 11 Same position as shot 9. Diver sees the object of the dive and moves towards it.

Although the above treatment is rough, and does not give precise camera information, it can readily be seen that the action has been broken up into units which, when edited together, recreate the total action. It will also be seen that the filming cannot all be completed while the action is taking place. It will be necessary to repeat the action more than once to ensure it is covered from the different camera positions specified in the treatment. If the action is repeated the diver must be dressed in the same way each time. If he changes, say, to a differently coloured air cylinder then the sequence cannot be edited together smoothly, and the audience will not be able to accept that the action has taken place continuously.

Establishing shot Long shot Medium shot

Close-up Extreme close-up

Figure 11.3. Typical visual content of standard types of movie shot

From the above example, it will be realised that filming is more than simply taking a series of shots and viewing them in order. A film cannot be made up from a series of unrelated shots; careful planning and strict scripting are necessary for successful results. This is especially so underwater, as a movie camera has a strictly limited film capacity.

Scripting

In order to ensure that every shot that is needed is actually taken, regardless of order, it is necessary to make a plan. The result of this planning stage is

a *filmscript*. It is quite possible that this will have to be altered in the course of shooting, but as long as every required shot is 'in the can' (has been completed), or an equivalent shot has been substituted, it will be possible to edit the film into a final, complete form. Nothing is more annoying than to find that one shot is missing from a completed sequence and that the sequence will not work without it. It may even be impossible to repeat the shot, necessitating the complete removal of the sequence from the film.

The scriptwriter's vocabulary

So that a script may be written with the minimum of explanation it is important to be familiar with film language and the shorthand way of expressing it. The terms shown at the foot of the page need to be understood; they are all in common use in film-making and video, and will be referred to throughout this chapter.

With these terms in mind it is possible to rewrite the outline script produced before in more precise terms. When this is combined with a storyboard, a clear idea of what the film is intended to portray is shown. Part of a script, combined with storyboard, is shown in Figure 11.5.

Continuity

In planning the film it is important to keep in mind how it will be edited and how the edited version is

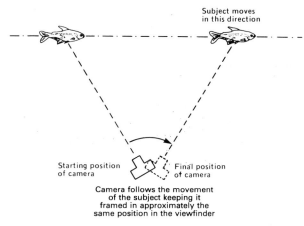

Figure 11.4. Principle of panning

to retain continuity. If certain basic principles are applied the task will be easier.

The film must have a definite theme or story, with a beginning, a middle and an end. Construct the individual sequences so that they build on the skeleton of the theme and ensure they all relate to this, as unconnected sequences confuse an audience. Different dive sequences can, for instance, be connected with shots of the locations above water, or a car laden with diving equipment travelling along a road. Do not assume that the audience will interpret the film in the same way as yourself unless you have presented adequate visual information and commentary. The audience was not

ESTABLISHING SHOT (ES)	A long-distance shot used to establish the whereabouts of the subject in its environment.
LONG SHOT (LS)	Shows the whole of a subject, without showing much detail.
MEDIUM SHOT (MS)	Shows the greater part of the subject (e.g. a waist-level shot of a person)
CLOSE-UP (CU)	Frames a small proportion of the subject, or a small creature filling frame.
EXTREME CLOSE-UP (ECU)	Shows specific detail in a small part of the subject.

An example of visual content typical of each type of shot is given in Figure 11.3.

PANNING	As the subject moves from one side of the camera position to the other the camera swings so as to keep it in frame all the time (Figure 11.4).
TRACKING	The camera bodily moves either with the subject or towards or away from it. Tracking (strictly, pseudo-tracking) can also be accomplished by the use of a zoom lens and may be combined with panning.
CUT-IN	A close-up of part of the subject which is not related to the sequency of action, e.g. the rush of bubbles from a regulator. It is used to overcome a continuity problem.
CUT-AWAY	A close-up which is not directly related to the subject, for example a fish swimming. It is again used to overcome continuity problems.
STORYBOARD	A series of rough sketches to indicate the camera and subject positions in the shooting script.

110

SHOT 5
Medium shot.
Camera tracks with
diver keeping above
and behind him.
Bubbles ripple past
camera

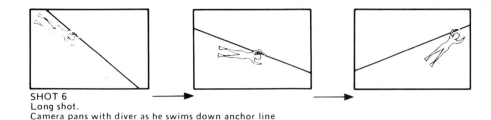

SHOT 6
Long shot.
Camera pans with diver as he swims down anchor line

SHOT 7
Long shot.
Camera assumes the
position of divers
eyes to show sea
bed appearing as he
continues down anchor
line

SHOT 8
Long shot.
→ Medium shot.
Diver approaching
bottom of anchor
line

Cut-in.
Close up of bubbles
escaping from regulator
fill screen to exclude
background and
repeat several times

Cut-away.
Close up of
fish swimming

Figure 11.5. A typical shooting plan

present when the film was shot, so are not party to all the other memories that help in understanding the structure of the film.

The storyboard indicates camera angle and subject content only. It does not specify the duration of each shot. This depends on the nature of the action being filmed. When the individual shots are joined, the action must appear to be continuous. This will be the case only if two or more cameras are used simultaneously from different camera angles. To ensure that these shots do join together when only one camera is used, they must start earlier and finish later than indicated by the storyboard. Each shot in a sequence should always start several seconds before the previous shot has finished. This ensures that there is always an overlap in the action. The longer the overlap the greater the number of possible points where the two shots may be cut together, and the greater the likelihood that the sequence will retain continuity.

When visualising subsequent shots try to change the angle or the image size or both. Consecutive shots taken from the same angle with the same image size will 'jump' when cut together. Try to give the audience as little cause as possible to doubt continuity; change angle and image size frequently. The value of this technique is well

illustrated by TV commercials. They use more different shots per minute than any other form of film in order to produce a strong visual impact. Do not try to imitate this underwater, as underwater action is far slower than on land, and demands a slower cutting rate. The subject matter is also less familiar to an audience, who need more time to assimilate it. Underwater shots should be of a longer duration than their equivalent on land, but as the water allows such smooth and versatile camera movements, such shots need not lose visual impact.

It is possible to investigate the methods used to obtain the required overlap in action by shooting a short sequence from three different camera angles, at three different scales. Try cutting the sequence together in differing ways, and at differing points, to see the resulting effects. This method is of real use in practice only when a firm script has not been written; it uses a great deal of both film and shooting time. If scripted more tightly, the film can rely on a shorter overlap between shots to retain continuity.

Panning is best used for following action than for establishing a scene. Beginners often make the mistake of panning static subjects at length. Do not use panning to 'paint' a subject; use the facility

to express movement. Subjects can be more readily established from further away or by a series of closer static shots, than by a single long pan. The start and finish of a pan should be stationary. If you cut into or out of a pan while the camera is still moving, the effect is most disturbing. The panning should be carried out smoothly and evenly, and at a distance from the subject sufficient for the panning movement to be steady enough to follow easily.

Directional continuity is often lost unintentionally when filming. If it is desired to take a series of shots showing a diver moving from point A to point B then the diver must always be shown moving in the same direction across the screen. Never cross the *line of action* (Figure 11.6). If you do, it will appear to the audience as though the subject has suddenly reversed its direction of movement.

If two directions of movement have been established, for example a shark swimming in to attack its prey, the situation demands even more care. If the shark has been established as moving from screen left to screen right and its prey moving from screen right to screen left, then the audience will gain the impression that they are converging. Provided the camera does not cross the line of action, the shark will continue to come from the left and its prey from the right. The confrontation continues to build up. A camera position actually on the line of action itself may be used to show head-on or tail-on shots; but once you cross the line of action for, say, the shark, it will now appear to be swimming in the opposite direction, chased by its prey! If you try to compensate by crossing the line of action for the prey as well, they will now appear to be swimming away from one another!

You must also take care when introducing subjects to the screen. The audience must be shown where they come from. Consider, for example, a continuation of the sequence with the diver swimming down the anchor line. One diver has entered the water, swum down the anchor line and moved off. If the next shot were to show two

divers together, continuity would have been lost. No explanation would have been provided as to how the second diver appeared. To avoid this the second diver could appear in shot 7, waiting at the bottom of the anchor line, or in shot 11, as the object that the first diver has seen and is approaching. Alternatively, the second diver could be introduced in the commentary as waiting at the bottom of the anchor line; but in every case he needs to be independently introduced visually. Similarly, continuity would be broken if a diver suddenly appeared to have acquired a camera, then in the next shot to have lost it again. A change in wetsuit, air tank, harness, mask or any other item of equipment will also interrupt continuity. When a sequence is to be filmed in parts, remember to keep a note of what the diver is wearing. Professionl productions use instant camera shots to establish a visual record of the subject for this purpose.

Editing

It may seem strange to be introducing a technique that takes place after a film has been shot, before discussing the shooting of the actual film; but this, as it happens, is the logical order. The effects that will be introduced at the editing stage play an important role in the planning of a film. The techniques available must be explained if the effects are to be considered at the planning stage, as their use may demand that the subject be filmed in a slightly different way.

Opticals

Various techniques, called *opticals*, are available for suggesting time transitions. Their use is limited in most productions because they have either to be created in camera (only certain models of 8 mm camera are capable of these effects), or optically when the film is finally printed. Opticals include *fade-outs, fade-ins, dissolves* and *superimpositions*. The situation is different in commercial

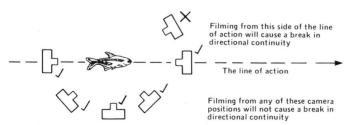

Figure 11.6. Principle of directional continuity

films as no professional production is ever edited from the original film. This is considered very valuable, and is stored in conditions of controlled temperature and humidity. It is handled only to make prints and then with cotton gloves, to avoid the hazards of static, dust and fingerprints. From the camera original a rough print is produced; this is used for editing. The original is then cut to this edited version and printed to make projection copies for showing. The original is then returned to its archive. Opticals are added to these productions at the printing stage. They can be chosen at any point in the film, and are largely independent of the way the film was exposed in the camera.

The situation is more difficult when the camera original is to be used for projection. The opticals will have to be produced on duplicate film and spliced into the original. They will therefore be second-generation copies, and unless the process is carried out to very tight specifications, the differences in density and colour balance between the original and duplicate will cause unacceptable visual jumps at the splices. The only alternative is to produce the opticals in the camera. This is far cheaper, but is not recommended for two main reasons. First, it is almost impossible to plan the shooting of a film so that two sequences to be joined together with an optical can actually be shot consecutively. Secondly, with a camera in a housing it is seldom possible to use the camera controls to create these effects.

Various optical effects are appropriate to different situations. When shooting a scene that is to begin or end with an optical, remember to include enough film to allow this to be made before the action has started or after it is complete.

A *fade-out* is where the scene progressively darkens until it becomes completely black. It implies the end of a sequence and a change of time scale. Fade-outs should be used only when changing location or subject within the overall context of the film.

A *fade-in* is the opposite of a fade-out. The screen is black to begin with, and the image appears progressively until it is at full brightness. A fade-in is used to start a new time sequence or introduce a new location.

A *dissolve* combines the two effects, so that one shot fades out as the the second fades in. The overlap between the two shots produces a temporary double image but the total brightness remains constant. Dissolves may be used to indicate the passage of time within the same location, or to produce an attractive visual effect where continu-ity is not desired. An example of the latter is where a series of individual shots of fish swimming is to be set to music. The shots are not related to one another in any way; a dissolve between them indicates that they are not to be treated as being continuous action.

The length of time taken for a fade-out, fade-in or dissolve depends on the effect required. Short periods of time are best indicated by fast fades or dissolves lasting 1 second or less; slower effects produce a more relaxed sensation and indicate a longer passage of time. The *superimposition* of titles over the subject is also achieved by means of optical devices. If such titles are desired, it is advisable to use the services of a professional laboratory.

Cut-ins and cut-aways

The use of the cut-in and cut-away has already been briefly introduced as an aid to continuity. These shots are also used in editing to complement the main action, both where there is a gap in a sequence and to provide information that is not directly provided by the main shots. They are additional to the main action, but their use provides a well-balanced and informative end product.

When filming a sequence it is always advisable to shoot a selection of cut-ins and cut-aways. Standard shots of fish, bubbles from the exhaust of a regulator, bubbles filmed from above a diver breaking over the camera lens, underwater scenery, plants, the effect of the sun on the sea bed, or the sun shot looking directly towards the surface, can all be used as cut-aways. In each case shoot for some 20–30 seconds, and build up a stock for use in a number of productions as the need arises; but remember that cut-aways should be anonymous, they are usually close-ups, and should not be visibly related to any one place, time or incident. Your friends may also find these shots useful, and it is an excellent idea to set up a small library for a club or a group of film makers, to cater for general needs. The availability of a cut-away can sometimes save a whole film from losing its effect.

Cut-ins, on the other hand, can be filmed only for a specific sequence as they need to be related to the subject. They are of more use in retaining continuity than cut-aways, because the audience is not distracted from the subject matter. They also provide extra information about the subject, making good use of film time to build up the overall story.

As an example, consider a diver carrying a camera and wearing a wrist depth-gauge and a compass. Cut-ins could be filmed around these as follows: The diver could be shown stopping, taking a photograph and moving on again, or glancing at his depth-gauge or compass while swimming along. Each shot would have to be complete in itself and begin and end on action. These shots could then be cut-in at any point in the sequence to provide additional information or overcome a continuity problem. Their use is therefore not necessarily part of the action designated by the sequence.

The practical aspects of editing cannot be discussed fully here, as it is a subject that demands lengthy and detailed treatment. Many specialist books have been written on the subject, and these should be referred to for instruction and guidance. There is, however, one piece of valuable advice when editing any film: when in doubt cut it out. If a sequence or an individual shot within a sequence does not work, do not use it in the film. Even if that shot is the most beautiful rendering of a picturesque subject, if it does not work in the overall context of the film, cut it out.

Shooting the film

One of the most difficult aspects of shooting a film is to explain to the actors exactly what they are required to do. In compiling a storyboard and film script, the whole concept of the film has had to be expressed visually and verbally. The film should now at least be clear in the cameraman's or director's mind and it is a comparatively easy step to brief the actors using these aids. If they are given a series of sketches to show how their piece of action will look on the screen, they will be able to carry out this action far more easily than if briefed only verbally.

Shooting script

Having completed the storyboard and script, it is now necessary to work out the order in which the film will be shot. This will almost certainly not be in the order of the film script. This would take too much time, especially when several non-consecutive shots need to be filmed from a single camera position. The film must be broken down into individual shots, and listed in the order in which they will be filmed. This list is called the *shooting script*.

For an example of how to compile a shooting script, let us look again at the treatment of a diver swimming down the anchor line. Shot 1 and shot 3 are filmed from the same camera position, and would be filmed consecutively. Shot 2 is above water, and would be filmed next. Shot 4 is next in the sequence and near the surface; it would conveniently be the first underwater shot. Shots 6, 9 and 11 are all long shots, 9 and 11 from the same camera position. The camera could be left running to complete both shots 9 and 11 in one shot, which would give more flexibility in editing-in shots 8 and 10. The long shots must be completed first, as action will stir up sediment and reduce visibility. Shots 5 followed by shot 7, will be completed next; they are similar shots, both in mid-water. Any sediment stirred up will by now have settled. Shot 10 will be completed before shot 8, again because of the possibility of stirring up sediment.

The shooting script would thus be as follows:

SHOOTING SCRIPT

Refer to storyboard and film script for details of individual shots.

SHOT 1 ⎫* Diver is sitting on side of inflatable
SHOT 3 ⎭ boat, then rolls into water.
SHOT 2 Dive marshall.
SHOT 4 Underwater – diver entering water.
SHOT 6 Pan down anchor line.
SHOT 9 ⎫* Diver approaching anchor.
SHOT 11 ⎭ Diver leaves anchor.
SHOT 5 Diver down anchor line.
SHOT 7 View as diver swims down anchor
 line.
SHOT 10 Survey of bottom.
SHOT 8 Diver approaches bottom.

* Same camera positions grouped together.

Filming in practice

Before the underwater filming starts a series of signals will have to be devised and agreed with the actors. This was discussed earlier (pp. 75–76). It is important for them to know when to start their action and when filming has stopped, without the need to look in the direction of camera. The best way of indicating that the camera is running is to use a small torch attached to the housing. Switch it on when action is to begin and switch it off when the shot is complete. The torch itself should be powerful enough to be visible to the actors, but

not powerful enough to produce an image on the film. If remote-powered light sources are mounted on the camera the torch can be dispensed with and the lamps used as the signal. Alternatively, a red filter can be fixed to the torch so that it can be distinguished from the lamps. A light signal is more precise than a hand or arm movement, and can be seen out of the corner of the actor's eye.

As everyone needs time to achieve fluent movement, and may also start to slow down before the end of a shot, brief the actor to start moving before the start position of the shot and to continue through the finishing position. This overlap in action, beyond the overlap required for continuity in editing, will ensure smooth action through all the cuts.

If the actor does not fully understand a shot, or if you are not sure about the best camera position to show the action, try a couple of rehearsals. Leave the actor in the camera position and show him exactly what he is to do, or follow his action through the camera viewfinder from the alternative positions. Start to film only when all parties are agreed that the result will be satisfactory. An underwater writing slate is essential for making suggestions without having to surface for discussion.

If the first take is not successful, repeat it. Do not leave the camera position until you are sure you have a perfect shot. It is very frustrating to see a whole sequence spoilt because you failed to take sufficient care over just one shot.

Individual shots underwater need to be longer than on land. The audience needs more time to become accustomed to the unfamiliar environment. Shots not coupled to action should last at least 15 seconds. This may seem a very long time if you are used to filming on land, but remember, that while you can always edit out surplus footage, you cannot lengthen a film that is too short.

Camera stability

One mark of a good underwater cameraman is a film that is steady. If camera movements are shaky the film will be tiring to watch. Camera unsteadiness is very apparent on land with a hand-held movie camera. There the solution is to mount the camera on a tripod. Underwater, this is out of the question, and other techniques must be used. The design of the housing plays an important part in achieving stability. It should be easy to handle, neutrally or slightly negatively buoyant, and retain a correct alignment relative to the subject. A

housing which is too heavy, or too light, or comes to rest with its lens pointing towards the surface, is much more difficult to hold steady when filming.

All divers are familiar with the fact that as they breath in they become more buoyant, and as they breathe out they lose this buoyancy. This results in a diver's depth changing rhythmically in time with his breathing pattern. So that this is not disturbing to the audience, it is important to cultivate a long, slow breathing routine. The resulting slow movements are not disturbing, and are masked by other camera movements. Breathing that is too rapid also carries the risk of bubbles appearing in front of the camera lens. Practise long slow breathing underwater, so that it will come naturally when you are filming.

Most divers use their hands when swimming, both as an aid to balancing and for propulsion. With a movie camera in your hands it is not possible to use them in this way. Practise swimming using only leg and body movements; better still, practise with the camera that you will be using when filming.

When making a tracking shot do not begin filming while you are stationary as there will be a slight jerk as you push away from the bottom or release a hand-hold. Give the signal for the actor to move towards the starting place for the shot and start to move yourself. When both movements are smooth start filming.

A useful trick for smoothing out action is to film at a higher speed than normal. Most 8 mm pictures are filmed at 18 frames per second (fps). If this is increased to, say, 24 fps and projected at 18 fps, the movement will be slowed down. Most sound films are made at 24 or 25 fps, so shoot at 32 fps instead, with normal projection speed. This will also slow down bumps and jerks, making them less obtrusive. Movement underwater is slower than in air and this additional slowing will be readily accepted by the audience. When you increase the filming speed, do not forget to compensate for this in your exposure calculations.

Lighting

Lighting has to be considered as carefully as the film script. Lighting for movies is not as simple as for still photography because it involves more bulky equipment with lower light outputs. Until you have acquired experience in filming, it is advisable to rely on available light, or to use a self-contained continuous source mounted on the

camera for close-ups only. This light should be used only to restore colour and not for the main lighting. It is used in the same way as fill-in flash (see p. 29).

When filming in poor light, continuous light sources will have to be used. There are two possible techniques, lighting attached to the camera, and remote lighting. Each technique has certain advantages and disadvantages.

Lighting attached to the camera

If the light is attached to the camera it remains under the control of the cameraman. He can alter its direction and switch it on and off at will. This ensures the light always illuminates the subject, but when subject distance fluctuates, exposure will also fluctuate. If the light is used primarily for fill-in, i.e. to restore colour to the subject, both exposure and colour balance will fluctuate. This is not important provided the subject is not approached so closely that the fill-in light becomes more powerful than the ambient light. Decreasing subject distance will in this case serve only to enhance the colours of a subject, an effect which is visually satisfying. Backscatter can also be a problem if the light is mounted close to the camera axis. This technique is most suitable for an inexperienced underwater cameraman.

Remote lighting

The use of remote lighting is normally reserved for larger productions where there are enough experienced members in a production team to cope with more complex lighting arrangements. Remote lighting is normally surface-supplied, as the greater subject distances involved demand more power. Remote lighting enables camera movement with little effect on exposure. The exposure is dependent on the total light path (light-to-subject-to-camera); but if the light-to-subject distance is constant any variation in the subject-to-camera distance will have a smaller effect than with the light mounted on the camera.

Surface-supplied lights are normally used remote from the camera to free the cameraman from the risk of becoming entangled in umbilicals. They may be mounted on the subject, for example clamped to a wreck behind a projection out of view of the camera, or carried by another diver, who must be carefully briefed and used to working in this situation. Remote lighting is versatile and can be used to produce subtle effects, as much

more advanced lighting techniques are possible than with lighting attached to the camera; but its complexity precludes its use in many productions. Exposure calculations are easier to carry out with continuous light sources than with a flash.

The finishing touches

No film is really complete without the addition of sound. The simple task of adding music, sound effects and commentary to the film will bring it to life. The use of music is a matter for individual taste; underwater subject matter lends itself to a wide variety of types. Both electronic music and classical pieces can be used. A film of underwater life has even been produced the sound track of which relied on purely mechanical sounds such as those of excavators, motor vehicles etc., to complement the action. The sound of the bubbles exhaled by the divers can also provide atmosphere. Music will create a mood; but much of the reality of a situation is derived from the sound effects. Excellent bubble sounds can be achieved by submerging a microphone protected by a plastic bag in a bucket of water. If a regulator is purged in this bucket there will be a rush of bubbles which can be timed to fit the film sequence. Do not fill the bucket too full or the sudden rush of air will cause large quantities of water to overflow. Other sounds, such as the splash as a diver enters the water, can often be recorded independently of the film and inserted in the sound track in approximate synchronisation. Copyright-free sound-effects records are available; these contain a variety of commonly encountered sounds, such as car or aeroplane noises, which can also be of use in compiling a soundtrack.

The commentary is often the most misused part of a film. It is generally written after the print has been edited, and is often rushed in order to meet a deadline. Too many commentaries provide information that is the same as the visual information. A commentary should complement the visual material, not merely describe it. For instance, in introducing a film of a wreck, a novice's commentary might be:

'This is the wreck of the SS "Saucy Sue" . . .
This is all that is left of its cargo . . .
This is its stern section still intact . . . !

This commentary is providing information that is also being presented visually. The scene may be better set by:

'On January 7th 1963, the SS "Saucy Sue" was caught before a storm. She could not stand up to the lashing waves and hurricane-force winds and was driven bow-first onto rocks. Her silent remains now lie one hundred feet below the surface.

'The force of the impact split her open, and she went down fast. Cargo spilt from the gaping holes in her side as she sank her stern section was left largely undamaged'.

This commentary provides information additional to that contained visually in the film. It brings extra interest into the presentation.

Summary

A successful film will have been thought out from the start. It will have been fully scripted and shot carefully to avoid gaps in the continuity. It will be full of action and close-up colour and will be complemented by music, sound effects and appropriate commentary. Above all, it will tell a story.

Remember the admonishment 'When in doubt, cut it out'; keep the film edited to show only action essential to the story. An audience will receive a short film that is full of relevant action far better than a loosely edited longer version, even though the latter may have outstanding shots of pretty fish and other scenes lacking in direct relevance to the central theme.

Film-making is a challenge which, when successful, can produce a great deal of satisfaction. Start off with short, simple productions, and very soon you may be making box-office hits.

12

THE KEY TO SUCCESS

Knowledge and technique

The shutter of a camera is open for only an exceedingly small percentage of the time that the camera is in use. In most cases the camera will only be in the right place because of much additional work already completed. Without doubt, pre-planning and preparation constitute the largest and most important part of taking a photograph. While many people, with only simple equipment and limited knowledge at their disposal, may stumble on a subject at exactly the right time and, almost by accident, produce an absolutely stunning photograph, it is only the photographer who thinks, accumulates knowledge, chooses appropriate equipment, and then puts his skills into practice, who will constantly be able to produce photographs that are both original and visually appealing.

Technical knowledge

Before a photographer can begin to break rules successfully, he must know what the rules are, and why they were written. A good photographer needs a sound technical knowledge of his subject. He needs to know how to produce correctly exposed, sharp results that would be a credit to any technical illustrator. He also needs to be able to diagnose why results do not turn out exactly as he expected. This knowledge can come only with reading, discussing problems with experienced practioners and constantly reviewing procedures.

More setbacks to the progress of aspiring novices have occurred through bad advice than from any other source, whether from a well-meaning friend, fellow-enthusiast or salesman. Do not accept any information without confirming that it is correct. Do not be satisfied with just one book on the subject either. Many books seem to have been written by extracting information from other sources, rather than by considering basic principles, and so errors can creep in.

Equipment

The photographer who is constantly changing from the equipment of one manufacturer to another will never learn to use any equipment to its limits. It is only by staying with the same equipment, learning all its individual characteristics, faults and limitations, that real progress will be made.

The time to consider changing your equipment is when you have outgrown it, and the performance of equipment limits your creative talents. Only when a photographer can operate without having to devote a large proportion of his time to the mechanical functions of his equipment can he concentrate effectively on the treatment of the subject matter. Just as with experience driving a car becomes more automatic, so that mechanical operations such as changing gear or steering no longer divert your attention from the road, so controlling the functions of a camera should become automatic and not something that you are constantly aware of. Also, if you are fully familiar with your equipment, you will be able to tell if one part of its is not functioning correctly, before a blank film proves it for you.

Techniques

It is often confusing for the beginner to be confronted with so many opinions on technique. Most underwater photographers have their own way of producing results, and their individual opinions as to what equipment may be suitable for a particular task. One thing is certain in photography: there is no single 'right' way to carry out a job. If no new approaches were tried there would never be any progress; we might still be using plate cameras in wooden boxes, with pig's bladders to equalise the pressure. Again, there is no substitute for experience. It is only by diving and trying out each proposed method and technique that you will find the one most suited to you. Perhaps you will not be satisfied with any existing techniques, and will

develop your own. If you do not try, you will never succeed; although discussing problems over a drink or at a club meeting may prove useful in developing ideas and the experience of others is always a useful starting point in any venture, only your own experience can be used to solve your own particular problems. If you wish to become a good underwater photographer, there is no substitute for jumping into the water and taking photographs.

Subjects

The next problem is what to photograph, and where to find it. It is here that the photographer must make a choice. He may carry a camera on every dive, to record the subjects that he encounters, or he may decide to specialise in the photography of certain types of subject matter, diving only to photograph a subject that has been specially selected. The former course of action needs no additional consideration; but the latter marks an entry into a new phase of photography. Research, planning and the development of specific equipment and techniques form an important part of it.

Information on dive sites is available from a number of sources. National diving clubs usually correlate such information from their individual member clubs, and may publish books or pamphlets on the subject. Other organisations, such as the British Society of Underwater Photographers (BSOUP), publish information on dive sites of interest to their members. Many independently published books also exist; these may be traced through diving magazines or local libraries. If such information is found to be inadequate, or more detail is required, a telephone call to the secretary of the local diving club, or to the local diving shop, will usually produce the answers. Addresses can be found in diving magazines. The accumulated knowledge of diving conditions, regularly encountered subjects, and special attributes of a site, either by the individual, or more effectively by a group or club, can make dives more interesting, and more successful in producing photographs suitable for building up a library.

The majority of subjects for photography underwater are usually related to some aspect of marine life. Although photographs of things that are readily seen underwater can be very beautiful, there are many subjects which are far less obvious, but may prove equally photogenic. The best way to find out about such opportunities is to study specialist books on the behaviour of marine life, and to attend short courses on the subject. This is the one certain way to increase your knowledge of life underwater, and give you new ideas about catching it on film. Try to correlate the information on any new subjects with the data you have already gathered on different dive sites. Having identified a likely site, these additional notes will help you to recognise suitable habitats and begin a search.

It is rare that any subject is effectively depicted with just one photograph. Once you have found a suitable subject, stay with it and photograph it in different ways, following its actions. Continued observation of a subject in this way may well produce some action that is unusual or more interesting or, by knowing its habits, such action may be influenced. For example, an octopus changes its colour when it feels threatened, to produce a better camouflage so that it may more effectively merge into its background. If it becomes frustrated and angry it turns a reddish colour, before ejecting the well-known jet of ink to mask its escape. Action such as this makes a fascinating film or series of still photographs. However, remember the ethics of nature photography, and do not provoke marine creatures. Never threaten a subject. Your presence alone will normally be enought of a threat for it to take avoiding action.

Competitions

The way that photography is approached is dependent on the reason behind the photographs; everyone must have thought about this at some stage. The reason for beginning a photographic project may be the wish to produce a record of dive sites much as one takes photographs as a record on a holiday, or it may be solely for personal satisfaction. On the other hand it may be in order to enter a competition.

While still experimenting and learning about underwater photography the majority of your photographs will be purely for personal pleasure. A successful photograph, in which the subject is well depicted both technically and aesthetically, will be a source of much satisfaction. It is when photography ceases to be carried out for individual satisfaction but must be produced to impress someone else that conditions become more stringent. You will find this out when you begin thinking about taking photographs for a competition.

Competitions are very much part of any club activity. They produce a challenge to photographic talents, especially when categories or themes that cannot be filled by stock photographs have been chosen. To win competitions you have to come up with original and unusual ideas and to execute them well. The preferences of the underwater photographer must often be subservient to the views and tastes of the members of the judging panel. This does not mean that you should try to change your own individual style, even less that you should ape the efforts of previous winners. On the other hand, if you know that a certain style or way of presentation is unpopular with the judges, you would be foolish to deliberately work in that style. By all means look at previous winning entries, but remember that in photography, as in every other artistic pursuit, fashions change. The judges will be looking for new approaches. However, a study of past winners can reveal the types of photograph that are likely to be successful, as well as general trends. For example, the panel may prefer to see a fish reproduced in its natural habitat rather than against a uniform background of water. Such points as this can save disappointment after hours of hard work planning and executing an idea.

The unusual is always well received. In a competition designed to produce photographs of subjects found in an area in one afternoon, one entrant actually took a cooked crab into the water to use as his subject. Unusual lighting techniques resulted in a very striking exhibit which, although it was not well rewarded on the day, has since received several awards.

Do not be discouraged if success is not immediate. In choosing subject matter well, keeping technical quality high and presenting the results appropriately you will be gaining valuable experience and the just reward for the effort expended will come eventually.

Publications

One way of subsidising the expense of taking photographs underwater is to have your work reproduced in magazines and books. Although it is often possible to succeed by a direct approach working through an agency usually proves more successful. Local papers are probably the only case where a personal approach is more likely to succeed.

Agencies do not require only unusual photographs of uncommon subjects. They also need photographs of even the most commonly encountered sea creatures and of divers. Individual treatment of subjects is best discussed with the agency direct, as they will be more familiar with their markets. If photographs are taken 'on spec', certain factors should be considered. Colour and black-and-white reproductions are made from colour transparencies and black-and-white prints respectively. Shooting on colour-negative film will necessitate the making of transparencies from these negatives, as colour prints are of no use as the starting point in the printing processes commonly used. The black-and-white prints are normally submitted on 203 × 254 mm (8 × 10 in) glossy paper and should have captions affixed to the back of each print. Transparencies should be mounted, or if of large format, stored in individual envelopes. All should be suitably referenced and spotted in the bottom left hand corner. Identify each transparency with your name and address in case they become separated; but write all the captions together, as there will not be enough space to write full captions on mounts. Alternatively hinge the captions to the lower edge of the transparency or mount using a narrow strip of cellulose tape. Send larger transparencies in individual envelopes with the captions written on these, making sure that there is a cross-reference by which transparencies can be put back in their correct envelopes.

A prospective publisher will take more notice of a large transparency than a small one. Transparencies of a 6 × 6 cm format have an image with an area nearly four times that of the 35 mm format and are proportionally more striking when viewed on a light box.

When a good subject has been found underwater, and it is intended to submit photographs of it to an agency, make sure that it is covered in a number of different ways, with different lighting, different framing (possibly with space left at the top of the frame for a title), and in both horizontal and vertical formats. If the subject is good and is subsequently published, another publisher would not want to publish exactly the same photograph. However, he would probably be perfectly happy to publish a photograph taken from a slightly different angle. The extra effort to ensure full coverage of subject will be returned many times over.

When a photograph is published the photographer receives a reproduction fee. The amount

of this fee varies from publication to publication but will normally be linked to the circulation of the magazine. The larger the circulation, the larger will be the fee. An outstanding photograph may be worth more than the standard fee, and more is usually paid for colour than for black-and-white reproduction. Front covers will also be paid on a higher scale. An agency will always ensure that they receive the largest possible fee for a photograph as they take a fixed percentage of any fees they receive on behalf of the photographer. Most agencies are honest and will not withhold any fees.

Occasionally a publisher or other organisation will try to buy the copyright of the photograph. Reproducing a photograph, and paying the necessary fee, does not transfer the copyright of a photograph, which remains with the photographer, or the individual or organisation that commissioned it. Such a photograph may be reproduced repeatedly, as long as no conditions to the contrary are attached to any one reproduction, but once copyright is sold then the photograph is no longer owned by the photographer. He may retain the original, but may no longer offer it for reproduction or sale, and indeed may not even make additional prints or copies of it for himself without permission from the new copyright holders.

Be aware of the difference between selling for a reproduction fee and selling copyright. Always read the small print in any agreement.

A final word

No book can adequately set out all aspects of a particular discipline of photography, particularly one as rapidly changing and open to personal approach as underwater photography. If this book has introduced the technical aspects in an understandable way, helped to produce confidence when photographing a subject underwater, answered some questions and provoked some ideas, then it has been of use. It is now up to you, the photographer, to continue to develop your personal ideas and record them on film. It is only by personal effort that progress can be guaranteed.

INDEX

Aberrations, 3
Absorption, 2, 5, 52
Accessory attachments, 16
Accessory bar, 11
Acutance, 48
Alkaline cells, 24, 25
Amphibious camera, 2, 7, 11, 63
Amphibious electronic flash, 24
Angelfish, 95
Angler fish, 92
Aqualung, 1
Artificial light, 5, 7, 19, 32, 76, 77, 89, 104
Audio-visual presentation, 103
Automatic exposure, 12, 39
 models, 11
Automatic focus, 7
Available-light photography, 7
Azo dyes, 47

Backlighting, 85, 88
Backscatter, 5, 11, 23, 34, 58, 85, 88, 116
Bad visibility, 51
Barnacles, 88
Barracuda, 94
Barrel distortion, 55
Bass, 94
Batteries
 alkaline, 24, 25
 dry, 20, 25
 nickel-cadmium, 20, 24, 25
Bellows, 62, 64
 extensions, 63
'Bends', 1
Blennies, 88–90
Bony flat-fish, 92
Bottom dwellers, 92
Boutan, Louis, 1, 2
Bream, 93
Buoyancy control, 72, 77, 78
Butterfly fish, 95

Calibration of close-up attachments, 65
Camera controls, 15
Camera stability, 115
Care of the housing, 17
Class FP flashbulbs, 20
Close-up lens, 62, 63
Close-up photography, 8, 24, 31, 60, 61, 65, 104, 105, 108
Colour temperature, 22, 30, 31, 33, 44, 45
Commentary, 116

Composition, 71
Condensation, 13
Conger eels, 91, 100
Continuity, 102, 108–110
 directional, 112
Continuous light source, 5, 19, 31, 59, 108, 116
Contrast, 5, 32, 34, 48, 52, 85, 88
Controls
 dissolve, 107
 fade, 107
Control rods, 14, 17
Corals, 81, 90
Crab, 88–90, 96
Crawfish, 91
Crayfish, 91
Crustaceans, 81, 82
Cut-aways, 113
Cut-ins, 113

Dab, 92
Damselfish, 95
Depth of field, 10–12, 33, 65, 69, 76, 89, 90, 95, 105
Diaphragm shutter, 20, 21
Diapositives, 44
Differential focusing, 85, 89
Diopters, 63
Directional continuity, 112
Dissolves, 113
Dissolve control, 107
Dogfish, 92
Dolphins, 94
Dome ports, 16, 55
Dry battery, 25

Editing, 112
Electronic flash, 11, 19, 22, 25, 29
Embolism, 1
Exposure compensation, 64, 89
Exposure latitude, 76
Exposure meter, 38, 40, 75, 76, 78, 95
 photoconductive, 38
 photovoltaic, 38
Exposures, bracketed, 27, 39, 44, 78, 88
Extension tubes, 13, 16, 62–64, 66, 89

Fade control, 107
Fade-ins, 113
Fade-outs, 113
Fill-in flash, 29, 60, 74, 77, 95, 105
Fill-in mode, 75, 76, 88

Film formats, 9, 42
Filmscript, 110, 114
Film speed, 45, 48
Film storage, 46
Filter factor, 32
Filters, 5, 31
 acrylic, 31
 colour-compensating, 31, 32
 colour-conversion, 31, 33
 contrast, 31, 32
 gelatin, 31
 glass, 31
 neutral density, 31, 33, 90
 polarising, 34
 special effects, 31, 33
Fish, 81, 96
Fisheye lens, 16, 39, 55–57, 60
 full frame, 55
Flare, 5, 52, 58, 88
Flash
 bulbs, 5, 19, 20, 22, 23
 cube, 11
 electronic, 5, 11, 22, 23, 29
 exposure, 24
Flash arms, 40
Flash calibration procedure, 27
Flash connection, 25
 Ikelite, 25
Flash cubes, 11
Flash exposure, 24, 26
Flash synchronisation, 9, 20, 33
Flash underwater, 72
Focal-plane shutter, 11, 12, 20–22
Focusing lamp, 96
Focusing lights, 41
FP synchronisation, 22, 25
Frontal lighting, 85
Full-frame fisheye lenses, 55

Garfish, 94
Gelatin filters, 30
Ghost images, 23
Goby, 93
Graininess, 48
Groupers, 95
Guide numbers, 26, 27, 29, 72

Handling qualities, 17
Handling systems, 39
Hermit crabs, 88, 89
Hot spots, 5
Housings, 2, 13
 aluminium, 14
 home-made, 13
 injection-moulded, 13
 metal, 14
 plastic, 14
 stainless steel, 14
Humidity, 46
Hydroids, 81, 82, 88–90, 101

Interchangeable lenses, 8, 12, 39
Interchangeable ports, 16
Internegative, 44
Ivanoff corrector, 56

Large formats, 13
Latent image, 47
Lateral chromatic aberration, 55
Leading blind, 21
Lens, 9
 wide-angle, 9, 10, 16, 23, 39, 53, 54, 75, 105
 superwide-angle, 10, 16, 24, 35, 39, 55, 57–60, 76, 77, 105
Lens attachments, 39, 53, 54, 56
Lighting, 115
Lighting from above, 85, 88
Line of action, 112
Lobster, 88–90, 96

Mackerel, 94
Macro lenses, 16, 65, 66
Marlin, 92
Materials for camera housings, 2, 13, 14
Moray eels, 95
Motor drives, 7
Movie cameras, 10, 33, 42
Movie photography, 5, 19, 31, 102
M-synchronisation, 21
Mullet, 94
Multiple flash, 29
Music, 116

Negative film, 44
Neutral density filters, 29, 33, 80, 90
Newton's rings, 48
Nickel cadmium rechargeable cells, 24, 25
Nikonos, 11, 25, 39, 40, 56, 65, 66
Nitrogen narcosis, 1
Nudibranchs, 88, 101

Open-water dwelling fish, 92, 93
Optical ports, 56
Opticals, 112
Optical density, 3
Optically accurate window, 2
O-rings, 17

Parallax, 8, 12, 35, 65, 69, 72
 compensation, 36
Parrot fish, 95
Pentaprism, 8
Perspective distortion, 57, 73, 75–77
Petroleum jelly, 17
Photography at night, 96
Pincushion distortion, 55
Plaice, 92
Plane port, 3, 9, 11
Pollack, 93
Porpoises, 94

Ports, 2, 55
 dome, 16, 55
 optical, 56
 plane, 3
Power winders, 7
Power zoom, 107
Prawns, 88
Puffer fish, 95

Quartz-halogen bulbs, 30, 31

Rangefinder focusing, 12
Rays, 92
Reflection, 2, 5, 52
Refraction, 2–4
Reversal film, 44
Ring flash, 88
Rock-, weed- and wreck-dwelling fish, 92, 93
Rule of thirds, 71

Scallops, 81, 92
Scattering, 2, 4, 9, 52
Scorpion fish, 92
Sea-anemones, 81, 82, 88–90, 97
Sea-cucumbers, 82
Sea-lilies, 88
Seals, 16, 94
Sea scorpion, 92
Sea-slugs, 81, 88
Sea-squirts, 82, 88, 90
Sea-urchins, 81
Sharks, 92, 94
Shooting script, 114
Shore crab, 90
Shrimps, 88
Shutters
 diaphragm, 9
 focal-plane, 9
Sidelighting, 85, 88
Silhouettes, 77
Silicon grease, 17, 24, 25
Silicon spray, 17
Simple cameras, 7, 10
Single-lens reflex, 8
Skate, 92
Slave flash, 29
Slave unit, 25
Slow-motion photography, 107
SLR cameras, 12, 66, 89
Snorkeling, 11
Soldier fish, 95
Sole, 92
Sound effects, 116
Speeded-up photography, 107
Spider crab, 90
Spiny lobster, 91

Split-image rangefinders, 8
Sponges, 81, 90
Squat lobsters, 91
Stability of camera, 115
Starfish, 81, 83
 brittle-stars, 83
 sea-stars, 83
Stickleback, 92
Stonefish, 93, 95
Storage of film, 46
Storyboard, 110, 114
Superimpositions, 113
Superwide-angle lens, 10, 16, 24, 35, 39, 55, 57–60, 76, 77, 105
Supplementary lens, 89
Surgeon fish, 95
Swimming crab, 90

Time-lapse photography, 107
Tracking, 115
Trailing blind, 21
Transparencies, 44
Tropical reef fish, 92, 94
Tropical waters, 19
Tuna, 94
Tungsten bulbs, 30
Twin-lens reflex, 8, 13, 67
Two-source lighting, 59

Underwater optical systems, 3

Video, 108
Viewfinder, 8, 35, 57
 frame- or sports-finder, 35
 optical, 35
Viewfinder cameras, 12
Viewing systems, 7
Visibility, 51, 72

Water-contact lenses, 56
Waterproof housing, 7, 73
Weed, 88
Weevers, 92, 93
Wide-angle lens, 9, 10, 16, 23, 39, 53, 54, 75, 105
 superwide, 10, 16, 24, 35, 39, 55, 57–60, 76, 77, 105
Wrasse, 93
Wrecks, 98

X-rays, 47
X-synchronisation, 21, 23, 25

Zone lighting, 88
Zoom lens, 107